WHARTON ESHERICK AND THE BIRTH OF THE AMERICAN MODERN

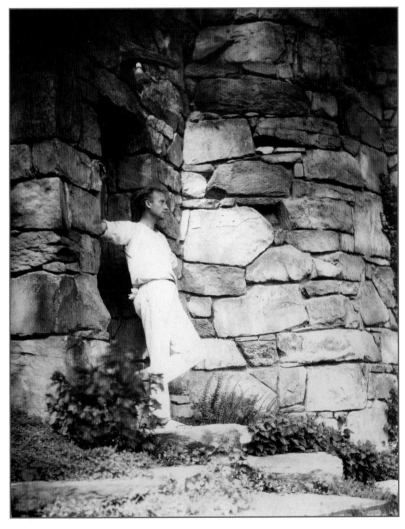

4880 Lower Valley Road Atglen, Pennsylvania 19310

In Cooperation with

Edited by Paul Eisenhauer and Lynne Farrington,
with an essay by Paul Eisenhauer

Wharton Esherick and the Birth of the American Modern has been supported by The Pew Center for Arts & Heritage through the Philadelphia Exhibitions Initiative

Schiffer Books are available at special discounts for bulk purchases for sales promotions or premiums. Special editions, including personalized covers, corporate imprints, and excerpts can be created in large quantities for special needs. For more information contact the publisher:

Published by Schiffer Publishing Ltd.
4880 Lower Valley Road
Atglen, PA 19310
Phone: (610) 593-1777; Fax: (610) 593-2002
E-mail: Info@schifferbooks.com

For the largest selection of fine reference books on this and related subjects, please visit our web site at
www.schifferbooks.com
We are always looking for people to write books on new and related subjects. If you have an idea for a book please contact us at the above address.

This book may be purchased from the publisher.
Include $5.00 for shipping.
Please try your bookstore first.
You may write for a free catalog.

In Europe, Schiffer books are distributed by
Bushwood Books
6 Marksbury Ave.
Kew Gardens
Surrey TW9 4JF England
Phone: 44 (0) 20 8392 8585; Fax: 44 (0) 20 8392 9876
E-mail: info@bushwoodbooks.co.uk
Website: www.bushwoodbooks.co.uk

CONTENTS

ACKNOWLEDGMENTS

This exhibition and catalog has been collaborative from its inception. The collaborators include, first and foremost, the Wharton Esherick Museum and Hedgerow Theatre, both of which have worked closely with the Rare Book and Manuscript Library and the Architectural Archives at the University of Pennsylvania to make this exhibition possible.

This exhibition began as a modest idea to present a show that brought together the collections of the Wharton Esherick Museum and the University of Pennsylvania Libraries. Once we began speaking with others, the depth and scope of the project grew. Those conversations led to the creation of a curatorial team that brought the needed range and depth of expertise to this project. We want to thank Andrea Gottschalk, Roberta A. Mayer, Mark Sfirri, and William Whitaker for their ongoing commitment and involvement. Without them, this would never have been possible.

Penelope Reed has been instrumental in bringing theater into the story on many levels and has helped shape both the exhibition and the related programming. The project benefited from the expertise and support of Kathleen Foster, David de Muzio and Elizabeth Agro of the Philadelphia Museum of Art, and David Brownlee, Peter Conn, and Holly Pittman of the University of Pennsylvania. Robin McDowell designed the typeface Everyman, used for the title of the exhibition; David Comberg of Penn's School of Design did fantastic design work for the exhibition and website; and Matt Neff, Sophie Hodara, and Ivanco Talevski of the Common Press executed several Esherick-related printing projects associated with the exhibition. Those projects were made possible through the generous support of John and Robyn Horn. Thanks to David Holmes, from whom the University of Pennsylvania Libraries was able to acquire the Centaur Archive, we were able to tell the story of the Centaur Book Shop and Press.

This exhibition and catalog would not have been possible without the help of Mansfield "Bob" Bascom and Ruth Esherick Bascom. Throughout the project, they have shared stories, photographs, letters, and information. Bob shared an advance copy of his biography of Esherick, which saved us from many errors in telling the story. Their support and enthusiasm for what we were trying to do made the project not only rewarding but also fun.

We are extremely grateful to the many lenders to this exhibition. They graciously invited us into their homes to show us their collections and generously allowed us to bring together a wealth of materials to illustrate the theme of the exhibition. Our sincere thanks go to all of the following: Mansfield Bascom and Ruth (Esherick) Bascom; Peter Esherick; David Esherick; Peter Fischer Cooke; Barbara Fischer Eldred; Enid Curtis Bok Okun; Susan and Keith Sandberg; Rita and Tom Copenhaver/Sherwood Anderson Collection, Ripshin Farm (Virginia); Kaitsen Woo; Jack Lenor Larson /LongHouse Reserve (East Hampton, New

York); Robert Aibel/Moderne Gallery; Jill Quasha; Mark Sfirri; Kate Okie; Caroline Hannah and Elizabeth Felicella; and James Mario, who photographed Esherick's work and kindly gave his photographs to the Wharton Esherick Museum.

In addition to the individuals and families who have contributed, the following institutions have also generously shared their collections with us: Wharton Esherick Museum; Hedgerow Theatre; Threefold Educational Center; Philadelphia Museum of Art; Howard Gottlieb Archival Research Center, Boston University; Brooklyn Museum (Brooklyn, New York); Newberry Library (Chicago, Illinois); Smyth-Bland Regional Library (Marion, Virginia); and Georgia O'Keeffe Museum/Artists Rights Society (ARS), New York.

Wharton Esherick and the Birth of the American Modern has been supported by The Pew Center for Arts & Heritage through the Philadelphia Exhibitions Initiative. Additional funding has come from the University of Pennsylvania Libraries, from the David A. and Helen P. Horn Charitable Trust, and also from the Center for American Art at the Philadelphia Museum of Art and the Department of the History of Art at the University of Pennsylvania in support of the Second Annual Anne D'Harnoncourt Symposium. They have allowed us to dream large and to realize those dreams.

Many thanks go to Rob Leonard, Tamara Barnes, and Lauren Otero, who generously picked up the slack at the Wharton Esherick Museum that allowed Paul the time to participate to the fullest. Our gratitude goes, as well, to H. Carton Rogers and David McKnight of the University of Pennsylvania Libraries for their continuing support for this project. Other Penn Libraries' staff deserving thanks are Andrea Gottschalk, Elizabeth Ott, and Chris Lippa, for many of the wonderful images in the catalog and exhibition; Cathy von Elm and Bryan Wilkinson for assisting with the grant; Sibylla Shekerdijiska-Benatova and Susan Bing for conserving pieces for the exhibition; Terra Edenhart-Pepe, Alyssa Songsiridej, and Jonah Stern for preparing the exhibition; and Alyssa Rosenzweig for working on the website. Special thanks go to Daniel Traister and John Pollack of the Rare Book and Manuscript Library for their invaluable editorial and formatting assistance with this catalog. Finally, we would like to thank Pete Schiffer for working with us to make this catalog a reality.

Paul Eisenhauer
Wharton Esherick Museum

Lynne Farrington
University of Pennsylvania Libraries

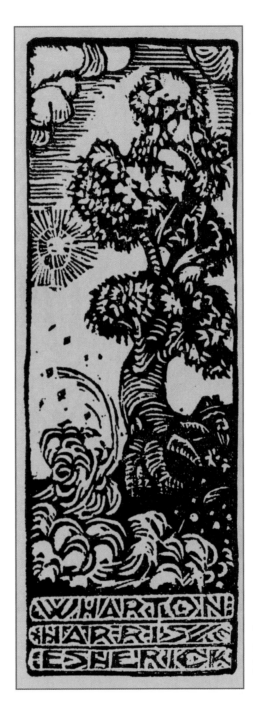

Wharton Esherick,
*Ex Libris—Wharton Harris
Esherick*, woodcut, 1922.
Wharton Esherick Museum.

FOREWORD

The University of Pennsylvania Libraries are known for our collaborative spirit. An expression of this spirit can be found in our exhibitions program. Over the years we have worked with artists, collectors, and other repositories to fashion exhibitions that educate the mind and delight the senses. We have brought together the resources and collections of the Libraries with those of other individuals or institutions to speak to a range of topics, from early education to artists' books. By bringing disparate materials together, we are able to tell stories in ways that no single individual or repository could alone.

Wharton Esherick and the Birth of the American Modern is yet another example of this collaborative spirit. The exhibition and catalog would not have been possible without the participation and support of the Wharton Esherick Museum and Hedgerow Theatre. The cooperation of the Architectural Archives of the University of Pennsylvania, one of the two venues for the exhibition, has been vital, as it allowed us to explore the development of Esherick's work over time, adding content to context. The Common Press, a Penn collaboration of the Libraries, School of Design, and Kelly Writers House, has been another important part of this project, working with the Wharton Esherick Museum to print a portfolio of restrikes of original Esherick woodblocks as well as participating in many exhibition-related events.

It has been exciting to see how the Esherick project has gained support from a variety of sources, including the Philadelphia Exhibitions Initiative, part of the Pew Center for Arts & Heritage; the Center for American Art at the Philadelphia Museum of Art; and Penn's Department of the History of Art. They, along with the many lenders and participants in this exhibition, have expressed enormous enthusiasm for this endeavor to reveal the range and depth of Wharton Esherick's work and world. Our thanks go to all of them for their interest and generous support.

H. Carton Rogers
Vice Provost and Director of Libraries
University of Pennsylvania

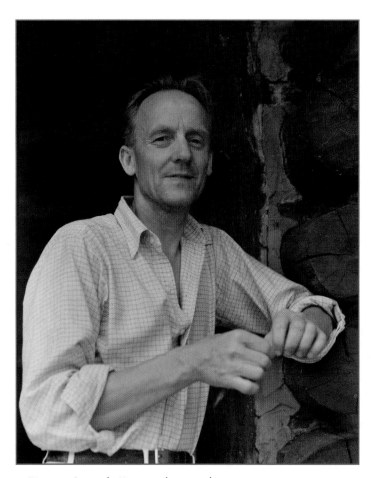

Figure 1. Consuelo Kanaga, photographer,
"Wharton Esherick," photograph, 1940.
Esherick Family Collection.

INTRODUCTION

A SONG WELL SUNG

I produce because I want to make something with my talent equal to his production. Fine music makes fine pictures. Fine pictures make fine drama. Fine drama makes fine music or poetry or song. Each stimulates the other. ... Life is not worth living if we keep measuring and grabbing. There is no limit to a great man, a great work, a great group. It cannot be measured. A song well sung keeps going into other songs, other pictures, other life. It has no end. What has no end cannot be measured.
—Wharton Esherick, "Esherick on Deeter"[1]

A mythology has grown up about Wharton Esherick since his death in 1970, a myth resonant with American archetypes. He is portrayed as a rugged individualist pursuing his craft in his own way, living a hermit-like existence in his rural hillside studio: a modern-day Thoreau. Like all good myths, this one has an element of truth to it. Esherick, an individualist who worked hard to realize his vision, loved Thoreau and moved to the country to lead an "organic" life.[2] But myth and reality, whatever element of truth they share, are not entirely congruent.[3]

Esherick was, first and foremost, a modernist artist. Modernism is the name given to a range of movements in arts, literature, architecture, and design that shared ways of seeing and understanding the world in the late nineteenth and early twentieth centuries. Modernists rebelled against uncritical acceptance of tradition, believing that individuals should struggle against the constraints imposed by society and religion. They believed in progress, striving to improve the world and to find new and better ways of doing things. But their faith in progress was leavened with a strong dose of pessimism about the established order. They followed various social or political philosophies, rejecting ideas of absolute truth and believing instead in a moral relativism. Their approaches to art and life were shaped by revolutionary developments in all spheres of human life and understanding. Charles Darwin, by uncovering the mechanisms of evolving biological diversity, toppled the idea of human exceptionalism, showing that people were, in essence, merely animals. Sigmund Freud and Carl Jung brought the unconscious mind into people's consciousness, showing that basic animal instincts drove human behaviors in subtle ways beyond an individual's awareness. Einstein upended the previously solid world of physics by introducing notions of relativity. Struggles between workers and owners, and the booms and busts of the business cycle, lent credence to Karl Marx's theories of the inevitability of class struggle and revolution in a capitalist economy that was at best only a temporary stage on the road to socialism. The rapid pace of industrialization and mass production transformed work and life, creating new conveniences that changed lifestyles and increased consumption. Family and gender

roles changed as women went to work outside the home and demanded a voice in politics. In this context Wharton Esherick lived and developed as an artist.

Esherick engaged with the world on many levels, as evidenced by the books on his shelves: Lenin, Freud, D. H. Lawrence, and John Dewey are there, as well as works of anthropology, biology, poetry, and adventure. Thoreau's *Walden* was a bible for Esherick, but he was also familiar with the Bible even though he was not a religious man.[4] He subscribed to contemporary journals of literature, art, and politics, and loved to argue and debate with his friends about the ideas he found in these periodicals. His books of literature, art, and poetry were not only western, but also came from the cultures of South Asia, Indonesia, Japan, China, and indigenous North and South American tribes.

No hermit, Esherick regularly left his hilltop sanctuary for the companionship and intellectual exchange that took place in Philadelphia and elsewhere. Frequenting Philadelphia's Academy of Music, Print Club, Centaur Book Shop, and galleries, he also traveled regularly to New York to visit museums, the Weyhe Gallery, and the American Designers' Gallery, as well as his friends. With his family he traveled to Fairhope, Alabama, and the Adirondacks. At Hedgerow Theatre, outside Philadelphia, he was an active participant who built sets and furniture and designed costumes and posters for shows.

Esherick saw himself as an artist, not a craftsman, and his concern was with form, not technique. He doggedly pursued his artistic vision in forms that might turn to furniture or other functional sculpture. More importantly, these were but one aspect of his art, complemented by the paintings, prints, drawings, poetry, and sculpture he also created. Moreover, his furniture was as much influenced by Brancusi, Matisse, and Picasso as by Chippendale, Greene and Greene, and the Shakers.

While he enjoyed his privacy, especially later in life, he was by no means a recluse. Esherick believed that different arts fed each other. Though his talent was in one sphere, other arts inspired and nourished him, helping him and his art continually to grow. His circle of friends shows this diversity of interests. He had friends who were artists, Henry Varnum Poor and Julius Bloch among them. But his closest friends were writers and theater people: Sherwood Anderson and Theodore Dreiser, two of the most significant early twentieth-century American writers; and Jasper Deeter, a leading figure in avant-garde American theater, who had left the Provincetown Players to form Hedgerow Theatre. Among his friends were a number of important women artists and writers: photographer Marjorie Content, friend and confidant of Georgia O'Keeffe and wife of Harlem Renaissance writer Jean Toomer, became one of Esherick's important patrons; socialist photojournalist Consuelo Kanaga, wife of artist Wallace Putnam, photographed Esherick's studio and work and became a friend and client; and Louise Campbell, writer and long-time editor of Dreiser, was a frequent visitor at the Esherick farm.

His circle did what all groups of friends do: they supported each other emotionally and intellectually. They provided shoulders to lean on in times of trouble. They celebrated each other's accomplishments and victories. They used one another to escape from the pressures of their lives. But they also helped each other professionally. They introduced each other to people who could further their careers, help them get published, or get their works exhibited in galleries. Esherick's close friends brought him into cultural circles central to the development of American Modernism. Carl Zigrosser introduced New York to Esherick's work through shows at the Weyhe Gallery. Esherick helped Dreiser and Anderson get their work produced at Hedgerow Theatre while simultaneously helping Jasper Deeter acquire works by famous American novelists for his stage. Similarly, he served as an intermediary between Anderson, Dreiser, and Harold Mason of the Centaur Press. By critiquing each other's work, these friends pushed one another to go farther. Their friendly rivalries inspired each to more and better work.

Argument and engagement were central to the friendships and careers of the people in Esherick's circle. All were involved, to some degree, in the political movements of the 1920s and 1930s. Censorship, the problems of capitalism and socialism, the emasculating effects of alienation, the First World War, the Russian Revolution, industrialization: all these topics are evident in their correspondence with each other and, we must assume, were topics of conversation when they were together. These discussions also filter into their published writings and art. Art itself is a frequent topic of their conversations: the relation of art to politics, the conflict between art and commerce, the duties of the artist in society, and the difficulty of reconciling artistic endeavor with family responsibilities. All seem to have been of considerable import to this circle of friends.

Both their conversations and their struggles with one another and the outside world helped move their art forward. Reveling in the new aesthetic possibilities modernism presented to them, they rejected the alienation and inhumanity that seemed to characterize the modern era. Confronting, while at the same time creating modernity in the first four decades of the twentieth century, Esherick and his friends were among those who put an American face on Modernism.

Early Years

Wharton Esherick was born to a prosperous West Philadelphia family in 1887. As a child he loved to draw, but his parents did not support his desire to be an artist, hoping he would pursue a more reputable and steady career. Esherick persevered, attending the Central Manual Training High School. There he was introduced to several crafts as well as to drawing, produced illustrations for his high school yearbook, and pitched for its baseball team. After graduation, he and a friend earned passage to Europe by working on a cattle boat. They "bummed around" for about four weeks. Esherick wanted to see the museums and galleries, but his friend was mainly interested in chasing girls.[5]

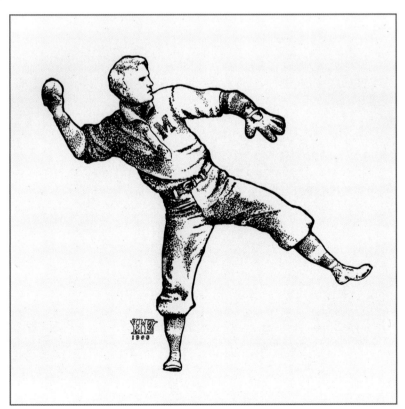

Figure 2. Wharton Esherick, *Baseball Player*, ink on paper, from *The Record of the Class of 1906*, the yearbook of Central Manual Training High School, 1906. Wharton Esherick Museum.

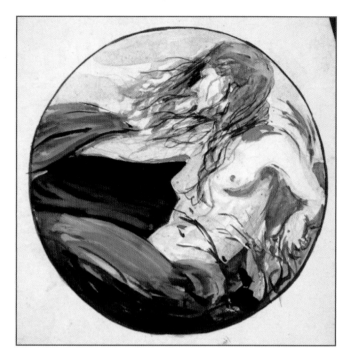

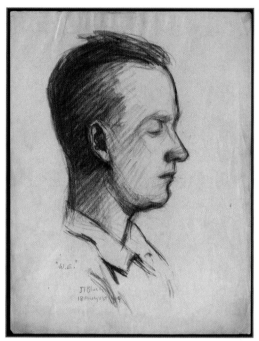

Figure 3. Wharton Esherick, *Nude*,
wash and ink drawing, ca. 1906.
Wharton Esherick Museum.

Figure 4. Julius Bloch, *Portrait of W.E.*,
drawing on paper, August 18, 1919.
Wharton Esherick Museum.

After returning to the United States, Esherick enrolled at the Philadelphia Museum School of the Industrial Arts (now the University of the Arts). There he studied drawing, printmaking, and commercial illustration, in deference to his parents' desire that he be able to support himself. Works that survive from this period show a competent student with a sense of humor, clearly imitating the best-known illustrators of the day. At the Museum School Esherick met Julius Bloch. Their shared sense of mischief and fun anchored a friendship that lasted throughout their lives. Bloch, who later made his name as a social realist painter portraying the working class life among black and white people, eventually moved to Chester County where he was became one of Esherick's neighbors.

Though Esherick studied illustration, his true love was painting. With encouragement from his teachers and grudging support from his parents, Esherick received a scholarship to study painting at the Pennsylvania Academy of the Fine Arts. There, studying under William Merritt Chase, Cecilia Beaux, and Thomas Anschutz, he learned the traditions of American Impressionism. His teachers initially found him a willing pupil, eager to learn what they had to teach. But after learning their lessons, and wanting to move on, he felt that they held him back. So with six weeks to go in his program, he dropped out, ready to pursue his own destiny.

Esherick initially found work drawing for Philadelphia newspapers: the *North American*, the *Evening Bulletin*, and the *Public Ledger*. In those days, working from photographs, artists made line drawings to be converted into engravings for printing in the paper. He later landed a similar job with the Victor Talking Machine Company in Camden, New Jersey, turning photographs of the Victor recording artists into drawings for use as advertising posters (see catalog no. 21). His boss, photographer Harry Attmore, proved to be an important influence on Esherick, becoming a good friend who introduced Esherick both to Thoreau and Socialism.[6] These were turbulent times. Workers were organizing against sweatshops; the Triangle Shirtwaist fire of 1911 killed 150 workers in New York; and the Bread and Roses Strike among

textile workers in Lawrence, Massachusetts, brought 20,000 men, women, and children out on the street in 1912. Attmore helped Esherick begin an intellectually alert and informed relationship with the world in which he lived.

The lessons of class struggle came home to Esherick in a personal way. His salary at Victor was high enough that he felt he could afford to get married. In 1912 he married Leticia (Letty) Nofer, like himself the left-leaning, freethinking child of wealthy parents. For their honeymoon, they sailed on a borrowed boat up the coast to New York and then up the Hudson. Returning home, he discovered that Victor had adopted the half-tone process of printing photographs and no longer needed artists to make drawings.[7]

Inspired by the humanistic philosophy of the Arts and Crafts movement, by Thoreau, and by the impressionist painters of the era, Esherick and Letty decided to move to the country where they could lead an "organic" life close to nature. Many area artists moved up the Delaware to New Hope, but land there was too expensive for the Eshericks. They looked west where they could have a rural bohemian life and, thanks to the Pennsylvania Railroad's Main Line, easy access to Philadelphia's cultural life.

In 1913, they found a small farm with five tillable acres on the northern rim of the Great Chester Valley, between Paoli and Phoenixville. Esherick later told the story of buying the house:

> [A]s we came through the woods we came out to this lower house here. ... I said 'Well, look at this! You show me a property with a tree like that on it'—It had a cherry tree that two men couldn't put their arms around it was so big—I said, 'You show me a property with a tree like that and I'll buy it.' And he didn't say anything but he drove up to the barn and got out of the carriage and tied the horse. And I sat in the carriage and I said, 'Is this the place you're going to show me?' And he said 'Yes.' I said 'With that tree?' And I said, 'Well! How much does the man want for it?'... He said, 'Come on. Get out and look at the house.' I said, I don't care what the house looks like. ... I told you I'd buy a house if I saw a tree like that on it ... I'll change it anyhow.[8]

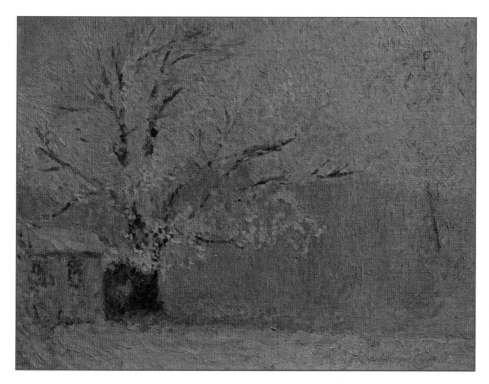

Figure 5. Wharton Esherick, *Cherry Tree*, oil on canvas, 1920. Wharton Esherick Museum.

This oil painting shows the tree as it stood outside of the Esherick's farmhouse.

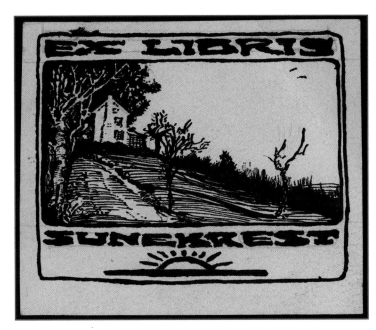

Figure 6. Wharton Esherick, *Sunekrest Bookplate*, ink drawing, ca. 1918. Wharton Esherick Museum.

The Eshericks quickly set to work making the farm the place of their dreams. They planted gardens and built a Japanese-inspired grape arbor (see catalog no. 4). They called the farm "Sunekrest." Esherick created a rising sun design that he put on the side of the house and carved into the shutters. Then he painted murals on the farmhouse walls.

Both Esherick and Letty came from city families with money and servants. They knew little about running a farm but, with the help of their neighbors, they survived. Their garden provided them with good food. Their ideals, along with help from their families, carried them through tough spots. Esherick discovered he liked country life. He appreciated the practical wisdom of farmers and quickly learned from his neighbors.[9] When faced with a problem to solve he was known to ask, "What would a farmer do?" Unlike many parlor socialists, Esherick made his living with his hands. He found satisfaction in hard work—and a good thing, too, because his paintings were not selling well.

Esherick roamed the countryside with his sketchpad, drawing barns, farmhouses, farmers working, and the landscape. Carrying a small easel he made quick oil paintings in the fields, studies to serve as the foundation for larger paintings later. He built himself a painting studio in one of the farmhouse bedrooms but, when his daughter Mary needed a bedroom, moved down to an old octagonal schoolhouse at the foot of Diamond Rock Hill.[10] Despite his best efforts, Esherick failed to find an audience for his paintings. A good impressionist painter at a time when there were many good impressionist painters, he could not find the "voice" that would allow his paintings to stand out from the crowd.

While Esherick painted, Letty did her best to make ends meet. She took care of children. She tended the garden and kept the family fed. She grew and sold peonies: the blooms would come in just in time for graduation at Bryn Mawr and Memorial Day, then called Decoration Day. Letty also home-schooled Mary. She and Esherick believed that traditional schooling would suck the life and creativity out of children. The school board, however, wanted Mary in school. After hearing educational reformer Marietta Johnson speak in Philadelphia, the Eshericks decided to travel to Fairhope, Alabama, for the 1919–20 school year. There Mary would attend Johnson's School for Organic Education and Letty could learn Johnson's educational techniques. She dreamed of opening her own progressive school at Sunekrest.[11] However, it was Wharton who found new direction and meaning. The trip changed both of their lives forever.

Fairhope

Figure 7. "Marietta Johnson," photograph in Esherick Family albums, ca. 1920. Esherick Family Collection.

Marietta Johnson was one of many American educational reformers in the early twentieth century who rebelled against the regimented rote-learning model common in public schools. That model focused more on instilling discipline and order than on encouraging creativity or a love of learning. She opened the School for Organic Education as a place where children would learn through play and where learning would be tailored appropriately to the developmental stage of the child. Dance was a central part of the curriculum, for Johnson believed that physical development was as important as mental development, each supporting the other.[12] Educational reformer John Dewey praised her school's educational philosophy: "The child is best prepared for life as an adult by experiencing in childhood what has meaning to him as a child; and, further, the child has a right to enjoy his childhood."[13] Johnson not only taught children but also opened her school to teachers who wanted to learn her methods.

Her school fit perfectly in Fairhope, Alabama, because of the community's utopian and socialist roots. Fairhope was a "single-tax" community founded in 1894 by followers of Henry George. George believed that land was common property that should not be owned by any individual, because ownership of land led to inequality and poverty in society. Single-tax communities had common land that was "leased" from the community (the single tax); the buildings built by individuals were their own private property.

The combination of the balmy climate of Mobile Bay and the liberal attitudes of Fairhope's residents made it a favorite winter spot for a variety of northern progressive thinkers and artists. Among those at Fairhope that winter were Sherwood Anderson and his wife Tennessee Mitchell. Anderson had dropped out of a conventional life as a businessman to become a writer. He worked for an advertising firm in Chicago while he wrote and became a regular fixture in the salons of Chicago. He developed a following among leftist intellectuals for his essays and short stories, but it was *Winesburg, Ohio* that brought him fame and enough money to quit his advertising job. He married Tennessee after an unconventional courtship. Their marriage was unconventional as well and would not long survive his time in Fairhope. Anderson's biographer, Kim Townsend, argues that his going to Fairhope was an attempt to put distance between himself and Tennessee but, after a period of separation, she joined him there.[14]

Anderson stumbled on Fairhope, having gone there to look up a painter, Ann Mitchell. Finding that he loved the ambiance of Fairhope, he moved there. He wrote in his memoirs, "It was a fantastic world. There was Wharton Esherick who at once became my friend, and Ann, both painters; there was Wharton's wife Letty, very dark, very beautiful. ... I loafed with Wharton and quarreled with him as one dares with a friend."[15] Anderson was intrigued with Esherick's painting, so Esherick showed him some basic principles. Anderson painted and tried ceramic sculpture, ignoring Esherick's criticism, trying to free himself through his acts of self-expression. He took his canvases back to Chicago where he exhibited them at the Walden Book Store and later at the Sunwise Turn Bookstore in New York.[16]

Anderson enjoyed the role of mentor and was known for taking young writers under his wing, introducing them around, and promoting them within his extensive circle of influential friends. Eleven years older than Esherick, Anderson seems to have played this role for him as well. In later years, Esherick would be able to return the favor.

Another winter resident was Florence King, known as Kinglet, who was also volunteering at the school while her daughter, Dux, attended it. Her husband, Carl Zigrosser, stayed in New York, where he had

just begun managing the Weyhe Bookstore and Gallery, which he would turn into an important center for modernism in New York. At Fairhope, Letty and Kinglet became fast friends. They were intrigued by Sherwood and Tennessee's stories of the Alys Bentley dance camp in the Adirondacks. Three years earlier, in 1916, Sherwood and Tennessee had spent the summer at the camp, where they were married. Johnson stressed the importance of dance in a curriculum, so Letty and Kinglet made plans to attend the camp when summer came.[17]

The Eshericks quickly settled into life in the community. While Letty volunteered at the school, Esherick wandered the beaches and woods with his easel, painting in oils and watercolors. They took an active role in the community pageants and in the life of the school. After Esherick criticized the way art was being taught at the school, Johnson asked him, "What are you going to do about it, Mr. Esherick?" He then found himself teaching art. He taught in the afternoons so that he could have the mornings free to paint.[18]

Both Esherick and Anderson were fascinated by the African-American culture of the nearby black community. Though Fairhope was progressive in many ways, it was still a strictly segregated community. The two men attended the African-American church, and Esherick taught art at the black school:

> Well, Sherwood and Tennessee went out there to the school and I said 'Would you like me to teach art here?' And the head of the school said, 'Oh, sure. Yes.' ... So I went out the following Monday to teach school—teach the negro school, and the whole school—the principal of the school and teachers of the school and the students of the school were my pupils.[19]

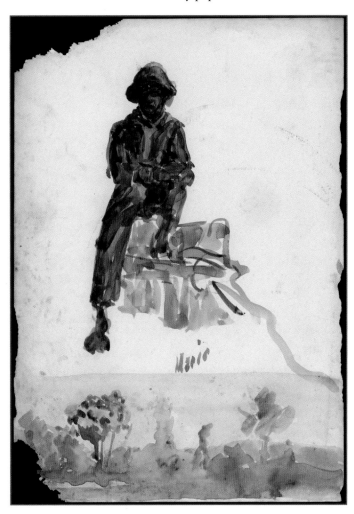

Figure 8. Wharton Esherick, *Mario*, watercolor on paper, 1919–1920. Esherick Family Collection.

One of several portraits of African Americans painted by Esherick in Fairhope, Alabama.

The watercolor portraits Esherick did of residents show a quiet dignity, quite unlike the stereotypical images of the era.

Esherick got in trouble for teaching at the black school. A lawyer warned him about the town's reaction:

> 'Mr. Esherick,' he says, 'You're going to be chased out of town.' I said 'Why?' He said, 'The people are very much disturbed at you. They know you're going out and teaching at that colored school and they don't like it. ... When you're away they will come here and they'll gather all the things in your house and put them on the wharf there and kick you out of town.'[20]

Esherick had to walk two miles out of his way so that the townspeople would not know he was going to the black community to teach. As the year was ending, Esherick had an exhibition of his paintings at Johnson's school. He invited the children from the black school, and again caused controversy—one that Marietta Johnson solved:

> I went up there ... and there they were all out on the pavement and two or three white women arguing with Mrs. Johnson ... 'That Northern white trash is not going to come down here and do that to us down here! Those niggers can't go in that school!' And Mrs. Johnson said to that woman, 'Mrs. So-and-so, are you a Christian?' She said, 'Yes, yes I'm a Christian!' 'Well,' she said, 'then you'd better not judge until you know what you're judging, if you're a Christian.' So the woman kept quiet.[21]

For his exhibition at the school, Esherick made his own frames decorated with carvings that related to the paintings. He got carving tools from Marietta Johnson and showed some aptitude for it.[22] Anderson remarked that the frames were more interesting than the paintings.

Mary Marcy, a socialist writer and the managing editor of the *International Socialist Review*, was also in Fairhope, trying to recover from the depression that set in after all of her papers had been confiscated by the United States government during the government repression of 1918. *The Review* had been closed down in part because of its stance against American involvement in the First World War. In 1919, Marcy's home

Figure 9. Wharton Esherick, *Man's Weapon, Fire*, woodcut, frontispiece from *Rhymes of Early Jungle Folk*, 1922. Rare Book and Manuscript Library, University of Pennsylvania.

In this print, the man's arms and the flames make opposing s-curves, a favorite design element of Esherick's. The image of the man reaching to the heavens comes from the Anthroposophists, showing Esherick's early exposure to their works.

had been raided and ransacked by government agents acting under the Espionage and Sedition Acts. At Fairhope, Mary Marcy joined the Eshericks' circle of friends. In 1920, she proposed that Esherick illustrate a book she was writing, a book of children's verse about evolution. This controversial idea appealed both to Esherick's politics and to his sense of fun. He decided to use his new carving skills to make woodcut prints to illustrate the book. After he and Letty returned to Pennsylvania, Marcy sent him verses, and Esherick carved blocks to go with them. They went back and forth until the book, *Rhymes of Early Jungle Folk,* was done.[23] When published in 1922, it included seventy-eight of Esherick's blocks.

Marcy committed suicide shortly before Charles Kerr, a prominent socialist, published the book. The Marcys had put their house up as collateral for bail for "Big" Bill Haywood, the International Workers of the World (IWW, or "Wobblies") organizer. The IWW, the most radical of the unions, was actively repressed by the government. Many of its organizers were tried in "show trials," and either jailed or deported. When Haywood skipped bail, the Marcys lost their home, which apparently proved the last straw for Marcy.

Esherick carved a woodblock to illustrate a memorial tribute that included a statement from Eugene Debs (see catalog no. 49). Esherick wrote of that pamphlet, in 1923:

> The booklet to Mary E. Marcy is a misleading bit of writing or, I might say, written by a political minded person appealing to the sympathies of a revolutionary crowd. Mary was a woman with a fine soul and willing to work and the socialist movement recognized and dragged her in. I wish her seed had fallen on an artistic ground instead of political, her strength of conviction, her playful philosophy would have created much, much more. But she got into this radical socialism and being true, loyal, and willing, she stuck and pushed. Underneath her words in her letters to me I find crying, reaching for a flower, a butterfly, a bird to toy with. How we did play in our letters. It was business, but we played together, had fun.[24]

Esherick's ambivalence toward politics is clear. While he believed in the socialist cause, as did most of his friends, he did not feel that everyone need be politically involved in the same way. His calling was as an artist. His political feelings would show in his art, but the art came first. He would argue and discuss politics with his friends but had little desire to be out in the streets supporting particular causes.

Their time in Fairhope was life-changing for both Eshericks. They made friends that they would keep for life and who opened up new opportunities for both of them. They were challenged by the cultural and intellectual life of the community. And it was at Fairhope that Esherick began his love affair with working wood.

The Adirondacks

The Eshericks returned to Pennsylvania invigorated and energized, ready to take on new challenges. The first priority for Letty was the dance camp in the Adirondacks.[25] From 1920 until well into the 1930s, the Eshericks attended camps run by Ruth Doing and Gail Gardner. Doing and Gardner had opened their first camp on Lake Chateaugay in 1916 and then moved it to St. Regis Lake in Paul Smiths, New York, in 1925. "The purpose of the camp," a 1923 prospectus states,

> ...is for the development of Miss Doing's system of rhythmics, which is designed to give a free, full, vigorous expression to the thought and feeling of people, who for the greater part of the year are subjected to the restraints and artificialities of city life.[26]

In addition to dance, the camps offered singing, crafts, art, boating, canoeing, "berrying parties," and other activities to provide "a well rounded life."[27]

Figure 10. Wharton Esherick, *Drawing of Dance Camp*, crayon on paper, ca. 1928. Wharton Esherick Museum.

The Eshericks fell comfortably into camp life. Letty loved the dance and the children. Esherick enjoyed having dozens of young, fit models for drawing and painting, although he danced as well. He sketched everything: dancers in motion, dance classes, the landscape, the camp, and the children eating, reading, and engaged in crafts. He drew a large bird's-eye view map of the Lake St. Regis camp (see catalog no. 95). In his first years, he painted, often in watercolors because they were more portable than oils.[28] He then moved into woodcuts. In 1922 he carved *Rhythms* and *Rhythms – Opening*, based on his drawings of dancers, and *Gail's Cabin* and *Lyon Mountain*, from his drawings of the landscape. Gardner and Doing used his prints and his drawings to illustrate their yearly prospectus advertising the coming season. Esherick would trade his drawings and prints, as well as his furniture, in exchange for tuition at the camp.

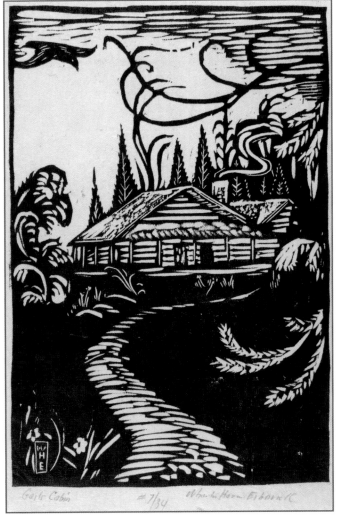
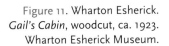

Figure 11. Wharton Esherick. *Gail's Cabin*, woodcut, ca. 1923. Wharton Esherick Museum.

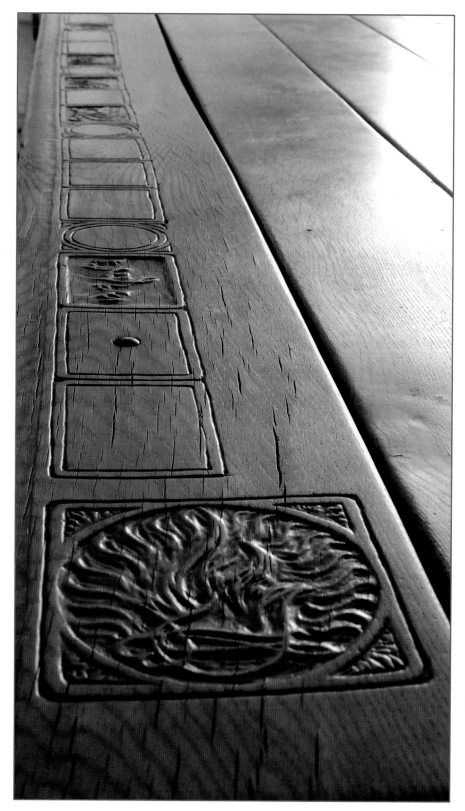

Figure 12. Wharton Esherick and others. *Ruth Doing's Trestle Table with Carvings*, oak, ca. 1923. Photograph by Mark Sfirri. Threefold Educational Center Collection.

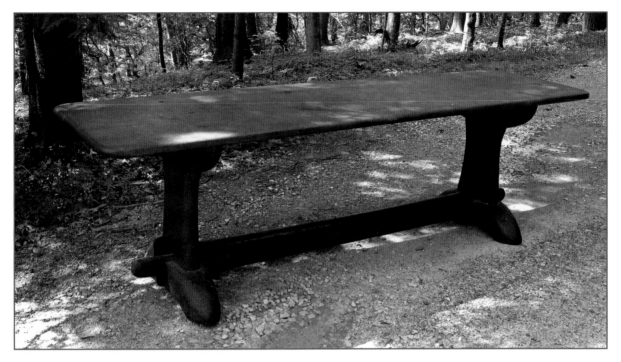

Figure 13. Wharton Esherick, *Camp Table*, pine,
ca. 1925. Photograph by Paul Eisenhauer.
Wharton Esherick Museum.

Some of Esherick's earliest furniture was made for the camp. He designed a large table that was built by a carpenter in Plattsburg, New York. One of the camp exercises was to listen to music and make free form drawings based on the experience of the music. Esherick collected these drawings intending to carve them around the perimeter of the table, but the work was never completed.[29] He made two long pine trestle tables in an Arts and Crafts style with gracefully rounded edges—they were simple but practical for camp life. He also made a short table to be used as a desk, with asymmetric prismatic trestles. The tables and the drawings he made for them are undated, so their year can only be guessed, but clearly they are among his first pieces of furniture.

As Esherick concentrated more on sculpture, he found himself increasingly tied to his studio. He would take Letty and the children to camp, drop them off, and head back home. On occasion, however, when Esherick was at the camp he would make sculpture there. In 1933, after watching a dance performance of St. Sebastian, Esherick was struck by the final pose of the dancer—the martyred saint, arms outstretched, head bowed, a pose similar to a favorite dance gesture he had often captured with his pencil. After making preliminary sketches, he carved the piece out of two large pine logs. The finished piece, called *St Se*, stood over thirteen feet tall its outstretched arms spanning over ten feet. When he brought the sculpture back to Paoli, people kept mistaking it for a crucifix, so he changed the name to *Dance Finale*. He eventually separated the two pine logs to display them.[30]

The dance camps influenced Esherick's work in several important ways. First, their emphasis on freeing oneself from the limits that city life imposed helped Esherick to release himself from artistic constraints imposed by the traditional training he had received at the Academy. During the time he was at the camps, Esherick's work became freer, his sketches more spontaneous, his vision more abstract. Second, Esherick's work tried to capture movement. His paintings had been landscapes and portraits, but his sculpture and woodcuts sought to depict the essence of dance. That attempt to capture the fluid rhythm of dancers

informed most of Esherick's sculpture and stayed with him until the end of his life. Third, the dance camps introduced Esherick to the design ideas of Austrian philosopher Rudolf Steiner.

Gardner and Doing, and their friend Louise Bybee, were Anthroposophists, followers of the teachings of Steiner.[31] Steiner's eurythmy was one of the forms of rhythmic dance taught at the camp. Bybee gave lectures on Steiner's ideas to all who were interested. She was also a founding member of the Threefold Commonwealth Group, a group of Anthroposophists in New York. Through them, Esherick was introduced to Steiner's many ideas, which spanned education, agriculture, architecture, art, and science. Esherick rejected the spiritualism in Anthroposophy, but nonetheless, took from Steiner the notion that design should be based on the forces of nature, the gradual metamorphosis of living organisms, and human needs (a style also described as "organic" or "spiritual" functionalism). Design influences thought, feelings, and connection to others. Proper design, drawn from essential organic forms, promotes harmony.[32] Esherick stayed true to these ideas throughout his career.

Travel back and forth to the camps provided wonderful opportunities to stop in Mt. Kisco, New City, or New York City, to visit with Theodore Dreiser, Henry Varnum Poor, or his other New York friends. These were times to catch up, talk over the newest things that were happening, meet new people, and do or show new work.

New York City and Environs

Esherick was well aware of New York City's importance as an art center. He had attended the 1913 Armory Show, which introduced American audiences to modern art. This was probably the first place where Esherick encountered the work of Constantin Brancusi, a major influence on his sculpture. He had exhibited his paintings in New York galleries with very little success. He had been stung when one gallery owner, after viewing his portfolio, told him to go back to Pennsylvania. They would call him if they wanted him.[33] His new friends from Fairhope and the dance camps, combined with his new artistic directions in prints and sculpture, helped him get a foothold in this difficult but important marketplace.

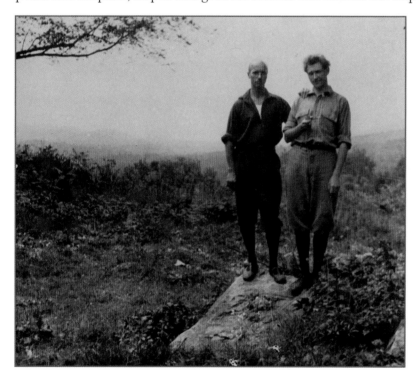

Figure 14. "Rockwell Kent and Carl Zigrosser," photograph, ca. 1925. Carl Zigrosser Papers, Rare Book and Manuscript Library, University of Pennsylvania.

Carl Zigrosser, in his role as manager of the Weyhe Bookstore and Gallery, was an important resource for Esherick. The Weyhe Gallery, which opened in 1919, became a center for modernist art under Zigrosser's management. It showed an eclectic range of work but specialized in prints. A 1928 Weyhe catalogue explained:

> We are living in an age of transition between two different standards of value in judging graphic art. The criterion of picturesqueness ... is gradually diminishing in importance and influence among serious collectors. It is being replaced by other criteria such as design, structure, rhythmic vitality, intensity of conception—all of these values loosely classed as modern. We present this catalogue ... in the full confidence that these modern standards of value will prevail.[34]

The facade of the Weyhe building was as interesting as its contents. Henry Varnum Poor designed tilework for the facade and Rockwell Kent designed its decorative grillwork (see catalog no. 127). Weyhe regularly showed and sold Esherick's prints, beginning in 1923, and mounted a solo show of Esherick's sculpture in 1927.

The Weyhe Gallery was where Zigrosser introduced Esherick to Henry Varnum Poor, a ceramic artist whose career parallels Esherick's in many ways. Both men were born in 1887, both were painters who had been unsuccessful in making their living with painting but succeeded by moving into a craft medium, and each transformed that medium through his work. Poor's technique was to paint on the ceramics before firing. He made plates, vessels, and decorative tiles. Among these were plates picturing all of Esherick's immediate family. In 1921 he built his home and studio in the hamlet of New City, New York. A rustic stone house reflecting and incorporating the work of its builder, it is believed to have inspired Esherick to build his own studio.[35] Both men wound up known for their architecture, although neither had received training in that field.

Figure 15. Henry Varnum Poor, *Wharton Esherick Portrait Plate*, ceramic, ca. 1926. Wharton Esherick Museum.

Their common interests and experiences formed the foundation of a strong friendship. Esherick and Poor visited each other regularly, traveled to the Jersey Shore together, and showed their work together when they could. Poor was also one of the collective of artists who started the American Designers' Gallery at 145 West 57th Street. The Gallery was a short-lived effort of artists working in various media to market their functional art. It closed in 1930, a victim of the Great Depression. Although Esherick was not a member of the collective, he did exhibit at the Gallery, probably at Poor's invitation. At the first show at the Gallery, Poor had turned two sawhorses upside down and put a door across the feet to make a table to show his wares.

Figure 16. "Wharton Esherick and Henry Varnum Poor at Barnegat, New Jersey," photograph in Esherick Family albums, 1927. Esherick Family Collection.

The form of this makeshift table inspired Esherick's aluminum-topped padouk and walnut desk, which he showed at the Gallery the following year (see catalog no. 226). It was probably at the American Designers' Gallery that Esherick met Ruth Reeves, a fabric artist and painter. Esherick would exhibit with Reeves and Poor at the Philadelphia Art Alliance in 1932 and had one of her paintings and some of her fabric in his own collection.

Esherick was quite familiar with the neighborhood of the American Designers' Gallery. It was not far from Dreiser's apartment at 200 West 57th Street, which was the subject of Esherick's 1928 print *Of A Great City* (see catalog nos. 125, 126). Dreiser leased the apartment in 1927 after the success of *An American Tragedy*. This was also the neighborhood of the Threefold Commonwealth Group, which, in the 1920s, had apartments and a vegetarian restaurant at 207 West 56th Street. There, in 1923, the Group presented an exhibition of Esherick's prints and paintings. In 1924 it opened a public vegetarian restaurant in the basement of the same building. Later, in 1929, it moved to a building at 318–320 West 56th Street with an expanded restaurant.[36]

Esherick was a regular visitor at the restaurant. These visits allowed him to stay in contact with his friends from the Adirondacks dance camps. Louise Bybee, the friend of Gardner and Doing, was a founding member of the Threefold Commonwealth Group. Ruth Doing's School of Rhythmics was at 139 West 56th Street. At the restaurant Esherick encountered the furniture of Fritz Westhoff, an Anthroposophist furniture maker whose work showed a kinship with the furniture produced around Dornach, Switzerland, the center of Anthroposophy.[37] Esherick's early experiments in furniture show the influence of Westhoff and other Anthroposophists, who also drew from the German Expressionist tradition.[38] Later in his career, Esherick was to take these ideas in other directions. Both Esherick and Dreiser had Steiner's books in their collections, and it is not hard to imagine the two of them discussing his ideas.

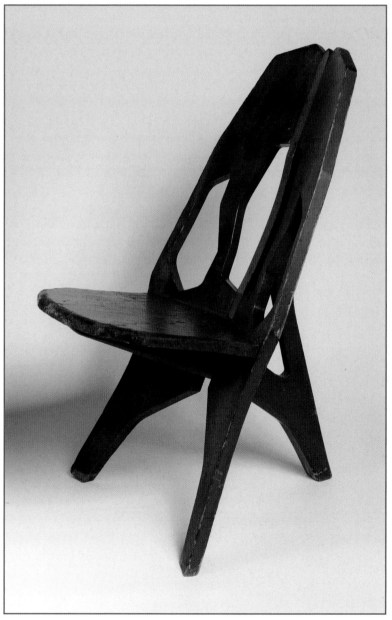

Figure 17. Fritz Westoff, *Threefold Restaurant Chair*, painted wood, ca. 1927-28. Photograph by Mark Sfirri. Threefold Educational Center Collection.

Centaur Press

Thirty-three years old when Mary Marcy invited him to illustrate *Rhymes of Early Jungle Folk* (1922), Esherick's carving technique was still rough, but his prints were both dynamic and whimsical. Esherick showed a copy of *Rhymes* to Harold Mason, proprietor of the Centaur Book Shop in Philadelphia, hoping that Mason would carry the book. Mason had opened the bookshop at 1224 Chancellor Street in 1921, backed by John Frederick Lewis and David Jester, Jr. An intellectual who loved stirring up the sedate world of Philadelphia society, Mason wanted a salon as much as a bookstore. The first-floor shop stocked all of the latest and best that the literary world had to offer, including whatever was controversial. The second floor was a Prohibition-era "private club" where members had lockers for their liquor. During Prohibition, Centaur became the place where the intellectual elite of Philadelphia gathered after hours for cocktails and conversation, and to meet writers. The bookstore took its name from James Branch Cabell's banned *Jurgen*: "'Up on my back,' said the centaur, 'and I will take you thither.'"[39]

Esherick, a habitué of the Centaur, not only made the iron and wood centaur that hung outside the shop for many years but also drew centaur logos for the shop. One example had a cartoon-like centaur, hands on his hips, looking over his shoulder at a stick figure astride his horse's body reading a book. He also carved two woodblocks depicting the Chancellor Street building.

Esherick seems to have been captivated by centaurs, sketching and sculpting many variations on this theme.

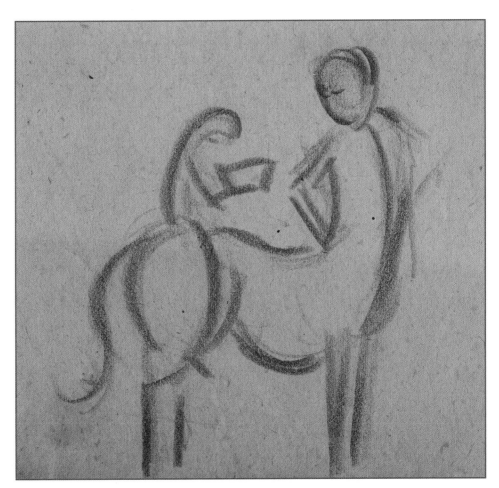

Figure 18. Wharton Esherick, *Centaur*, pencil on paper, ca. 1923. Wharton Esherick Museum.

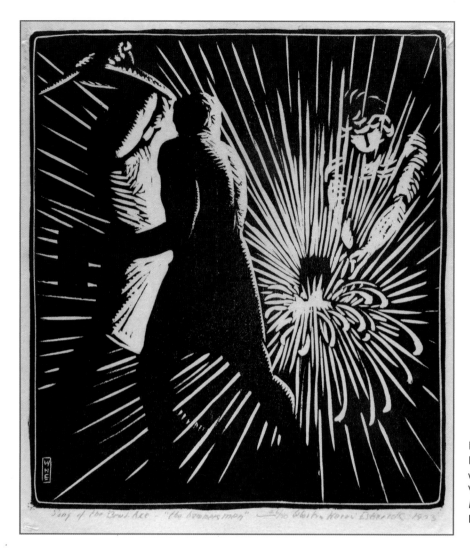

Figure 19. Wharton Esherick, *Hammersmen*, woodcut, illustration from Walt Whitman, *Song of the Broad-Axe*, 1924. Wharton Esherick Museum.

In addition to the shop, Mason hoped to start a press that would publish books "that lend themselves naturally to private press production":

> In carrying out this intention the Press will be governed by two considerations: *first*, the publication of material of sufficient literary or artistic value; *second*, the production of books in a format to merit the attention of the collector.[40]

Impressed by Esherick's work for Marcy's *Rhymes,* Mason asked him to illustrate Walt Whitman's poem, *Song of the Broad-Axe,* the first publication of his new Centaur Press. Long a fan of Whitman's poetry, Esherick agreed. The themes of *Broad-Axe* spoke to Esherick's world-view and the path in life that he had chosen:

> The beauty of independence, departure, actions that rely on themselves,
> The American contempt for statutes and ceremonies, the boundless impatience of restraint,
> The loose drift of character, the inkling through random types, the solidification;
> The butcher in the slaughter-house, the hands aboard schooners and sloops, the raftsmen, the pioneer,
> Lumbermen in their winter camp, daybreak in the woods, stripes of snow on the limbs of trees, the occasional snapping,
> The glad clear sound of one's own voice, the merry song, the natural life of the woods, the day's work,[41]

Figure 20. Wharton Esherick, *Winter Fields*, woodcut, illustration from A.E. Coppard, *Yokohama Garland and other Poems*, 1926. Rare Book and Manuscript Library, University of Pennsylvania.

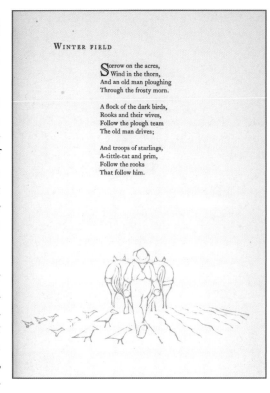

The Centaur edition, released in 1924, was limited to 400 numbered copies, of which only 375 were for sale. The book was "printed upon a specially made pure rag paper of natural mellow colour ... [and] set by hand in one of the best modern revivals of fifteenth century roman types used at Venice,"[42] its boards covered in paper with woodcut illustrations of trees. The dust jacket featured *Welcome Are All Earth's Lands*, an Esherick print not included in the book.

Next, Esherick carved a porcupine as the frontispiece for D. H. Lawrence's *Reflections on the Death of a Porcupine*. This book brought Centaur Press international attention. In 1926 Esherick offered to illustrate a book of poems that A.E. Coppard had offered to Centaur. Coppard and Mason were thrilled.[43] Esherick carved a series of delicate vignettes, printed in a soft gray, that look almost like line drawings. Coppard's *Yokohama Garland and Other Poems* was a success: reviewers commented on the quality of its production.

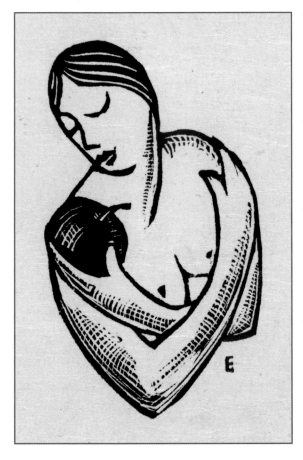

In 1924, at the same time that *Song of the Broad-Axe* was published, Esherick carved thirty-one blocks to illustrate the Biblical *Song of Solomon* and hand-bound three books. In 1927 Centaur published an edition of Esherick's *Solomon*. Centaur's designer, Elmer Adler, copied Esherick's plan as faithfully as possible. The book was beautiful and so impressed Bennett Cerf that he helped to distribute it. All 525 copies quickly sold.[44]

In 1933 the Centaur Book Shop moved from Chancellor Street to Juniper Street. The Chancellor Street site was too small, and its only heat in winter came from fireplaces. "Wharton was ... a member of the safari that moved the contents of the Centaur Book Shop from our first miserable little place," Mason reminisced. "[T]he move over was fun because we all pitched in, and I can remember Wharton very well doing a yeoman's job of moving books and pictures and everything else in the world."[45]

Figure 21. Wharton Esherick, *Apple*, woodcut, illustration from *The Song of Solomon*, 1927. Wharton Esherick Museum.

In the early 1930s Esherick introduced Sherwood Anderson to Mason, which led Centaur to publish Anderson's *No Swank* in 1934. Esherick helped Anderson prepare the book, which included essays about Jasper Deeter and Theodore Dreiser, while he visited Ripshin, Anderson's home outside of Marion, Virginia, that summer.[46] Anderson became another regular visitor at Centaur gatherings.[47]

Books were only one outlet for Esherick's woodcuts. He produced individual prints drawn from his life: many prints document life in rural Chester County, and his family was another ready source of inspiration and subject matter. But, as is the case with all great art, Esherick's individual subjects and experiences spoke to wider audiences. Magazines and journals like *Vanity Fair, Century, The Dial,* and *American Girl,* and newspapers like the *New York Times,* all published his blocks. His work was also reproduced in international woodcut annuals.[48]

Woodcut prints gave Esherick his first real success as an artist. They led him to experiment in carving and woodworking. Through carving, he came to realize that he was a sculptor, not a painter. After the early 1930s, he rarely carved woodcuts, but his woodcuts represent an important step in his evolution as an artist and constitute a genuine contribution to American printmaking. Providing for his transition from two-dimensional art to sculpture, his prints allowed Esherick to move organically from one form to the other.

The Third Dimension

Carving frames and woodblocks led Esherick to carve in furniture. At first, he purchased antiques and decorated them with carvings. He then began making furniture, based on the Arts and Crafts style found at Rose Valley. Among his early pieces were a plate rack for the farmhouse kitchen, a chisel and gouge rack to hold his carving tools, and a trestle table. For advice on furniture-making, he turned to his neighbor, John Schmidt, a cabinet maker in Valley Forge. As a child in Hungary, Schmidt had apprenticed in his brother Karl's shop, working before and after school to learn furniture-making in the traditional way. Immigrating to the United States as a teenager, he set up shop in Valley Forge, primarily restoring and repairing antiques.

Figure 22. Wharton Esherick, *Tool Rack*, pine, ca. 1923. Wharton Esherick Museum.

Figure 23. "John Schmidt's workshop,"
photograph, ca. 1930-1950. Esherick
Family Collection.

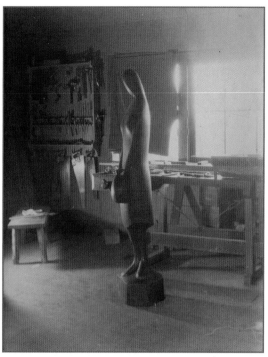

Figure 24. "Wharton Esherick's studio
with *Essie*," photograph, ca.1933.
Esherick Family Collection.

Esherick and Schmidt became friends and collaborators: Esherick had ideas and vision, Schmidt had skill and knowledge to realize that vision. According to Ed Ray, Esherick's wood man, "[t]hey both had something that the other didn't have."[49] Esherick learned techniques of joinery from Schmidt. In turn, he brought designs, work, and customers to Schmidt's shop. Schmidt was mechanically inclined and built more than furniture. His shop had a band saw sawmill, powered by an automobile engine, able to turn large trees into usable lumber. He also made smaller band saws out of bicycle wheels for woodworking, including one made for Esherick.

Esherick's modernist ideas often conflicted with Schmidt's traditional techniques. Schmidt could make a set of dovetails that were identical, a traditional sign of quality joinery. But identical dovetails looked mechanical and boring to Esherick, who wanted joinery to be part of the design. Sometimes one of Esherick's forms would not pass muster with Schmidt's sense of engineering. So they would argue about it, sometimes quite loudly. Schmidt's daughter remembers that "Wharton would want something one way and my dad would tell him it wouldn't be strong enough that way. We kids sometimes thought they were fighting."[50] Out of their arguments came pieces that were interesting, beautiful, and strong enough to be functional. In the early years of their relationship, Esherick sometimes put Schmidt's initials on the piece, along with his own signature, a sign that he felt Schmidt's contribution was important. They collaborated for thirty years.

Most of Esherick's earliest pieces of furniture were not elaborate or original creations but simple Arts and Crafts pieces for use, and he wound up selling them. Such furniture was not art but craft, and it helped him pay the bills. But fairly quickly Esherick began to use his developing skills as a carver to decorate his pieces with illustrations. These illustrations become increasingly abstract as he began more fully to realize the artistic possibilities of furniture. By the late 1920s, recognizing that furniture has form, he understood that it can be treated like sculpture rather than as a two-dimensional canvas to illustrate. This realization

Figure 25. Wharton Esherick, *Drop-Leaf Desk*, red oak, 1927. Photograph by James Mario. Wharton Esherick Museum.

Esherick called the carved illustrations on the furniture "literature." This desk show the bark and undergrowth on the doors below, the bare winter branches on the drop-leaf, and turkey buzzards soaring on the upper doors.

did not come easily for him. Writing to Dreiser in 1930, he said: "I have a lot of ... orders with freedom. This new enthusiast certainly has faith in me. ... [B]ut I have so many things stored up to do for Wharton the job annoys me."[51] As long as he saw furniture as unrelated to and different from sculpture, the "job" would continue to "annoy" him.

The "new enthusiast" he spoke of to Dreiser was Helene Fischer. Her commissions, along with those of Marjorie Content and Curtis Bok, provided Esherick the freedom he needed to grow. During the 1930s that growth led to the transformation of his furniture making. He pushed John Schmidt's skill and patience to their limits with his new designs.

Hedgerow Theatre

About fifteen miles from Esherick's farm was the town of Rose Valley. There, in the early twentieth century, architect Will Price attempted to create an Arts and Crafts community based on the ideas of William Morris. Price had previously been one of the founders of Arden, Delaware, a utopian single-tax community like Fairhope, Alabama. Rose Valley's old nineteenth-century mill buildings were converted into workshops and a community center, and, for a brief period, Rose Valley artisans produced furniture and pottery. Rose Valley furniture had a heavy, medieval look, decorated with surface carving and the carved rose symbol of Rose Valley. Esherick's early furniture clearly shows a Rose Valley influence. Although the Rose Valley enterprises could not sustain themselves, before its industries collapsed the community attracted an interesting group of artists, artisans, and intellectuals.

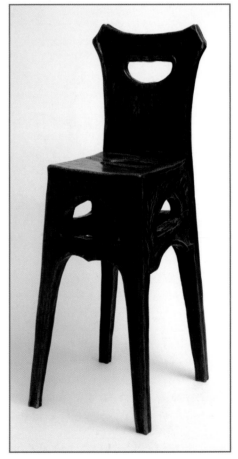

Figure 26. "Detail of ca. 1905 *Rose Valley Library Table*," photograph, n.d. Rose Valley Historical Society. Note the Rose Valley symbol carved on the table.

Figure 27. Wharton Esherick, *High Chair*, oak, ca. 1924. Photograph by Mark Sfirri. David Esherick Collection.

The form and textured surface of this piece show the influence of Rose Valley.

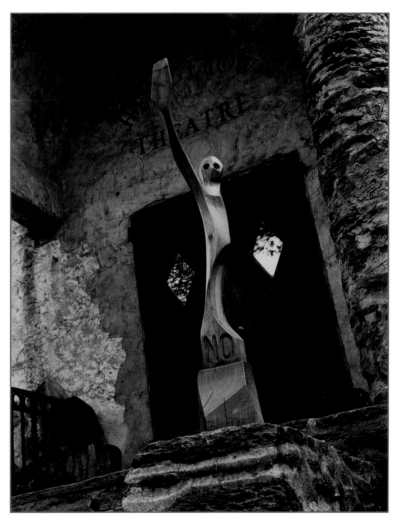

Figure 28. Consuelo Kanaga, photographer, "Wharton Esherick's 1934 pearwood sculpture *No* at the Hedgerow Theatre entrance," photograph, ca. 1940. Esherick Family Collection.

Esherick carved this sculpture as a sign to keep people off the stairs to the balcony at Hedgerow Theatre.

Among them was one of Letty's friends, Dr. Ruth Deeter, an osteopathic physician whose brother Jasper Deeter was an actor and director with the legendary Provincetown Players in New York. The Provincetown Players, originally founded by a group of writers and actors in Provincetown on Cape Cod in order to push the boundaries of American theater, soon moved to Greenwich Village, where they began to attract attention. The Players launched the careers of members Eugene O'Neill and Susan Glaspell, among others. O'Neill's *Emperor Jones* brought success to the Players but also created tensions within the company (see catalog no. 162). Deciding in 1922 that Broadway was not for him—he wanted a true repertory theater company—Jasper Deeter moved to Rose Valley where he set up shop in the old mill building, once the community hall. Some community members questioned his right to use the building. He replied that they would have a theater even if they had to perform in the hedgerows, and so the Hedgerow Theatre was born.

As it developed, Hedgerow had a number of plays in repertory, performing different plays on successive nights—as many as five different plays in a week. Actors lived together in neighborhood houses, prepared food and ate communally, and everyone pitched in with the work necessary to keep the theater going. It was an intense and creative experience held together by everyone's devotion to Deeter. The Theatre performed George Bernard Shaw, Eugene O'Neill, Henrik Ibsen, and Sean O'Casey, among others, helping to create modern American theater. Deeter's intelligent staging and interpretations made him a favorite among playwrights. Talented actors were drawn to Hedgerow and, under Deeter's direction, did exceptional work. Hedgerow Theatre achieved a national reputation, its productions regularly reviewed in *The New York Times* and in theater journals.

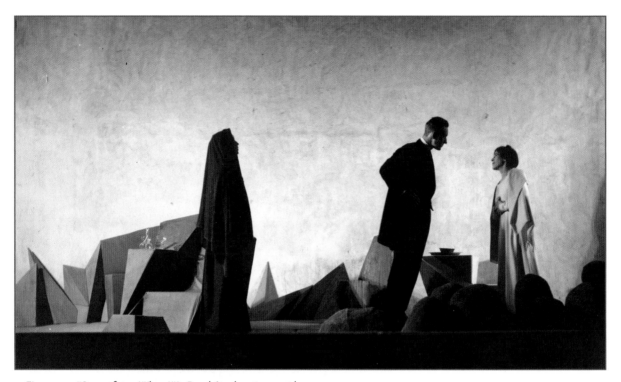

Figure 29. "Scene from *When We Dead Awake*, stage set by Wharton Esherick," photograph, 1930. Esherick Family Collection

Ruth Deeter introduced Esherick and Deeter to one another and they quickly became friends. Esherick respected Deeter's artistry. The epigraph for this essay comes from Esherick's tribute to Deeter: "Because I love this man and love what he is doing and what he is going to do, that is why I give, give all within my power to help."[52] Esherick's entire family got involved in Hedgerow, working on or performing in its productions. Esherick helped with stage designs and general carpentry around the theater, making a staircase to the balcony and a spiral stair that linked the three backstage levels in the theater (the spiral stair was destroyed in a fire in 1985). He made numerous woodblock print posters to advertise the Theatre generally or specific shows. His woodcut designs graced Hedgerow Theatre's playbills and stationery.

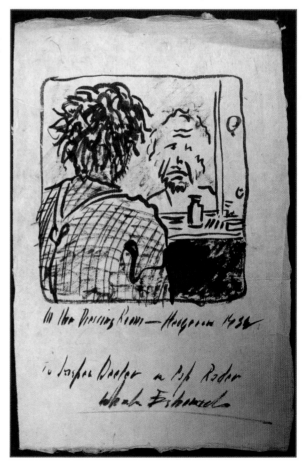

Figure 30. Wharton Esherick, *In the Dressing Room – Hedgerow 1932*, ink on paper, 1932. Wharton Esherick Museum.

A humorous sketch of Jasper Deeter, inscribed "To Jasper Deeter as Pap Rader" and signed Wharton Esherick.

Esherick made furniture for Hedgerow as well. A large trestle table still stands in the Theatre's green room. He made a large rustic table for Hedgerow House, the school and living quarters for the Hedgerow community. Hedgerow also provided Esherick with the occasion for what became one of his more famous creations. His daughter Ruth wanted to attend Hedgerow's acting school but Esherick could not afford to pay her tuition. He struck a deal with Deeter to make thirty-six chairs for Hedgerow's rehearsal room in exchange for Ruth's tuition. Two recently purchased barrels of hammer handles provided Esherick the materials to make the chairs, using approximately a dozen handles per chair. The handles presented some interesting design limitations. They were not long enough to serve as both a back leg and a back support, as most chairs have. Esherick had to re-engineer the chair, joining the back supports into the rear legs, or into a stretcher. He made the chairs in small batches, each batch improving on the previous. The initial chairs were a bit boxy and not very comfortable. By the time he reached the final version, he had a chair that was as attractive as it was strong and comfortable. He used the lessons of the hammer handle chair in most of his subsequent chair designs.[53]

All three Esherick children acted in children's roles at Hedgerow. Both Mary and Ruth would go on to make theater their career. Mary continued to act, while Ruth moved into lighting and stagecraft. Esherick acted only once, playing the Milkman in Dorothy Nichols's *Hickory Dickory*. His stage name, John Thornton—an old slang term for penis—caused great merriment among those who caught the reference and confusion for those who didn't understand why people were laughing.[54]

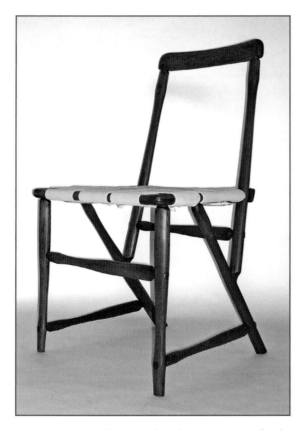 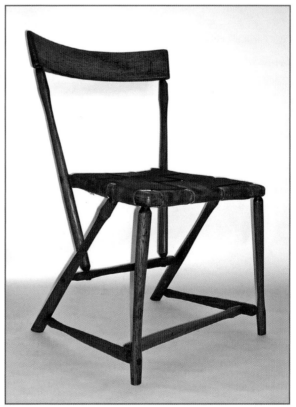

Figures 31, 32. Wharton Esherick, *Hammer Handle Chairs*, hickory and industrial belting, 1938. Photographs by Paul Eisenhauer. Hedgerow Theatre.

The evolution of Esherick's design is evident in these two hammer handle chairs.

One August night in 1924 Esherick went to see his friend Kirah Markham, an actress, artist, and former Provincetown Player, in Virginia Farmer's play *The Artist* at Hedgerow Theatre. Kirah asked Esherick if she and her friend, Theodore Dreiser, could stay at his farmhouse after the post-production reception, since it would be too late for Dreiser to return to New York. Esherick agreed and went into the audience to find her friend. Sitting behind Dreiser, he introduced himself, but Dreiser barely responded and refused to turn around and look at Esherick. It was a cold beginning to what would become a very warm friendship. Later, at the farmhouse, Dreiser warmed up, and he and Esherick found they had much in common.[55] Dreiser would become a frequent visitor to the Eshcrick farm.

In the 1930s, Esherick introduced Jasper Deeter to Dreiser and encouraged Deeter to stage *An American Tragedy* at Hedgerow. Deeter and Dreiser chose an adaptation by German avant-garde director and Marxist Erwin Piscator. Louise Campbell, one of Dreiser's secretaries who had helped edit the manuscript of *An American Tragedy*, translated Piscator's adaptation into English and Hedgerow staged its American premier. The production's stark black-and-white staging emphasized the class conflict inherent in Dreiser's story and was positively received. A version was later produced in New York at the Ethel Barrymore Theater as *The Case of Clyde Griffiths*.[56]

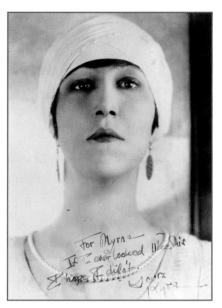

Figure 33. "Kyra (or Kirah) Markham," photograph, ca. 1920. W.A. Swanberg Papers, Rare Book and Manuscript Library, University of Pennsylvania.

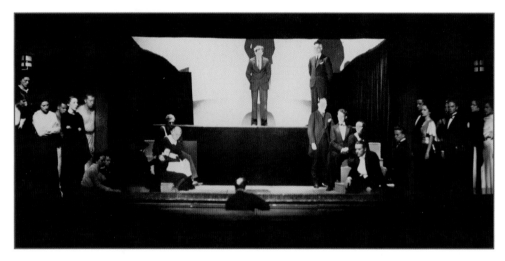

Figure 34. "Scene from Hedgerow Theatre's Production of *An American Tragedy*," photograph, 1935. Rare Book and Manuscript Library, University of Pennsylvania.

Some confusion about business arrangements followed because of the informal way in which these friends did business together. Dreiser's agent wrote to Deeter demanding to know who had given him rights to perform *Tragedy*. Miriam Phillips, the Hedgerow's business manager, replied, "Mr. Deeter has asked me to tell you … that our authorization comes from Mr. Dreiser himself. … Mr. Dreiser will no doubt straighten this out with you."[57] Similarly, Piscator demanded royalties for his adaptation. Dreiser responded to Piscator's agent:

> All I can see in the matter is, that Mr. Piscator, through his agents, is unofficially seeking to step in and direct matters as though he were the owner of 'An American Tragedy.' I wish you would get it into your mind, and if possible into Mr. Piscator's, that I am the author of 'An American Tragedy' and personal owner of all rights connected with it.[58]

Piscator had not met the terms of the contract made with Dreiser for this adaptation and so had forfeited his right to it. The battle continued in the courts for many years.

Esherick performed a similar midwife's role in bringing Sherwood Anderson's *Winesburg, Ohio* to the stage. After Anderson expressed the desire to do a theatrical adaptation, Esherick suggested he go to Deeter. Esherick tells the story:

> I said, 'Sherwood, I have just the man to talk to!' He said 'Who?' I said. 'Jasper Deeter.' 'Who the hell is Jasper Deeter?' And I said, 'Well, he's a theater man, and he knows theater. He can help you better than I can. I can't help you.' So he said, 'Well, how do we get ahold of him?' I said, 'We get him on the telephone.' Sherwood says, 'We'll call him right now.' So from Sherwood's apartment in New York we got Jasper. ... Then we came over together and went down to Jasper and they talked it over ... and then Jasper began to jerk it around ... said it was bad drama, or something like that, and Sherwood listened to him and finally they came out with this [production of 1934]. And Oh! It was wonderful! It had all the quality of Sherwood still in the play.[59]

Despite Esherick's modesty about his role, Anderson's correspondence with Deeter indicates that Esherick provided the production with an artist's eye and offered ongoing commentary about how the production could be improved. After he first saw the play, Esherick wrote a five-page letter to Anderson dissecting it scene by scene.[60] Anderson fell in love with the whole Hedgerow experience. He took every opportunity to go and spend time with the company. He wrote to them:

> Dear Hedgerowers, ... More and more, as I think of Hedgerow, it comes to mean more and more to me and often I wonder if it is not about the nearest thing we have in America to a healthy place to live and work. ... It has been a very fine thing in my own life, that you have, in a way, included me as you have. ...[61]

Hedgerow was an artistic resource for Esherick. The intellectual challenges of the plays provided Esherick and his friends with material for stimulating discussions. Out-of-town visitors would often see a play at Hedgerow and then spend the night or weekend at the Esherick farm. Stage design provided Esherick with a wonderful laboratory to imagine three-dimensional space on a totally new and grand scale. He designed and created expressionistic sets for Ibsen's *When We Dead Awake*. Hedgerow also provided a diverse set of models for Esherick to draw, and he produced thousands of pages of drawings, some of which would be turned into sculpture. *Oblivion*, one of Esherick's most sensuous pieces, began as sketches of the climatic scene of Lynn Riggs's *Son of Perdition*.

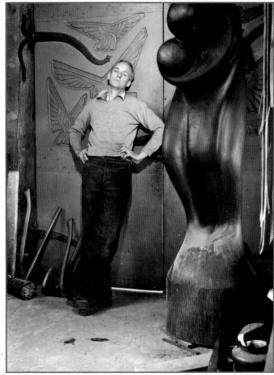

Esherick used Hedgerow Theatre as a gallery as well, reasoning that people who liked the kinds of plays Hedgerow produced might also like his sculpture. Some of his most significant patrons first saw his work at the theatre.

Figure 35. Emil C. Luks, photographer, "Wharton Esherick with *Oblivion*," photograph, ca.1934. Esherick Family Collection.

The Studio

After Esherick returned from Fairhope in 1920, he converted the barn behind his farmhouse into a studio for painting and carving. His painting *The Woodcarver's Shop* depicts this space. It proved to be too close to home, however, and the children annoyed him while he tried to work.[62] When Esherick heard that the farmer who owned the property above his farm was thinking of selling it to a man who planned to open a quarry, he received money from Grandmother Esherick and bought the property himself. On a cleared acre and a half at the top of the hill that had been used for farmland he built a new studio for sculpting.[63] Inspired by Henry Poor's Crow House, Esherick built a place that reflected who he was—part vernacular, part Arts and Crafts, part Modernist. Made from cast-off stone and recycled mill timbers, Esherick's studio blended the old and the new to produce something completely original.

He hired Albert Kulp, a local mason, to help build the new studio. They purchased cast-off pieces of hard sandstone from a local quarry and hauled the large pieces of stone to the site. The building's basic form derived from the stone bank barns that dot the Chester County landscape. Rather than trying to impose himself on the land in building his studio, Esherick followed Frank Lloyd Wright's ideas of organic design so that the structure seemed to have grown from the site. The result was an Arts and Crafts funhouse of a bank barn. The walls tapered as they rose, like a tree trunk growing from the ground. Where a farmer would have placed a large double door to a hayloft, Esherick put in a large industrial window facing north, its frosted glass providing diffused light over his workspace. The ridge of the roof appeared to sag, but the curve was intentional, breaking the stark linearity of a roof line and giving a nod to the old sagging roofs on local barns that Esherick enjoyed drawing. On the west side, a double door allowed Esherick to bring in large logs for carving. To the east was an entry alcove with a lean-to roof. Next to the door, coat pegs bore carved caricatures of the men who had helped him build the building.

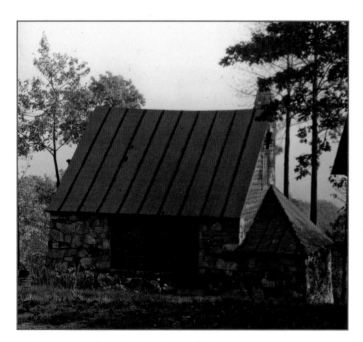

Figure 36. "Wharton Esherick's Sculpting Studio," photograph, ca. 1930. Esherick Family Collection

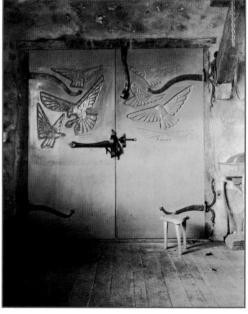

Figure 37. Emil C. Luks, photographer, "1926 *Carved Loading Doors* in Studio," photograph, ca. 1930. Esherick Family Collection.

Esherick was thrilled with his new studio, writing to Dreiser: "I am conceited enough to feel that you should see my new studio before you make any very large alterations or extensions on your place. It would be an inspiration to you."[64] Dreiser had recently purchased an estate in Mt. Kisco, New York, which he called "Iroki," where he wanted to build his own country retreat. Esherick's advice to Dreiser showed his growth as an artist since he and Letty had originally decorated Sunekrest: "I made so many mistakes the first year I lived here, removing trees, changing fences, fields, trying hard to make it a part of me before I became a part of it."[65] Esherick did indeed help Dreiser with his new estate, building its gates and supervising the construction of the guest house. Henry Varnum Poor provided ceramic light fixtures for Iroki as well.[66]

Later, at Dreiser's urging, Esherick wrote about Kulp and the process of building his studio in a piece he called "He Helps Me Build a Building." Dreiser tried to publish the piece in the *American Spectator*, but the *Spectator's* other editors rejected it. Esherick had enjoyed the writing, producing a nice piece of storytelling that conveys Esherick's love and respect for skilled workers. In his story, he makes Kulp say:

> 'The trouble is that we are too educated; we know too much about things that the man who does not labor with his body knows, and most of us think that 'cause we know all these things, we can have them. Somebody has to dig and chop but they (he used they here instead of we) think they are too good for it. Sometimes I think this education business is going too far!'[67]

Esherick allowed that the *Spectator's* editors were probably right and that he should stick to making art.

The loft of the studio, used for wood storage, had no floor, just beams for wood to be laid across. Esherick built a bed in the loft so that, while Letty and the kids were at the dance camp, he could remain in his studio and rent the farmhouse to friends who wanted a "country retreat" for the summer. These rentals provided both much needed income and someone who could cook dinner for him.[68] His daughter Ruth remembers coming home from camp and finding the house still rented, so that the family had to sleep in the studio. Mary slept in a hammock, boards were laid over the rafters to make a bed for Ruth, and the infant Peter slept in a drawer below the bed.

His studio shows Esherick coming into his own as an artist. He had found his path and was determined to follow it. The family he loved was coming between him and his art—and he chose art. "In those days," he said, "the trees weren't so high and I used to go up there to get away from the house. I was getting tired of family life I think. I still cared for Letty and all that kind of stuff. ... I wanted to get away and do something."[69] The studio allowed Esherick the opportunity to move his art away from, and to pursue it without, the "annoying" interruptions and distractions of his family. Letty knew what was happening. Esherick's daughter Mary remembered watching her father walk up the hill to his new studio, Letty staring after him, saying, "Well, there he goes."[70]

The growing distance between Wharton and Letty increased when, in 1928, Letty had a near-fatal attack of encephalitis while serving as a housemother at the Hessian Hills School in Croton-on-Hudson, New York. In a coma for two months, she emerged with permanent disabilities. After convalescing at a sanitarium in York, Pennsylvania, she returned to Marietta Johnson's school in Fairhope in 1929 and 1930. Esherick felt somehow responsible for Letty's illness. His letters to Dreiser during this period express his guilt and frustration:

> It is true my future is before me. But that future doesn't bother me so much now. It's the present. It's hard to write about it. I try [to] work & it goes along well for a few days & then the bottom drops out; ... I'm trying to pull thru the storm. I am not sentimental about it but practical. I am a worker I feel primarily. I keep

going from one job to another ... then I get mad at myself & all around me, life's damn existing problems. I am not complaining, it is not hurting me, it has given me a good twist, but things are piled up high & I know they will be ignored.[71]

While Letty was convalescing in Alabama, Esherick built a spiral stair to the second floor of his studio. He fashioned a trunk of red oak with three faces that spiraled upward. The steps were cantilevered into one of the faces with a mortise and tenon joint. At the opposite end of the through mortise, Esherick fashioned a rectangular washer of oak. A furniture bolt ran through it and connected with a nut embedded in the tenon. As the bolt is tightened, the washer pulls the stair tight against the trunk. The trapezoidal form of the steps, combined with the ax-hewn oak, creates a work of rustic cubism.[72] The *Spiral Stair* was a conceptual and an engineering breakthrough for Esherick. Fortunately, he soon found a series of sympathetic patrons who gave him freedom to explore his new ideas in the work they commissioned and to take furniture design to a new level.

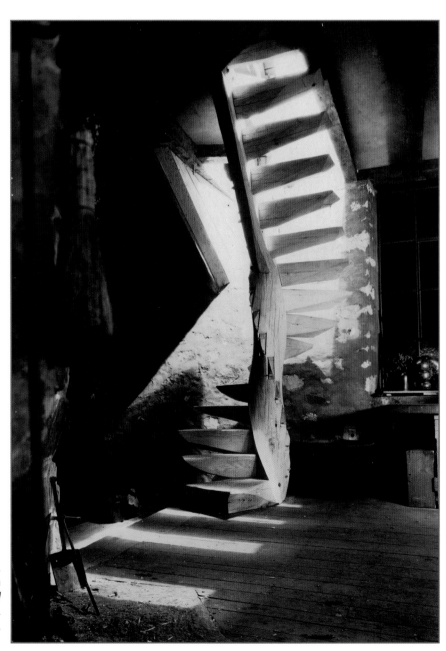

Figure 38. Emil C. Luks, photographer, "Wharton Esherick 1930 red oak *Spiral Stair*," photograph, ca.1934. Esherick Family Collection.

Patrons

Helene Fischer, owner of the Schutte and Koerting Company in Philadelphia, purchased *Finale,* Esherick's sculpture of a reclining dancer, after seeing it displayed at Hedgerow Theatre. She then commissioned a Victrola (record player) cabinet to serve as a pedestal for the sculpture and, later, a hall bench that would also hold phonograph records as a companion piece to the Victrola cabinet.

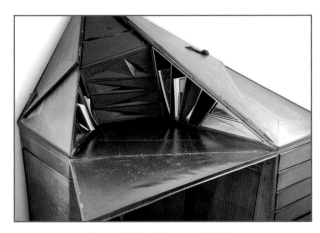

Figure 39. Wharton Esherick, *Corner Desk* (open), walnut and ebony, 1931. Photograph by Mark Sfirri, 2008. Barbara Fischer Eldred Collection.

Esherick also produced for Fisher a prismatic corner desk that remains one of his most admired pieces.[73] He showed the desk at his studio in March 1931. Esherick wrote to Dreiser: "Wish you could have seen the desk finished. People like ants swarmed the studio, spilled the butter, but really I think, were thrilled, if not pleased."[74] Ma Fischer, as Esherick came to call her, followed this with commissions for a guest room suite with a day bed and an accompanying prismatic side table as well as a sewing cabinet.

Visiting Munich, Germany, in 1930, Helene Fischer was so impressed by the carved ivory Hannah Weil exhibited at the *Glaspalast* that she invited Weil to America for an extended visit. Fischer threw a birthday party for Weil at Esherick's studio. During the rest of her visit, Weil and Esherick spent much time together, Wharton helping her improve her English, and each inspiring the other's creativity. After Weil returned to her home in Germany with Fischer's son, York, she invited Esherick to visit. In the summer of 1931 Esherick went to Holzhausen where Weil was living with her seven year-old daughter, Hanlo, and York. While York watched Hanlo, Wharton and Hannah toured Sweden, Denmark, and Norway. Wharton sketched constantly, capturing the people and places they visited. He wrote about

...dreaming thru wide streets & on the docks, bumping into interesting fountains and sculpture sprinkled thru the city. I could draw it better than write about it, wide streets tree lined, broad side walks, open squares and fountains where the water moving was part of the design. On to Oslo. There is a high point in fact if nothing else was seen, those old Norse log house[s], filled with tools, tables, beds, tankards wonderful in

Figure 40. Wharton Esherick, *Fjord,* wood engraving, 1932. Wharton Esherick Museum.

their simplicity & variety yet over it I felt that great love, the workmans love of materials, love of the use of the objects, love of the family for which they were made, how they loved a log, loved a grain house which kept their food.[75]

Esherick used a pencil the way most people use a camera. He documented the trip but also used the sketches as fodder for future art. Two notable prints came from the trip: *Holzhausen*, the view from Hannah's house, which he printed repeatedly on cloth for Hannah to make curtains from, and *Fjord*, the eerie shimmering image of two people in a rowboat on a fjord.

Wharton had lent Dreiser his studio while he was away. When he returned, Letty and the children also returned, Letty and Mary from Fairhope, Peter and Ruth from the Adirondacks dance camp. Although they all tried to resume family life, doing so was a struggle. Wharton poured himself into Ma Fischer's commissions, waiting for his next inspiration. It came from photographer Marjorie Content.

Esherick had originally met Content in the late 1920s at a picnic at Henry Varnum Poor's house in New City, New York. Content, Poor's neighbor, lived in New City with her husband Michael Carr, a painter and set designer. She had known Sherwood Anderson when she was the business manager of the Sunwise Turn Bookshop, a bookstore owned and run by women, and was also a friend of Carl Zigrosser. In 1932 she commissioned Esherick to make furniture for her new house on 10th Street in New York City.

He first made a bed and chest of drawers for her. The thick walnut slabs of the bed's base slope outward as they rise from the floor. The slope of the head mates with the back of the chest of drawers. Instead of a straight or rectangular form, the chest is a quarter of an irregular circle that narrows as it rises. The drawers open by pivoting from the far corner. The pattern is repeated in the telephone table that mates with the foot of the bed. Esherick followed with a prismatic vanity: two floor-to-ceiling inverted pyramids with mirrors on the interior faces and pull-out drawers on the outer faces. The pyramids are joined by a trapezoidal mirror. A triangular stool completes the piece (see catalog no. 242). Of the suite, Esherick wrote, "It is one of the biggest & most complete thing[s] in furniture I have done. The new corner chest of drawers which also acts as a head board to the bed I think is my best piece."[76]

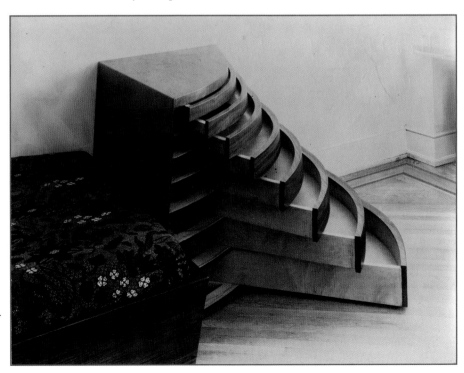

Figure 41. Marjorie Content, photographer, "Wharton Esherick's 1932 walnut and padouk *Content Daybed* and *Chest of Drawers*, photograph, 1932. Esherick Family Collection.

As was true with his relationships with many of his other clients, Esherick became friends with Content. She would stay at his farm whenever she traveled west, which she often did to visit with her friend Georgia O'Keeffe and to photograph for the Bureau of Indian Affairs. "I always stopped at Wharton's before sundown. ... [w]e never seemed to think that we were on the road until we took off from Paoli."[77] Content's house was large, and so there was always a bed available for Esherick when he visited the city.

Content introduced Esherick to her friend, photojournalist Consuelo Kanaga. In 1930 Kanaga visited Paoli and photographed Esherick's studio, his new spiral stair, and his daughter Mary. She would return many times to photograph his work. She and her husband, Wallace Putnam, became friends and clients of Esherick.

In the early thirties, Esherick used a lot of exotic woods, particularly padouk, for the Fischer and Content commissions. In 1932, Ed Ray, a local logger and woodman who had learned to log in the Pacific Northwest, returned to Valley Forge and started his own logging business. Ray appreciated what Esherick did with wood; Esherick appreciated Ray's ability to find spectacular specimens. After Ray's return, Esherick worked almost exclusively

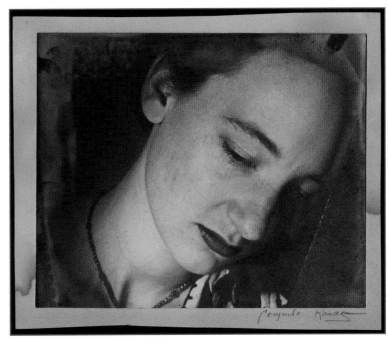

Figure 42. Consuelo Kanaga, photographer, "Portrait of Mary Esherick," photograph, ca.1930. Esherick Family Collection.

in domestic wood supplied by Ray. Ray often complained to Esherick about how much wood his carving wasted, adding that his soreness over the waste would turn to admiration when he saw the sculpture emerge from the log.

Ray enjoyed Esherick's imagination and became his willing collaborator. Esherick's ideas required logs of specific shapes; Ray would find them. Esherick, he said,

> ...could do with wood what couldn't be done. And I used to get a big bang out of going out and looking for some screwy-looking materials that he wanted. And we always found them. ... But I haven't had any fun going out in the woods looking since Mr. Esherick left. I just don't go out.[78]

Their collaboration was greased by a shared sense of humor. Ray told an interviewer:

> But I can remember some of the things down at Hedgerow Theatre and this was on a Sunday and all them people layin' around in there, hardly any clothes on or anything, and I was quite young in them days, and Wharton knocked on the door and he said, 'Cover up, everybody! I've got a bad man with me today.' And I said, 'Oh, Mr. Esherick, you shouldn't say that about John Schmidt here.' And I knew he meant me all along, and he says, 'No, I mean you.' And he opens the door and starts to walk through ... and I says, 'Hey Wharton, how much do you think it will cost me to get a job down here? I'll pay for it!'[79]

Flexing His Artistic Muscles

Content's commissions released a new optimism in Esherick. He felt confident in his art, even if the rest of his life was troubled. He wrote to Dreiser in 1933:

> ... those were days when I felt freer economically but struggling artistically—now it seems the reverse—economically it's tighter. I feel that there are more cares & responsibilities with three kids & the mother not as alert & finances twisted—but artistically or creatively I fear nothing—If God asked me [to] make a portrait of him, I would start in, chisel, pen, pencil, or brush. I've never gone thru more difficult years yet I feel I have done my best things in sculpture & furniture.[80]

A meeting with Curtis Bok would provide Esherick the opportunity to move boldly forward. Curtis Bok was heir to the Curtis Publishing Company empire but showed more interest in law and politics than in publishing. After completing law school, he entered practice, became a trustee of Philadelphia's Eastern State Penitentiary, and served as the president of the board of directors of the Philadelphia Orchestra. When Bok and his wife purchased a large old house in Gulph Mills, Pennsylvania, that lacked bookshelves, he mentioned to Alexander Hilsberg, the concert master of the Philadelphia Orchestra and a friend of Esherick's, that he needed a carpenter. Hilsberg told Bok, "I know a man who has what you need and needs what you have."[81] Thus began a three-year project that at times exasperated both Esherick and Bok. Esherick swung between elation at what he produced and despair at having become a contractor instead of an artist. Bok was thrilled with the product but distressed by its cost.

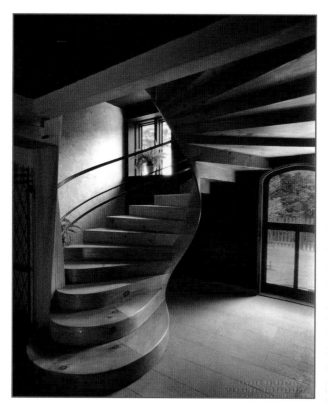

Figure 43. Rueben Goldberg, photographer, "Wharton Esherick's 1935 *Bok House—Spiral Stair*, photograph, ca. 1938. Esherick Family Collection.

Esherick started this commission with an arts-and-crafts style fireplace surround for the Boks' dining room. He followed with a spiral stair for the foyer, made of large pine beams recycled from a colonial-era bridge that once spanned the Delaware River. The stairs seemed to defy gravity as they spiraled up in the hallway. A steel band, concealed in the outside edge of the steps, provided support where the steps were not anchored to a wall. As the stairs spiraled upward, they gradually change from a circle at the base to a triangle at the top. Bok's wife, Nellie Lee, felt that the stairs looked unsafe and insisted on railings. Esherick acquiesced and designed sleek railings for the outside; later—again at Nellie Lee's insistence—he added an inner rail, as well.

Esherick's crew constructed bookshelves to line the parlor that were specifically designed to fit the Boks' books. They built an alcove with a desk and sofa and finished off the room with a prismatic fireplace surround and a double door to the music room (see catalog no. 252). Both pieces, made from oak, featured carved, faceted surfaces in an art deco design reminiscent of drapes pulled back at the corners. Each faceted piece was of a different size from every other, creating

Figure 44. Edward Quigley, photographer, "Wharton Esherick's 1935 *Bok House— Bookshelves*," photograph, 1938. Esherick Family Collection.

a wonderful visual rhythm. Lining the hearth in copper, Esherick created a sunburst design with nails that mimicked the pattern in the wood. A grand archway connected the dining room and the book room. Esherick also designed a small law library with oak book cases, a desk with sides that would fold out to triple the work area, and a three-step library ladder with two handles, one carved as a donkey and one as an elephant, reflecting Bok's appearance on both the Democratic and Republican tickets when he was seeking election as a Common Pleas Court judge.

The project's final cost was considerably higher than Esherick's estimate. Bok protested, but to no avail. He loved what Esherick had done, and so he paid.[82]

A few months later Esherick was awakened by a phone call from a clearly distressed Bok. Esherick tells the story:

> He [Bok] called me in the middle of the night and he said, 'This is Curtis.' I said, 'Yes?' He says, 'God damn it, nobody will go into our music room!'... He says, 'We have a party here!' I said, 'Well, what did you call me for?' He says, 'I want you to do something about it!' And that's the way I got my order for the music room.[83]

The music room was a masterpiece. Esherick removed the back wall and replaced it with a new wall that contained a circular fireplace with an adobe-like look. Behind the fireplace he built an exterior expressionist stair that spiraled around the chimney to reach an outdoor patio. The chimney supported two other fireplaces, one in the bedroom above the music room, the other on the patio below it. Along the side wall Esherick installed a picture

Figure 45. Consuelo Kanaga, photographer, "Wharton Esherick's *Bok House—Exterior Stair and Chimney*," photograph, ca. 1937. Esherick Family Collection.

window, four feet high by sixteen feet long. Massive oak beams surrounding the window were carved to enable Mrs. Bok's curtains to be hidden when open. Opposite the fireplace a set of shelves held phonograph records, sheet music, and a portable record player that could be tucked into the bookcase when not in use. Speakers were located behind a carved wood grill that Esherick installed over the fireplace. Bok did not like the grill; he wanted a picture to hang in front of the speakers. Esherick hung the picture in such a way that it could be raised when music was playing. The other side wall was made of oak paneling that curved down from the ceiling to hide recessed, indirect light behind. The new ceiling was made of curving pine boards, joined with splines to hold them together (see catalog no. 255).

Esherick's nephew Joe helped with the music room. Joe, an architecture student at the University of Pennsylvania, later went on to a successful architectural career in California (the Monterey Aquarium and the Hedgerow Houses at Sea Ranch were among his most famous structures). Joe was one of eleven people who worked for Esherick during this project. The largest commission Esherick had ever had, it clearly established him as a force to be reckoned with in art and architecture.

Esherick knew that the Bok house was something special. He wrote to Dreiser, "All has gone well with me this summer, although it has been a long hard fight, but I think what I have brought forth means something more than just another room decorator—(or interior decorator)."[84] The Bok house enabled Esherick to work through ideas he had derived from Arts and Crafts, German Expressionism, Art Deco, and Anthroposophy, and move toward a synthesis. The prismatic melded into flowing curves. He had achieved something important, and now it was time to move on.

A World Stage

The New York World's Fair, its theme "The World of Tomorrow," opened in 1939, highlighting all the wonderful things that technology was about to bring. People complained that the Fair was so focused on industry that it did not show how people would live in this upcoming modern world. Therefore, the 1940 version of the Fair included the America at Home pavilion, with works by noted architects. Esherick's friend, George Howe, designed a rustic modern room called the Pennsylvania Hill House and filled it with Esherick's furniture and architecture. It featured the 1930 Spiral Stair, a curving sofa, and an elk-hide chair with a Scotty-dog foot stool. The centerpiece of the room was a five-sided table with delicate hickory legs and a phenol top. The natural look of the hickory legs contrasted beautifully with the modern plasticity of the black phenol. The chairs around this table were based on the design of Esherick's hammer handle

chairs, only their legs and stretchers were carved of hickory, with joints that seemed to flow together organically,[85] and with seats of translucent hide.

The World's Fair Table represented a break for Esherick. Experiments with Expressionism and Art Deco had characterized much of his work in the 1930s. These styles now gave way to an organic simplicity of form, clean and rustic, yet modern and timeless. His voice as an artist was stronger than

Figure 46. Wharton Esherick, *World's Fair Table and Chairs*, hickory, phenol, and leather, 1940. Collection of LongHouse Reserve, East Hampton, New York.

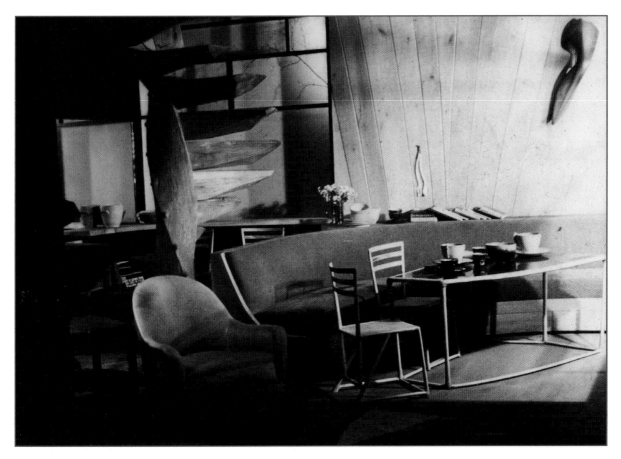

Figure 47. "Wharton Esherick and George Howe's 'Pennsylvania Hill House' exhibit in the World's Fair display, 'America at Home,'" color photograph, 1940. Esherick Family Collection.

ever, and his confidence could not be shaken. But his timing was bad. The World of Tomorrow turned out to be World War II; any economic gains that the Fair might have produced were lost.

Esherick also suffered personal setbacks. His long relationship with Letty had finally ended in 1938. She left Sunekrest for good and moved to Hedgerow Theatre, where Mary and Ruth were already living. Then in 1941, his friend Sherwood Anderson died unexpectedly of peritonitis on his way to South America. Esherick was crushed. He wrote to Dreiser,

> I felt very sad seeing you go—and then the next day came news of Sherwoods death. I tried to find you in N.Y. & and would have be[en] there to see you, if only to weep on your shoulder & return. he was so important in my life.[86]

At the funeral, Bob Anderson, Sherwood's son, read a eulogy composed by Dreiser because Dreiser himself could not attend. Jasper Deeter had planned to read the eulogy but was unavoidably detained at the last minute, and Esherick would not read it because he was afraid "it would be lost in my tears."[87]

At the funeral Esherick saw Felix Sullivan, a friend and neighbor of Anderson, leaning on his staff by the grave site—a view that inspired him to create *Reverence*, one of his greatest pieces. Anderson had asked that Esherick design his grave marker. Esherick carved *Reverence*, a twelve-foot tall somber figure leaning on a staff, from a walnut log. Eleanor, Anderson's widow, rejected the piece, arguing that wood would not

survive the elements and a tall, thin figure would in addition be subject to vandalism. Esherick created a smaller abstract piece, rendered in black granite by Victor Riu. The words "Life, not death, is the great adventure" are carved across its face.

For Esherick life and art were inseparable. Living to create, he created to live. He drew his art from his life, its joys and pains, its triumphs and its adversities. When his muse demanded that he choose between his art and his family, he ultimately chose art—struggling between his love of family and his drive to create. He was fifty-three years old in 1940. His creativity would sustain him for the remaining thirty years of his life.

Esherick had written to Dreiser in 1929: "I am a worker I feel primarily. I keep going from one job to another & seem to be making a new job while working the old one"[88] And so he would live his life, moving from one project to the next, always growing and creating. By the 1940s he had found his voice, and he sang clearly.

Figure 48. Consuelo Kanaga, photographer, "Wharton Esherick's 1942 walnut *Reverence*," Wharton Esherick Museum.

Endnotes

[1] Wharton Esherick, "Esherick on Deeter," undated notes, compiled by Sue Hinkel, Wharton Esherick Museum, Paoli, Pa.

[2] Esherick himself used the term "organic" to describe his work and his lifestyle, meaning by it a life he considered in accord with nature, art, and his own needs as an artist and human being. The term has also frequently been deployed in discussions of Esherick's furniture; see, for example, Edward S. Cook, Gerald W. R. Ward, and Kelly H. L'Ecuyer, *The Maker's Hand: American Studio Furniture, 1940–1990* (Boston, Mass.: MFA Publications, 2003).

[3] For an examination of this myth, see Roberta A. Mayer and Mark Sfirri, "Early Expressions of Anthroposophical Design in America: The Influence of Rudolf Steiner and Fritz Westhoff on Wharton Esherick," *The Journal of Modern Craft* 2, no. 3 (November 2009): 299–324.

[4] Esherick surprised a discussion group in Fairhope when he opened the discussion with a Bible passage. He described it in a letter to Dreiser:

> This is a full town, full of all kinds of isms, the philosophical kind, you know. On Sunday mornings a group of 30 or 40 meet to discuss open subjects at each others house When they met here I opened up with the Bible (passage good Samaritan). The crowd was surprised as it was the first time the bible was brought into the meeting. Even the intellectuals are scared. I didn't do it as a joke either. I followed it with Anderson's mountain girl story in Vanity Fair. A 'good samaritan' act which didn't work out.
> —Esherick to Theodore Dreiser, 27 January 1930, Theodore Dreiser Papers, Rare Book and Manuscript Library, University of Pennsylvania.

[5] Wharton Esherick, interviews by Mansfield Bascom, ca. 1968–70, Wharton Esherick Museum, Paoli, Pa.; Mansfield Bascom, *Wharton Esherick: The Journey of a Creative Mind* (New York: Abrams, 2010), 14.

[6] Bascom, *Wharton Esherick*, 17.

[7] Bascom, *Wharton Esherick*, 19.

[8] Esherick, interviews by Mansfield Bascom.

[9] Bascom, *Wharton Esherick*, 21–39.

[10] Bascom, *Wharton Esherick*, 31–32.

[11] Bascom, *Wharton Esherick*, 33.

[12] Marietta Johnson, *Thirty Years with an Idea* (Tuscaloosa, Ala.: The University of Alabama Press, 1976), 1–16.

[13] John Dewey, *The Middle Works, 1899–1924*, ed. Jo Ann Boydston (Carbondale: Southern Illinois University Press, 1979), 8:222. See also the website of the Marietta Johnson Museum, Fairhope, Alabama: http://www.mariettajohnson.org.

[14] Kim Townsend, *Sherwood Anderson* (Boston: Houghton Mifflin, 1987), 161–62.

[15] Sherwood Anderson, *Sherwood Anderson's Memoirs* (New York: Harcourt, Brace and Company, 1942), 273.

[16] Townsend, *Sherwood Anderson*, 165.

[17] Bascom, *Wharton Esherick*, 37.

[18] Esherick, interviews by Mansfield Bascom.

[19] Esherick, interviews by Mansfield Bascom.

[20] Esherick, interviews by Mansfield Bascom.

[21] Esherick, interviews by Mansfield Bascom.

[22] Bascom, *Wharton Esherick*, 38.

[23] Bascom, *Wharton Esherick*, 48; Esherick, interviews by Mansfield Bascom.

[24] Esherick, notes, 1923, comp. Hinkle (see note 1).

[25] Bascom, *Wharton Esherick*, 41.

[26] *The Ruth Doing Camp for Rhythmics, July 2 to September 10, 1923, Eighth Season* [camp prospectus] (n.p., 1923), [1].

[27] *The Ruth Doing Camp for Rhythmics*, [3].

[28] Bascom, *Wharton Esherick*, p.41.

[29] The table is now at the Threefold Commonwealth Education Center in Spring Valley, New York. The drawings are in the archive of the Wharton Esherick Museum, Paoli, Pa.

[30] Bascom, *Wharton Esherick*, 131.

[31] Bascom, *Wharton Esherick*, 42.

[32] For more on Steiner's influence on Esherick, see Mayer and Sfirri, "Early Expressions of Anthroposophical Design in America."

[33] Bascom, *Wharton Esherick*, 43.

[34] *Illustrated Catalogue of Lithographs, Engravings, and Etchings Published by the Weyhe Gallery, 794 Lexington Avenue, New York* (New York: Weyhe Gallery, 1928), 1.

[35] Bascom, *Wharton Esherick*, 68.

[36] C. E. Parker, *A Short History of the Threefold Community* (Spring Valley, N.Y.: Threefold Community, 1972), 3–4; see also Mayer and Sfirri, "Early Expressions of Anthroposophical Design in America," 305, 309.

[37] Mayer and Sfirri, "Early Expressions of Anthroposophical Design in America," 312.

[38] Mayer and Sfirri, "Early Expressions of Anthroposophical Design in America," 310–15.

[39] Harold Mason, interview by Mansfield and Ruth Bascom, n.d., Wharton Esherick Museum, Paoli, Pa.

[40] *The Centaur Press Announcement* [for *The Song of the Broad-Axe* and *Edgar Saltus: A Critical Study*] (Philadelphia: The Centaur Press, 1924), [4].

[41] Walt Whitman, *The Song of the Broad-Axe*, illustrated by Wharton Esherick (Philadelphia: The Centaur Press, 1924), 6.

[42] *The Centaur Press Announcement*, 3.

[43] Mason, interview by Mansfield Bascom and Ruth Bascom.

[44] Mason, interview by Mansfield Bascom and Ruth Bascom.

[45] Mason, interview by Mansfield Bascom and Ruth Bascom.

[46] Bascom, *Wharton Esherick*, 138.

[47] Mason, interview by Mansfield Bascom and Ruth Bascom.

[48] Publications in which his prints appeared include Geoffrey Holme, ed., *The Woodcut of Today at Home and Abroad* (London: The Studio Ltd., 1927); Herbert Furst, ed., *The Woodcut: An Annual* (London: The Fleuron Limited, 1928); and Malcolm Salaman, *The New Woodcut* (New York: Albert and Charles Boni, 1930).

[49] Ed Ray, interview by Mansfield and Ruth Bascom, Wharton Esherick Museum, Paoli, Pa.

[50] Mae Shearer, interview by Mansfield Bascom, February 11, 2002, Wharton Esherick Museum, Paoli, Pa.

[51] Wharton Esherick to Theodore Dreiser, 13 July 1930, Theodore Dreiser Papers, Rare Book and Manuscript Library, University of Pennsylvania.

[52] Esherick, "Esherick on Deeter," in Wharton Esherick, undated notes, compiled by Sue Hinkel, Wharton Esherick Museum, Paoli, Pa.

[53] Mark Sfirri provides an interesting look at the Hammer Handle chair in Sfirri, "The Hammer-Handled Chairs: Found Object Art by Wharton Esherick," *Woodwork*, no. 110 (April 2008): 60–62. See also Mansfield Bascom, Exhibition catalog for *Hammer Handle Chair* exhibition (Paoli, Pa: Wharton Esherick Museum, 2006), and Bascom, *Wharton Esherick*, 162–3.

[54] Bascom, *Wharton Esherick*, 132.

[55] W. A. Swanberg, *Dreiser* (New York: Charles Scribner's Sons, 1965), 289–90.

[56] Swanberg, *Dreiser*, 438.

[57] Miriam Phillips to E.W. Hart, April, 1935, Correspondence, Box 15, Hedgerow Theatre Collection, Howard Gotlieb Archival Research Center, Boston University.

[58] Theodore Dreiser to agents of Erwin Piscator, 5 July 1935, Correspondence, Box 15, Hedgerow Theatre Collection, Howard Gotlieb Archival Research Center, Boston University.

[59] Esherick, interviews by Mansfield Bascom.

[60] Wharton Esherick to Sherwood Anderson, ca. 1934, Sherwood Anderson Papers, Midwest Manuscript Collection, The Newberry Library, Chicago.

[61] Sherwood Anderson to "Hedrerowers," n.d., Correspondence, Box 14, folder 6, Hedgerow Theatre Collection, Howard Gotlieb Archival Research Center, Boston University.

[62] Esherick, interviews by Mansfield Bascom.

[63] Esherick, interviews by Mansfield Bascom; Bascom, *Wharton Esherick*, 68–75.

[64] Wharton Esherick to Theodore Dreiser, 1 September 1927, Theodore Dreiser Papers, Rare Book and Manuscript Library, University of Pennsylvania.

[65] Wharton Esherick to Theodore Dreiser, 15 October 1927, Theodore Dreiser Papers, Rare Book and Manuscript Library, University of Pennsylvania.

[66] Swanberg, *Dreiser*, 357–58.

[67] Wharton Esherick, "He Helps Me Build a Building," ca. 1931, Theodore Dreiser Papers, folder 14448, Rare Book and Manuscript Library, University of Pennsylvania.

[68] Bascom, *Wharton Esherick*, 96.

[69] Esherick, Interviews by Mansfield Bascom.

[70] Bascom, *Wharton Esherick*, 77.

[71] Wharton Esherick to Theodore Dreiser, 6 August 1929, Theodore Dreiser Papers, Rare Book and Manuscript Library, University of Pennsylvania.

[72] Bascom, *Wharton Esherick*, 116.

[73] Mark Sfirri provides a detailed portrait of this desk in "Anatomy of a Masterpiece: The 1931 Corner Desk by Wharton Esherick," *Woodwork*, no. 112 (August 2008): 52–56.

[74] Wharton Esherick to Theodore Dreiser, 9 March 1931, Theodore Dreiser Papers, Rare Book and Manuscript Library, University of Pennsylvania.

[75] Wharton Esherick to Theodore Dreiser, 27 September 1931, Theodore Dreiser Papers, Rare Book and Manuscript Library, University of Pennsylvania.

[76] Wharton Esherick to Theodore Dreiser, 23 November 1932, Theodore Dreiser Papers, Rare Book and Manuscript Library, University of Pennsylvania.

[77] Marjorie Content Toomer, interview by Mansfield and Ruth Bascom, n.d., Wharton Esherick Museum, Paoli, Pa.

[78] Ed Ray, Interview by Mansfield and Ruth Bascom, n.d., Wharton Esherick Museum, Paoli, Pa.

[79] Ed Ray, Interview by Mansfield and Ruth Bascom.

[80] Wharton Esherick to Theodore Dreiser, 6 January 1933, Theodore Dreiser Papers, Rare Book and Manuscript Library, University of Pennsylvania.

[81] Bascom, *Wharton Esherick*, 142.

[82] Bascom, *Wharton Esherick*, 150–61.

[83] Esherick, Interviews by Mansfield Bascom.

[84] Wharton Esherick to Theodore Dreiser, "Labor Day" (6 September) 1937, Theodore Dreiser Papers, Rare Book and Manuscript Library, University of Pennsylvania.

[85] On the term organic, see note 2.

[86] Wharton Esherick to Theodore Dreiser, 17 March 1941, Theodore Dreiser Papers, Rare Book and Manuscript Library, University of Pennsylvania.

[87] Wharton Esherick to Helen Dreiser, 20 March 1941, Theodore Dreiser Papers, Rare Book and Manuscript Library, University of Pennsylvania.

[88] Wharton Esherick to Theodore Dreiser, 6 August 1929, Theodore Dreiser Papers, Rare Book and Manuscript Library, University of Pennsylvania.

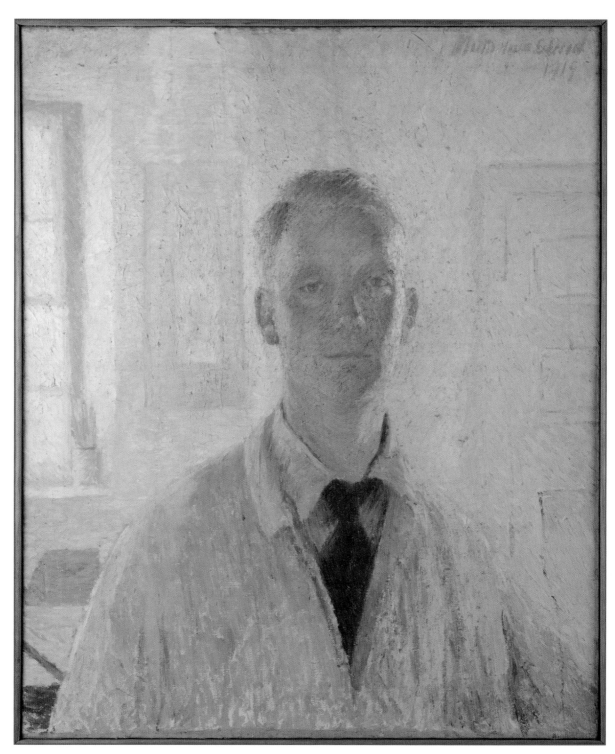

Catalog no. 1.
Wharton Esherick.
Self-Portrait.
Oil on canvas, 1919.
Wharton Esherick Museum.

WHARTON ESHERICK AND THE BIRTH OF THE AMERICAN MODERN

EXHIBITION INTRODUCTION

Fine music makes fine pictures. Fine pictures make fine drama. Fine drama makes fine music or poetry or song. Each one stimulates the other. ... [O]ne art helps another; one art owes nothing to the other.
—Wharton Esherick, "Esherick on Deeter"

Wharton Harris Esherick (1887-1970) was an artist whose distinctive synthesis of art, theater, dance, and design forged an early and compelling example of American Modernism. Recognized in his own day as a printmaker, illustrator, sculptor, designer, and builder, he is best known today for his sculptural furniture, which is regularly exhibited in shows highlighting twentieth-century American modernist design. But this limited view of Esherick and his oeuvre subsumes Esherick's art to his craft. Esherick saw himself as an artist, not a craftsman—a modernist sculptor for whom furniture was a kind of sculpture. As he succinctly put it, "some of my sculpture went into the making of furniture."

Wharton Esherick and the Birth of the American Modern explores Esherick's artistic evolution during the early decades of the twentieth century, culminating in the exhibition of his work as part of the Pennsylvania Hill House at the 1940 World's Fair in New York City. Trained as an illustrator and painter, experienced in modern theater and dance, well exposed to new ideas in philosophy, politics, and literature, Esherick experimented with wood carving and printmaking, laying the foundations for his emergence as an artist of remarkable range. He produced paintings and woodblock prints, set designs, furniture, and architecture. He and his community of friends created an artistic circle in which arts and crafts were both joined, and in which radical new ideas flourished, helping to shape the course of American Modernism.

Esherick's studio, located and still surviving on Diamond Rock Hill in rural Chester County, seems to suggest that he was an artistic hermit who created whimsical and imaginative furniture and sculpture in isolation. To the contrary, he fully engaged the world around him, absorbing whatever interested him and collaborating with a wide range of writers and artists working in fiction, poetry, dance, theater, architecture, sculpture, and crafts. His was a world in rapid motion, a world in which revolutions in politics, psychology, science, technology, and the arts, all taking place simultaneously, created a distinctly twentieth-century version of modernity.

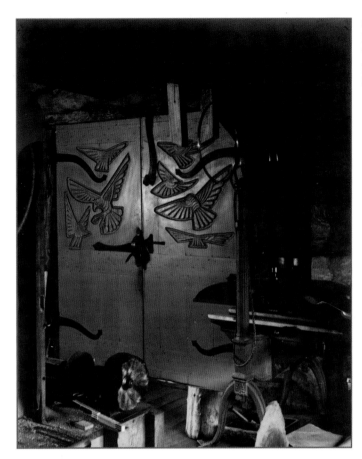

Catalog no. 2.
Emil Luks, photographer.
"Carved door in Esherick's studio."
Photograph, 1930.
Esherick Family Collection.

This exhibition occupies two venues, the Kamin Gallery in the Van Pelt-Dietrich Library and the Kroiz Gallery in the Architectural Archives, both at the University of Pennsylvania. Additionally, the Wharton Esherick Museum and Hedgerow Theatre, collaborators on this project and central spaces in Esherick's life, are two important venues well worth visiting in conjunction with this exhibition. So, too, is the Philadelphia Museum of Art, with its installation of several examples of Esherick's work in their collection alongside their permanent installation of the Bok House Library fireplace and doorway. Each place offers perspectives that complement and enrich this exhibition.

Esherick's work captures the spirit of his times and simultaneously transcends it. Continuing to speak to us, to resonate with our interests and concerns even as it delights our senses, its impact, and that of American Modernism generally, still reverberates.

The **Kamin Gallery** section of the exhibition explores the social, political, and artistic milieu of Esherick in the 1920s and 1930s and illuminates many of the institutions and relationships that made the American modernist movement possible. Esherick was part of a circle of friends whose lives and works, in many ways inseparable, put a particularly American face on Modernism. Esherick's works on paper, canvas, and wood, exhibited alongside contemporary photographs, books, correspondence, printed ephemera, and works by other artists, evoke the excitement, chaos, and creativity of the time.

This portion of the exhibition both uncovers and reinstates individuals and institutions whose roles in the creation of American Modernism have faded from memory over time. Key figures include writers Theodore Dreiser and Sherwood Anderson; print curator Carl Zigrosser; theater director Jasper Deeter; painter and ceramicist Henry Varnum Poor; and photographers Consuelo Kanaga and Marjorie Content. Institutions that influenced and were influenced by Esherick include Hedgerow Theatre in Rose Valley, Pennsylvania;

Centaur Book Shop and Press in Philadelphia; Marietta Johnson's School of Organic Education in Fairhope, Alabama; Gail Gardner and Ruth Doing's Rhythms Camp in the Adirondacks; and Threefold Commonwealth Group in New York. In these places, people freely came together to recreate themselves and their communities.

The **Kroiz Gallery** section of the exhibition explores Esherick's evolution as an artist in wood. Esherick drew upon leading figures of European Modernism in his work, among them Constantin Brancusi, Ernst Barlach, Carl Milles, Georges Braque, Edvard Munch, Antoni Gaudi, and Henry Moore, as well as the American Frank Lloyd Wright. Whatever his intellectual referents, however, what stands out about Esherick's work is its functionality. Deeply respectful of the wisdom of the farmers and tradesmen who were his neighbors in Chester County, Esherick combines the aesthetic of the modern and the practicality of the traditional. Ezra Pound told the modern writer to "make it new." Leavening both the modern aesthetic and the traditionally practical with a sense of wit and play, Esherick creates something truly new and uniquely his own.

The **Hedgerow Theatre** was a place central to Esherick's life. Both a source of inspiration for Esherick and a conduit to interesting people and ideas, Hedgerow was where he relaxed with friends, experimented with new ideas, and found a gallery to display and sell his work. Its charismatic and innovative founder and director, Jasper Deeter, brought the avant-garde to rural Pennsylvania and his theater put Esherick into close touch with one of his period's most intellectually provocative and artistically wide-ranging art forms.

The **Wharton Esherick Museum** is the site, indeed the very building, where Esherick lived and worked. In his studio, which he created on a hillside in Chester County, the natural world surrounded Esherick, providing him with his most consistent source of inspiration. Here he entertained friends: Sherwood Anderson, Jasper Deeter, Theodore Dreiser, Ford Madox Ford, Consuela Kanaga, Leopold Stowkowsi, and many others. Here he also struggled to reconcile the demands of his art and his family. Esherick called his studio "my autobiography." For him, life and art were inseparable.

KAMIN GALLERY

Home

"Sunekrest" was the name Wharton Esherick and his new bride, Letticia "Letty" Nofer, gave to the small farm they purchased in 1913 on a hillside in Chester County. Any romantic illusions of rural life that he and Letty might have had when they bought the property were quickly dispelled by the realities of living on the farm, but both took to it anyway and learned quickly. Sunekrest proved to be an anchor for Esherick in all senses of the word. Working the farm connected him strongly to the land and taught him the rhythms of nature. This connection informed his art for the rest of his life. He began by capturing scenes of country life in his drawings and paintings. Then he moved to make his farm itself a work of art. As he moved into sculpture and furniture making, biomorphic forms from the natural world permeated his designs.

But Sunekrest seemed also to hold him back and keep him from following his artistic vision. The pressures of family life began to intrude on his art. In 1926 he built a new studio up the hill. That new studio is now the Wharton Esherick Museum. Far away from the disturbance created by children and the demands of his family, he sculpted a new life for himself. When Letty took the children—Mary (born in 1916), Ruth (born in 1922), and Peter (born in 1926)—to dance camp in the Adirondacks for the summer, Esherick moved into his studio and rented the farmhouse to friends from Philadelphia. As his marriage slowly dissolved, the studio became his home and he expanded it over the years. It evolved as his art evolved.

Esherick also regularly entertained his friends at the farm and studio. He extended invitations to far-flung friends to visit for days or weeks, and they came, sometimes singly, sometimes in groups. Often they would traipse down to the nearby Hedgerow Theatre to take in that day's offering.

This drawing of his farm shows both Esherick's early interest in illustration and his romantic approach to life on the farm. Esherick was not consistent in spelling the name of his farm, which is sometimes, as here, "Sunekrest," and other times "Sunnekrest."

Catalog no. 3.
Wharton Esherick.
Sunekrest.
Ink on paper, ca. 1918.
Wharton Esherick Museum.

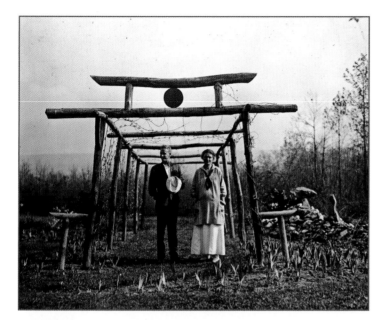

Catalog nos. 4-8.
"Grape arbor."
"Wharton and Letty."
"Peony garden."
"Mary, Peter, Ruth, and monkey
 playing on *Pooh* sculpture."
"Family farmhouse."
Photographs in Esherick Family
 albums, late 1910s-1920s.
Esherick Family Collection.

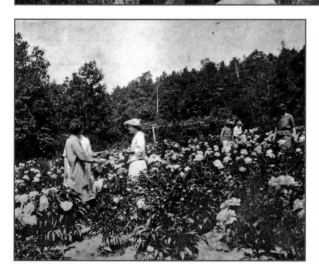

The Esherick family farmhouse was the center of family life. Esherick turned his farm into a work of art, building an elaborate Japanese-influenced grape arbor, shown here, as well as carving the Sunekrest rising sun on his shutters and painting murals on the farmhouse walls.

Esherick used his own woodcuts to illustrate his advertisements. Shown here are two, one advertising one of his exhibitions, the other peonies, a cash crop for the Eshericks. They sold the flowers at Bryn Mawr and Rosemont College graduations; the flowers as well as the plants could be bought directly at the farm, "Sunnekrest Gardens," here with the alternative spelling for Sunekrest. According to this June advertisement, you could "See Your Plants in Bloom, Roots Delivered in September."

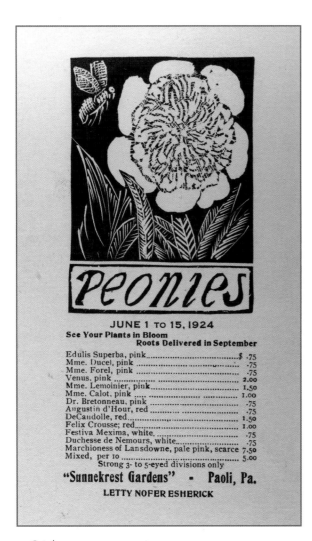

Catalog no. 9.
Wharton Esherick.
Peonies.
Wood engraving, illustration on advertisement
for "Sunnekrest Gardens," 1924.
Wharton Esherick Museum.

Catalog no. 10.
Wharton Esherick.
Family at Exhibition.
Woodcut, cover illustration for *Some Pictures Prints and Sculptures at the Studio of Wharton H. Esherick, Diamond Rock Hill, Paoli, Penn., Sunday, June 8th to Sunday, June 15th*, 1924.
Wharton Esherick Museum

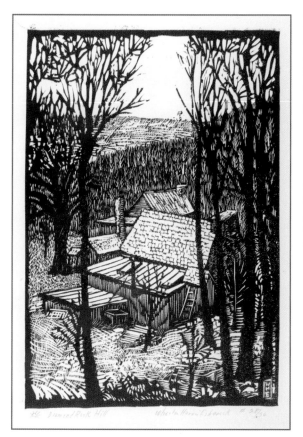

Esherick's barn, seen in the foreground of his print *Diamond Rock Hill*, served as a painting and carving studio. *The Wood Carver's Shop* shows its interior. Carving frames was Esherick's first foray into woodworking. Woodcuts and wood engravings soon followed.

Catalog no. 11.
Wharton Esherick.
Diamond Rock Hill.
Wood engraving, 1923.
Wharton Esherick Museum.

Catalog no. 12.
Wharton Esherick.
The Wood Carver's Shop.
Oil on canvas, with carved frame, 1922.
Mansfield and Ruth Bascom.

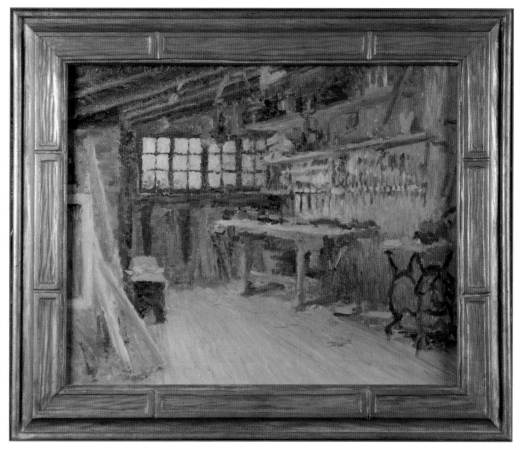

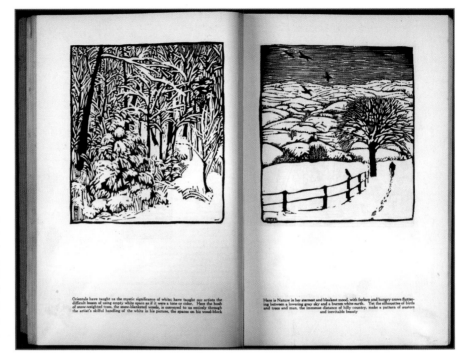

Catalog no. 13.
Wharton Esherick.
February (left) and *January—
Blankets of Snow* (right).
Woodcut and wood
engraving, in *The Century
Magazine,* 106:2 (June
1923).
Wharton Esherick Museum.

Esherick captured the effects of various seasons in prints of his farm and the surrounding countryside. Some of them, published in national magazines of the period—*The Century Magazine, The Dial, The Forum, The New Republic, Vanity Fair*—gave Esherick his first widespread recognition as an artist.

Esherick had a number of different studios over the years. One photograph shows the exterior of his studio and garage as it looked around 1930. The other shows the interior of his studio from the same period. John Schmidt, the cabinetmaker who was Esherick's collaborator for thirty years, made the band saw on the right side of the photograph using bicycle wheels.

Catalog no. 14.
"Esherick's studio and garage."
Photograph, ca. 1930.
Esherick Family Collection.

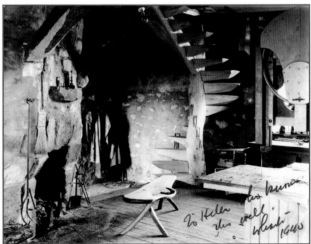

Catalog no. 15.
"Interior of Wharton Esherick's Studio."
Photograph, ca. 1930.
Theodore Dreiser Papers, Rare Book and
 Manuscript Library, University of Pennsylvania.

This photograph shows Esherick printing at his Washington Press, acquired from the *Pottstown Mercury* in the 1920s.

This light pull—the original of which was cut from cocobola, a tropical hardwood from Central America—reflects Wharton's belief that all aspects of a room could be art.

Catalog no. 16.
Emil C. Luks, photographer.
"Wharton Esherick at his printing press."
Photograph, ca. 1930.
Esherick Family Collection.

Catalog no. 18.
Wharton Esherick.
Female light pull.
Bronze, ca. 1930.
Wharton Esherick
 Museum.

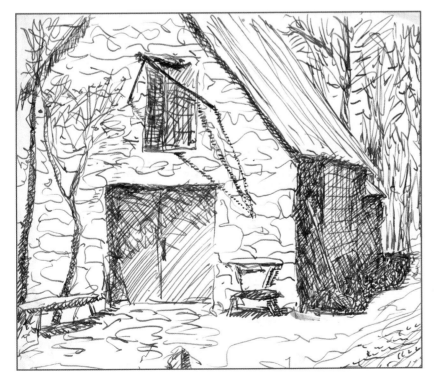

This drawing is a view of the east side of Esherick's studio. The large door led to the interior work area. In nice weather he would work outside in the area pictured.

Catalog no. 17.
Wharton Esherick.
*Two Empty Benches by my Studio
 Door.*
Ink on paper, 1930-31.
Mark Sfirri Collection.

Philadelphia

Esherick was born and raised in Philadelphia, at 39th and Locust Streets, next to St. Mary's Church. The house was later razed to make way for student housing for the University of Pennsylvania. After graduating from the Central Manual Training School and the Pennsylvania Museum School of Industrial Art (now part of the University of the Arts), Esherick attended the Pennsylvania Academy of the Fine Arts, leaving just short of graduation. Both institutions would later honor him.

By no means did his move to the hillside in Paoli cut his ties to Philadelphia. Indeed, part of his reason for choosing Paoli was because the Pennsylvania Railroad Main Line permitted easy access to Center City. He eagerly took part in the cultural life of the city, visiting the museums, exhibiting at the Print Club, the Philadelphia Art Alliance, and other galleries, attending concerts at the Academy of Music, and frequenting after-hours sessions at the Centaur Book Shop.

Both in high school and at the Museum School of Industrial Art, Esherick considered becoming an illustrator.

Catalog no. 19.
Wharton Esherick.
Man Perched on Stool Reading Book in Front of Bookcase.
Ink on paper, ca. 1906.
Wharton Esherick Museum.

Esherick (right) and Julius Bloch (1888-1966) were students together at the Pennsylvania Academy of the Fine Arts. Bloch, later known for his lithographic prints of working class and African-American life, and Esherick remained friends throughout their lives.

Catalog no. 20.
"Wharton Esherick and Julius Bloch with unidentified female model."
Photograph in Esherick Family albums, ca. 1906.
Esherick Family Collection.

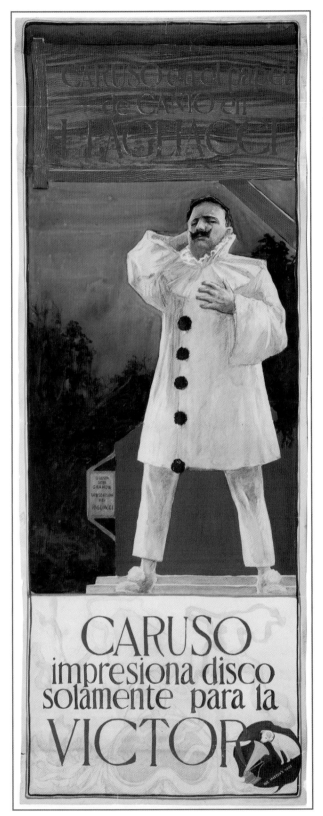

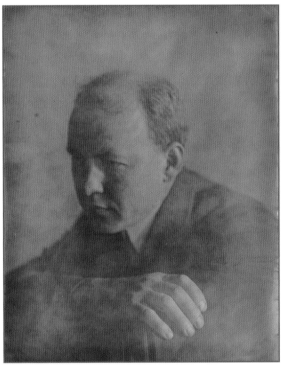

After dropping out of the Pennsylvania Academy of the Fine Arts, Esherick did commercial illustration work for the *Philadelphia Bulletin*, the *Philadelphia Public Ledger*, and the Victor Talking Machine Company, making line drawings from photographs. At Victor, he met Harry Attmore, who introduced him to the writings of Henry David Thoreau and to socialism.

Catalog no. 22.
"Harry Attmore."
Photograph in Esherick
 Family albums, 1910s.
Esherick Family Collection.

Catalog no. 21.
Wharton Esherick.
*Caruso Advertisement for Victor
 Talking Machine Company.*
Tempera on paper, ca. 1912.
David Esherick Collection.
Photograph by Mark Sfirri.

Rhythmics is a style of Modern dance. Esherick used this dance woodblock, made the previous year, to illustrate an invitation to a "demonstration of Rhythmics by MISS DOING and her Pupils" on October 19, 1923, as well as an announcement that "Ruth Doing, of New York, will resume her classes in Rhythmics in Philadelphia in November, assisted by Louise Bybee and Letty Nofer Esherick. Dorothy Joline, Pianist." Letty not only assisted Ruth Doing at the Oak Lane Day School but also taught Rhythmic dancing at the Esherick home on Diamond Rock Hill.

Catalog no. 23.
Wharton Esherick.
Dance print.
Woodcut, illustration for invitation
to Rhythmics demonstration and
announcement, 1923.
Wharton Esherick Museum.

Catalog no. 24.
Wharton Esherick.
Corn harvest print.
Woodcut, cover illustration for
*Exhibition of Woodcut Prints and
Sculpture in Wood and Stone by
Wharton Esherick, November 16 to
28 Inclusive, The Print Club, 1614
Latimer Street,* ca. 1925.
Theodore Dreiser Papers, Rare Book
and Manuscript Library, University
of Pennsylvania.

During the 1920s and 1930s, Esherick exhibited his work at several Philadelphia-area locations, among them Hedgerow Theatre, The Print Club, and The Philadelphia Art Alliance. In the Art Alliance exhibition, he shared space with textile designer Ruth Reeves and his good friend, the ceramicist Henry Varnum Poor (1888-1970). Esherick made this eye-catching postcard, with its weave-like background, to announce an exhibition in 1932.

Catalog no. 25.
Wharton Esherick.
*The Philadelphia Art Alliance, 25
South 18th Street, Furniture:
Wharton Esherick; Fabrics: Ruth
Reeves; Pottery: Henry Varnum
Poor, February 1st to February,
MCMXXXII.*
Woodcut postcard, 1932.
Courtesy of the Moderne Gallery.

Theodore Dreiser (1871-1945) was regularly invited by Esherick to visit and spend time at his home and studio, sometimes in conjunction with performances of plays, including Dreiser's own *An American Tragedy* and Sherwood Anderson's *Winesburg, Ohio*, at the nearby Hedgerow Theatre.

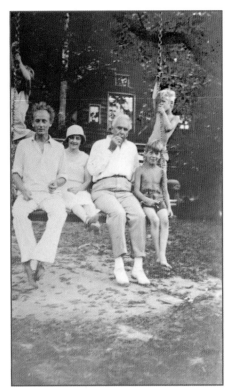

Catalog no. 26.
"Wharton Esherick, unidentified woman [probably Helen Richardson or Louise Campbell], Theodore Dreiser, and three unidentified children on swing in Paoli." Photograph in Esherick Family albums, late 1920s or early 1930s. Esherick Family Collection.

Esherick sculpted this centaur as an addition to the shop sign displayed outside the door of the Centaur Book Shop. (For years it was exposed to the elements, as one can easily see.) He inscribed it to Harold Trump Mason (1893-1983), owner and proprietor of the Centaur Book Shop and Press. Mason had taken the name for the bookshop from a line in James Branch Cabell's novel *Jurgen*—"'Up on my back,' said the Centaur, 'and I will take you thither.'"

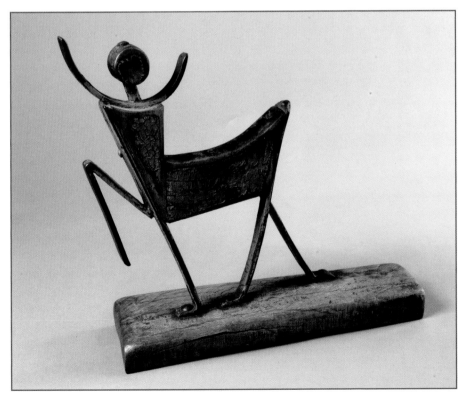

Catalog no. 27.
Wharton Esherick.
Centaur.
Iron and Walnut, 1924.
Inscribed "W.E. to H.M. MCMXXIV."
Wharton Esherick Museum.
Photograph courtesy of James Mario.

Along with the works Esherick illustrated for Centaur Press, he also made linoleum cuts for Amory Hare's *Tristram and Iseult* and woodcuts for an edition of Walt Whitman's *As I Watched the Ploughman Ploughing.* This print was used in the Whitman book, its text set to music by Philip Dalmas. Printed in Philadelphia in 1928 by the Franklin Printing Company, the book appeared in a limited edition of 200 copies distributed by the Centaur Book Shop.

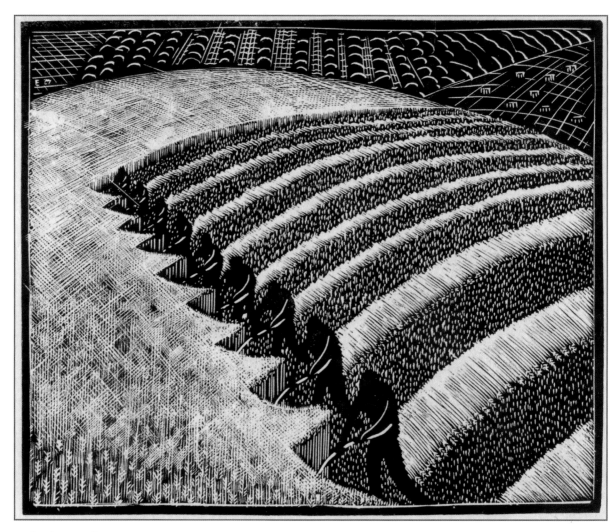

Catalog no. 28.
Wharton Esherick.
Harvesting.
Woodcut, 1927.
Wharton Esherick Museum.

Esherick and Amory Hare (maiden name and pen name for Mrs. James Pemberton Hutchinson) collaborated on *Tristram and Iseult*, a tale of potions and adulterous love published in a limited edition of 450 copies. Writing in the May 20, 1931, *Public Ledger*, Harry Emerson Wildes reviewed the work, declaring: "[f]ormat and design are beautiful in their loveliness and the Tristram legend, based primarily upon the Bedier version of the eleventh-century Beroul fragments, is couched in Amory Hare's loveliest style."

Catalog no. 29.
Amory Hare.
Tristram and Iseult: A Play by Amory Hare with Scenes by Wharton Esherick.
Gaylordsville, Connecticut: Slide Mountain Press, 1930.
Rare Book and Manuscript Library, University of Pennsylvania.

Catalog no. 30.
"Amory Hare."
Photograph, ca. 1931.
Courtesy of Kate Okie.

A Progressive Education

During the winter of 1919-20, Esherick, Letty, and their three-year old daughter Mary traveled to Fairhope, Alabama, on Mobile Bay, so that Letty could study progressive education at Marietta Johnson's School for Organic Education. Fairhope was founded as a single-tax colony based on the ideas of Henry George, who in *Progress and Poverty* argued that the cure to poverty and other social ills was to tax only the use-value of land, which would be owned collectively by the community. The trip turned out to be a learning experience for Esherick as well. At Fairhope, he met people who would come to play a significant role in his life, and the experience started him on a period of artistic experimentation that lasted throughout the 1920s and 1930s.

In Fairhope, Esherick began his close friendship with Sherwood Anderson (1876-1941), then forty-three years old. In 1912 Anderson had given up his family life and his position as president of the Anderson Manufacturing Company in Elyria, Ohio, to become a writer. His success with *Winesburg, Ohio* provided him the money and opportunity to quit his advertising job in Chicago and move to Fairhope. Esherick encouraged Anderson to paint and Anderson encouraged Esherick to write.

Florence King (Kinglet) and her daughter Dux were also in Fairhope at this time; Kinglet knew Anderson and typed his manuscripts. Her husband, Carl Zigrosser (1891-1975), who would later become Curator of Prints and Drawings at the Philadelphia Museum of Art, had just begun working as director of the newly established Weyhe Book Store and Gallery, one of the first galleries in New York City to specialize in prints, and did not join his wife and daughter in Fairhope, although Esherick did correspond with him during this time about printmaking and the work of Rockwell Kent.

Esherick met Mary Marcy (1877-1922), as well, at Fairhope. The managing editor of the *International Socialist Review*, she later asked him to illustrate her own *Rhymes of Early Jungle Folk*, a book of children's verse about evolution. Esherick carved his first woodblocks to illustrate Marcy's book. Sadly, Marcy committed suicide shortly before the book was published. Esherick carved a block in her honor that was used on her memorial booklet.

Esherick returned to Fairhope for a second time in 1929-30 under much more difficult circumstances. Letty, having contracted encephalitis a year earlier, had returned to Alabama to convalesce. Esherick stayed with her for a while and also spent time with the potter Peter McAdam in nearby Daphne, Alabama, making ceramic sculpture.

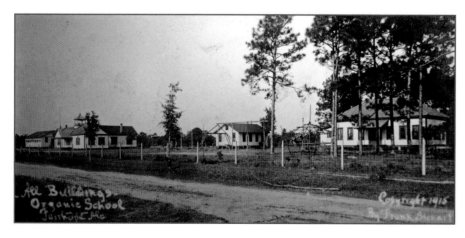

Catalog no. 31.
Frank Stewart.
"All buildings–Organic School, Fairhope, Ala."
Photographic postcard in Esherick Family albums, 1915.
Esherick Family Collection.

Johnson opened the School for Organic Education as a place for children to learn through play and where learning would be staged appropriately to the development of the child. She taught both children and teachers. Letty wanted to learn Johnson's methods in hopes of opening an organic school at the farm in Paoli. Johnson convinced Esherick to teach art at her school, giving him his first carving tools, which he used to carve frames for an exhibition of his paintings at the school.

Catalog no. 32.
"Marietta Johnson (far right), founder of the Organic School in Fairhope, with unidentified women."
Photograph in Esherick Family albums, ca. 1920.
Esherick Family Collection.

Catalog no. 33.
Marietta Johnson.
The Fairhope Idea in Education.
New York: Fairhope Educational Foundation, 1926.
Rare Book and Manuscript Library, University of Pennsylvania.

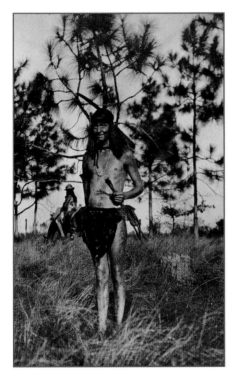

Fairhope was, and still is, the oldest and largest single-tax colony in America. A utopian socialist experiment, it attracted writers, artists, educators, and other progressive types. Plays and pageants, a popular communal dramatic form in the first half of the twentieth century, were a frequent part of life in Fairhope.

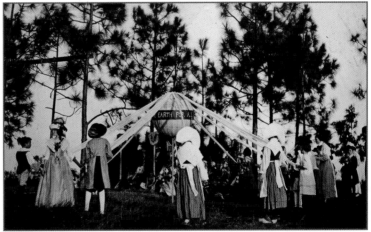

Catalog no. 34.
"Wharton Esherick in costume at Fairhope, Alabama."
Photograph in Esherick Family albums, ca. 1920.
Esherick Family Collection.

Catalog no. 35.
"Children's performance at the School for Organic Education's 'One Earth For All' pageant."
Photograph in Esherick Family albums, ca. 1920.
Esherick Family Collection.

The writer Sherwood Anderson first visited Fairhope at a friend's request to speak with Ann Mitchell, who was there to paint. That visit made him decide to live there. In his *Memoirs*, he called it "a fantastic world. There was Wharton Esherick who at once became my friend, and Ann, both painters; there was Wharton's wife Letty, very dark, very beautiful and presently another, Florence King (we called her the Kinglet), the wife of Carl Zigrosser, who would do my typing for me."

Catalog no. 36.
Sherwood Anderson.
Sherwood Anderson's Memoirs.
New York: Harcourt, Brace, 1942.
Rare Book and Manuscript Library,
 University of Pennsylvania.

Esherick was appalled by the racial segregation he witnessed in the south. After beginning to teach at Marietta Johnson's school, he also started teaching drawing at the "Negro" school. Local residents warned him not to do this—or at least to hide the fact that he was doing it—but he caused further problems by inviting his black students to the white school to see an exhibition of his paintings. This watercolor, inscribed "Melancholy Jones," is one of several portraits he made of African-American residents from the area.

Catalog no. 37.
Wharton Esherick.
The Mobile Roustabout.
Watercolor, 1920.
Esherick Family Collection.

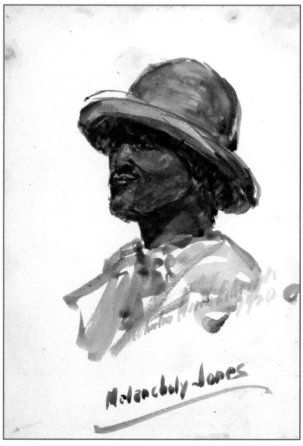

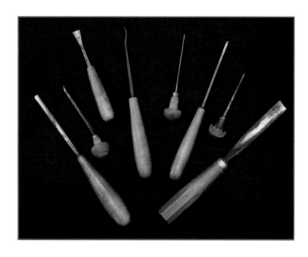

Catalog no. 38.
Gouges for carving.
Wood and metal, various dates.
Wharton Esherick Museum.

The young Esherick planned to become an illustrator as a way to earn a living while working as an artist. Although he did not pursue that path, he returned to look at work by illustrators whom he had admired when, in 1920, he began to contemplate illustrating Mary Marcy's *Rhymes of Early Jungle Folk.* Esherick had written to Carl Zigrosser, asking him to send him a copy of Rockwell Kent's *Wilderness* and to recommend a collection of Aubrey Beardsley's work to him. In this letter, which concerns costuming for school folk dances, Esherick declares that Kent "has done what is certainly needed in art, he has opened the window & let the fresh air, healthy air blow in."

Catalog no. 39.
Wharton Esherick.
Autograph letter to Carl Zigrosser.
Fairhope, Alabama, April 22, 1920.
Carl Zigrosser Papers, Rare Book and Manuscript Library,
 University of Pennsylvania.

Catalog no. 40.
Rockwell Kent.
*Wilderness: A Journal of Quiet Adventure
in Alaska.*
New York: G. P. Putnam's Sons, 1920.
Wharton Esherick Museum.

The illustrations for *Rhymes of Early Jungle Folk* were Esherick's first attempts at woodcut prints. His carving technique was cruder than it would later become, but his images already display both power and whimsy and capture the essence of an animal or scene in relatively few strokes.

Catalog no. 41.
Mary E. Marcy.
Rhymes of Early Jungle Folk.
 Woodcuts by Wharton H.
 Esherick.
Chicago: Charles H. Kerr, 1922.
Mark Sfirri Collection.

Catalog nos. 42-47.
Wharton Esherick.
The Cock, The Sabertooth, and
 The Camel, from Rhymes of
 Early Jungle Folk.
Three woodblocks and
 woodcuts, 1922.
Wharton Esherick Museum.

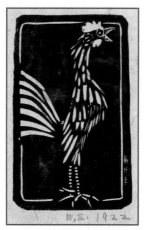

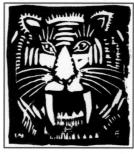

Rhymes of Early Jungle Folk

Kerr & Co. Chicago, $2.00

Profusely and handsomely illustrated, Mary E. Marcy's "Rhymes of Early Jungle Folk" is a good piece of work. Wharton Esherick's seventy one wood cuts are of a very high average quality. Some of them are mighty good. Nearly all are interesting, with but a very few somewhat crude in drawing. As works of art, these illustrations are so far beyond any we have ever seen in a book of this kind as to be in a class by themselves.

The frontispiece and the title page are admirable. The same fine feeling for design is to be found in the examples on pages 18, 33, 62, 99, 108 and 120. Many of them have an attractive whimsicality about them, such as the elephants on page 41. I would like also to mention the four small cuts of animals on pages 24 and 25, the hands on pages 70 and 71 and the leopard at the bottom of page 83.

If there is anything more *alive* than these in modern illustration I should like very much to see it.

Mrs. Marcy starts out with a rhyme on the origin of our planet (beg pardon, *our masters' planet*, on which we are allowed to live and labor). The appearance of life in the seas and its emergence therefrom to inhabit the coastal marches is very ably suggested. The geological eras following with their corresponding eras of biological development are passed over very rapidly. From the appearance of pithecanthropus erectus through the time of the great glaciers is very interestingly but briefly told. It is a pity that Mrs. Marcy did not live to give us a volume covering this theme more fully.

The fact of *process* is the most powerful single argument that science has given the revolution. The bright thread of *development* is fascinating, shining through the worlds' life history, that it is a wonder any author can resist following it. Mrs. Marcy gives two pages on the conditions following the recession of the ice cap.

The evolutionary theme is dropped here and the rest of the volume is mainly concerned with sketches of cave and jungle folk life. Most of the poetical explanations of primitive descoveries and inventions are very good indeed. A convincing explanation of the discovery of the mechanical principle of the bow and arrow and its use would have been very interesting.

We must take exception to the explanation that the elephant's trunk developed by *stretching* for young blooms and nuts. The reviewer was of the opinion that Bernard Shaw alone any longer held to this doctrine. Then there is that one about the goat. The rhyme would be appropriate to a capitalist-press funny sheet. But the statement that the goat lives on old clothes, wooden-spoons, hose etc., is out of place in a book of educational nature.

There is on the whole much to praise in this last work from the pen of Mary Marcy. It is a worthy work to round out a really fine and useful career. It is to be hoped that Kerr and Company will find it possible to issue this volume eventually in a cheaper form, so that it may reach the widest possible circle of readers.
 —*Breit.*

Catalog no. 48.
"Breit" [pen name for Milton Breitmayer].
Review of *Rhymes of Early Jungle Folk,* in
 The Proletarian, 6:3 (March 1923).
Mark Sfirri Collection.

Esherick made this woodcut, in the style of his illustrations for *Rhymes of Early Jungle Folk*, for the cover of a memorial pamphlet for Mary Marcy, who committed suicide at the age of forty-five. Writing in 1923, Esherick said: "Mary was a woman with a fine soul and willing to work and the socialist movement recognized and dragged her in. I wish her seed had fallen on artistic ground instead of political, her strength of conviction, her playful philosophy would have created much, much more. ... Underneath her word in her letters to me I find crying, reaching for a flower, a butterfly, a bird to toy with. How we did play in our letters. It was business, but we played together, had fun."

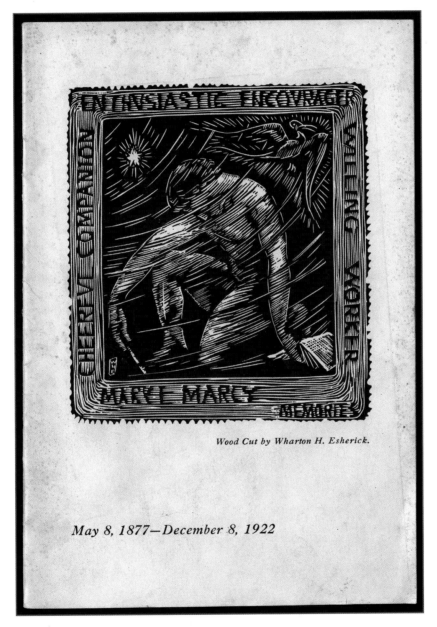

Catalog no. 49.
Mary E. Marcy—Memories.
Wood engraving, cover illustration for
 Mary E. Marcy—Memories, 1922.
Wharton Esherick Museum.

Esherick played an active role in the Fairhope community as well as in Marietta Johnson's school, carving, for example, these bookplates for the library. The three bookplates show him playing with the design, making it increasingly abstract.

Catalog nos. 50-52.
Wharton Esherick.
Ex Libris—Fairhope Public Library.
Three woodcuts, 1929-1930.
Wharton Esherick Museum.
Mark Sfirri Collection.

Together with Peter McAdams, a potter. Esherick made a number of whimsical pieces of garden statuary, including *Monkey*.

Catalog no. 54.
Wharton Esherick.
Monkey.
Resin cast of ceramic original, 1930.
Wharton Esherick Museum.

Daphne Pier, the subject of this woodcut, is located in Mobile Bay. Esherick's second trip to Fairhope in 1929-30 led to this engraving, as well as to the Alabama Tree series.

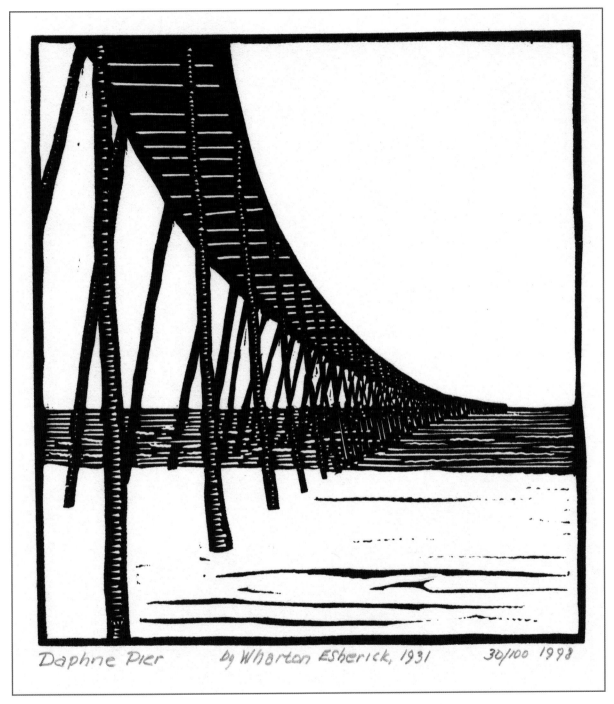

Daphne Pier by Wharton Esherick, 1931 30/100 1998

Catalog no. 53.
Wharton Esherick.
Daphne Pier.
Wood engraving, 1931.
Wharton Esherick Museum.

Alabama Tree Prints

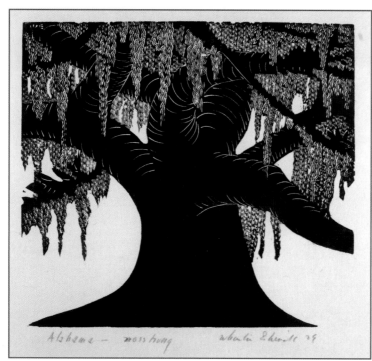

Catalog no. 55.
Wharton Esherick.
Alabama—Moss Hung.
Wood engraving, 1929.
Wharton Esherick Museum.

Catalog no. 56.
Wharton Esherick.
Alabama—Pine.
Wood engraving, 1929.
Wharton Esherick Museum.

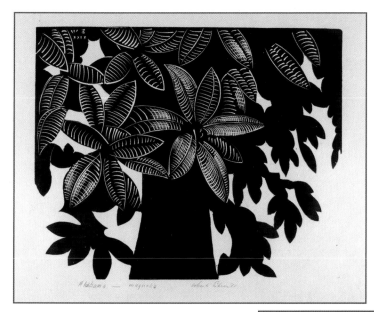

Catalog no. 57.
Wharton Esherick.
Alabama Magnolia.
Wood engraving, 1929.
Wharton Esherick Museum.

Catalog no. 58.
Wharton Esherick.
Alabama Columns.
Woodcut, 1929.
Wharton Esherick Museum.

Catalog no. 59.
Wharton Esherick.
Alabama—Live Oak.
Wood engraving, 1929.
Wharton Esherick Museum.

Exploring the Book Arts

On October 1, 1921, the Centaur Book Shop officially opened its doors at 1224 Chancellor Street, Philadelphia. A little street somewhat off the beaten path, Chancellor is close to the city's business district. Centaur was the brainchild of Harold Trump Mason. In 1959, he told historian of Philadelphia John Marion, "[i]t was my idea of what a career ought to be." Centaur focused on modern literature: first editions, limited editions, fine printing, and signed copies, as well as assorted literary and philosophical magazines and, in the 1930s, even phonograph records. But its stock was only one side of Centaur, which was also known as an after-hours gathering spot, something between a club and a salon, for a number of well-known figures in Philadelphia and the region's arts and letters world, among them Christopher Morley, Bennett Cerf, and Wharton Esherick. There they could stop in, have a drink or two (this was the era of Prohibition, after all), and talk.

Not content simply to be a book shop and watering hole for avant-garde artists and writers, Centaur had larger aspirations. Its catalogues, advertised in *The New York Times*, included works by Sherwood Anderson, Theodore Dreiser, D.H. Lawrence, and H.L. Mencken, among others. By 1922, Mason and one of his partners, David Jester, Jr., who helped run the shop, began publishing bibliographies of contemporary writers. By 1928, *The Centaur Bibliographies of Modern Authors* would include, for instance, a bibliography of Theodore Dreiser. The Centaur Press also published Anderson's *No Swank* in 1934 and distributed *Thwarted Ambitions*, by Anderson's son Robert ("Bob"), with contributions by Anderson and Esherick.

Many of the books and ephemeral items produced by the Centaur Book Shop and Press, including catalogues and prospectuses as well as letterhead and order forms, show Mason's interest in fine printing. No wonder Esherick himself, given his own appreciation of fine work, became involved with Centaur. Esherick illustrated several Centaur Press publications. For Walt Whitman's *Song of the Broad-Axe* (1924), Centaur's first publication, Esherick provided twelve woodcuts. He created the woodcut porcupine for D.H. Lawrence's *Reflections on the Death of a Porcupine and Other Essays* (1925), which Centaur convinced Lawrence to let them publish, much to the chagrin of Lawrence's new American publisher, Alfred Knopf. Esherick would go on to illustrate A.E. Coppard's *Yokohama Garland and Other Poems* (1926) and *The Song of Solomon* (1927). In 1934, he illustrated the broadside *Turkey Gobbler Land* for the poet Thomas Caldecot Chubb, one of Mason's clients.

In fact, over time Esherick developed many different and varied associations with Centaur, much as he did with Hedgerow Theatre. He drew pages and pages of centaurs, more and less abstract, playing with the form over and over again. Woodblock prints of the shop's exterior; designs for boards and dust jackets for books; illustrated

Catalog no. 60.
"Harold Mason."
Photograph, early 1940s.
Centaur Book Shop and Press Archive,
Rare Book and Manuscript Library,
University of Pennsylvania.

title-pages and prospectuses; even the sign for the book shop ("a beautiful centaur with a wooden body and iron legs," according to Mason): all absorbed a great deal of Esherick's time and aesthetic attention.

Two prints shown here—one inscribed to Harold Mason—show Centaur at its original location, 1224 Chancellor Street. In 1924 the shop expanded into the small house next door. The photograph shows Centaur's interior at the same time Esherick was making the two prints. Above the mantelpiece can be seen the framed woodblocks that Esherick used to illustrate Whitman's *Song of the Broad-Axe*.

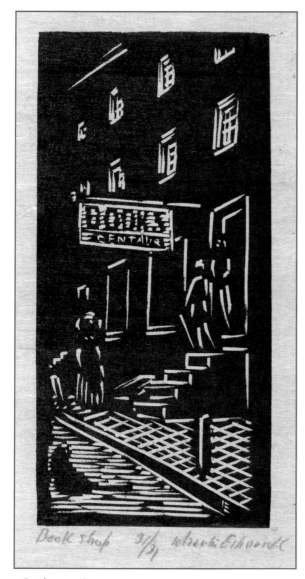

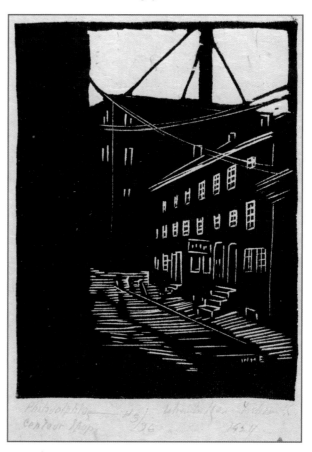

Catalog no. 62.
Wharton Esherick.
Philadelphia — Centaur Shop.
Wood engraving, 1925.
Wharton Esherick Museum

Catalog no. 61.
Wharton Esherick.
Book Shop.
Wood engraving, 1925.
Wharton Esherick Museum.

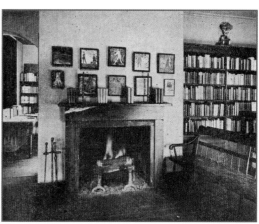

Catalog no. 63.
"Interior of Centaur Book Shop at 1224 Chancellor Street."
Photograph, in *The Publisher's Weekly*, 107:14 (April 4, 1925).
Centaur Book Shop and Press Archive, Rare Book and
Manuscript Library, University of Pennsylvania.

Esherick frequently played with the idea of the centaur in drawings, woodcuts, and sculptures during the early 1920s.

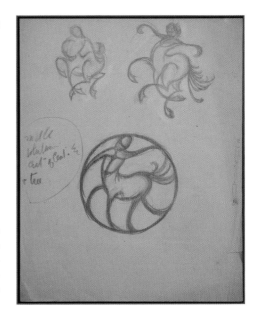

Catalog no. 64.
Wharton Esherick.
Sketches of Three Centaurs.
Pencil on paper, ca. 1923.
Wharton Esherick Museum.

Song of the Broad-Axe, the first book to appear over the Centaur Press imprint (as opposed to those books published under the name of the Centaur Book Shop), was very successful and quickly sold out. This copy of *Song of the Broad-Axe* was inscribed by Esherick to Theodore Dreiser in 1928.

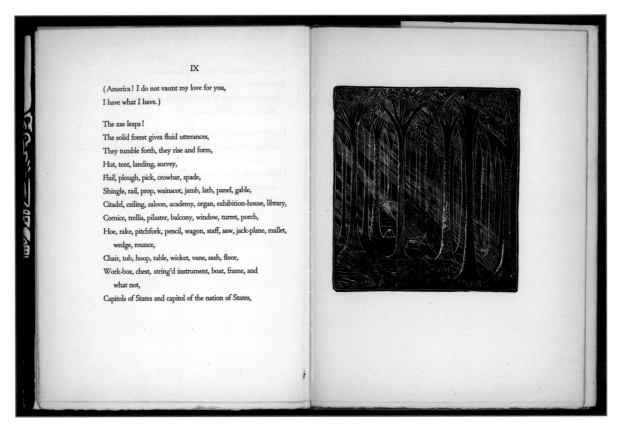

Catalog no. 65.
Walt Whitman.
Song of the Broad-Axe. With Illustrations Cut on Wood by Wharton H. Esherick.
Philadelphia: Centaur Press, 1924.
Rare Book and Manuscript Library, University of Pennsylvania.

Centaur's relationship with D.H. Lawrence began in 1924 when the Book Shop published Edward D. McDonald's bibliography of Lawrence in the *Centaur Bibliographies* series. At about the same time, Mason asked Lawrence to write a story about a centaur. Lawrence replied that he could not do so "in these white countries, where the lower half of man is an automobile, not a horse." Mason suggested instead publishing a book of essays. Esherick's woodcut porcupine was the only illustration associated with this work. Esherick's drawing of a porcupine may have been the precursor to his woodcut on the prospectus for Lawrence's *Reflections on the Death of a Porcupine*.

Catalog no. 66.
D. H. Lawrence.
Reflections on the Death of a Porcupine.
Philadelphia: Centaur Press, 1925.
Rare Book and Manuscript Library,
 University of Pennsylvania.

THE CENTAUR PRESS
announces for immediate publication
Reflections on the Death of a Porcupine and other Essays
BY D. H. LAWRENCE

NEARLY half the book is devoted to *The Crown*, a long and important philosophical essay. A portion of *The Crown* appeared originally in the pages of a comparatively little known magazine, *The Signature*, copies of which are practically unobtainable. The whole of *The Crown*, which E. M. Forster calls the finest of Lawrence's shorter pieces, is thus made available for the first time. The remaining essays, five in number, have not hitherto been printed.

The edition consists of 925 numbered copies, printed from type. The book contains 250 pages, and is bound in brilliant French boards. Each copy is individually boxed.

The price of this, the second book of *The Centaur Press*, is four dollars a copy.

1224 Chancellor Street ⸱ Philadelphia

Catalog no. 67.
Wharton Esherick.
Porcupine.
Woodcut, illustration for prospectus to D. H.
 Lawrence, *Reflections on the Death of a Porcupine
 and other Essays*, ca. 1925.
Wharton Esherick Museum.

Catalog no. 68.
Wharton Esherick.
Porcupine.
Ink on paper, ca. 1925.
Centaur Book Shop and Press Archive, Rare Book and
 Manuscript Library, University of Pennsylvania.

This work, with woodcuts by Esherick, was published in an edition of 525 copies signed by the artist and printed by Elmer Adler's Pynson Printers of New York. Mason considered it Esherick's most interesting book. Bennett Cerf took over distribution, and the edition quickly sold out.

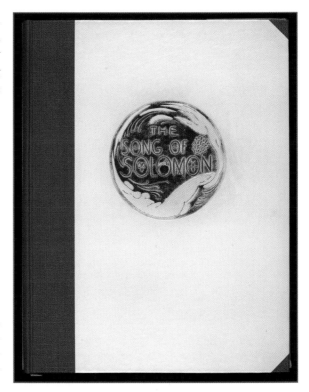

Catalog no. 69.
The Song of Solomon.
Philadelphia: Centaur Press, 1927.
Rare Book and Manuscript Library,
University of Pennsylvania.

Early in 1933, Centaur moved to 206 South Juniper, partly because the only heat at the old location had come from fireplaces. Centaur would stay at the South Juniper location until the shop closed its doors permanently in 1942. Mason recalled Esherick as "a member of the Safari that moved the contents of the Centaur Book Shop from our first miserable little place in the Chancellor St. alley just below Walnut to the Library Company on Juniper St. [actually a building owned by the Library Company at this address, now a parking garage], and a very lovely place it was. ... [T]he move over was fun because we all pitched in, and I can remember Wharton very well doing the yeoman job of moving books and pictures and everything else in the world."

Catalog no. 70.
Milton R. Holmes.
"Exterior of the Centaur Book Shop
 at 206 South Juniper Street."
Photograph, 1930s.
Centaur Book Shop and Press
 Archive, Rare Book and
 Manuscript Library, University of
 Pennsylvania.

Esherick helped Anderson prepare this book for publication while visiting him in Virginia during the summer of 1934. Anderson has short pieces on Theodore Dreiser and Jasper Deeter in this work.

Catalog no. 71.
Sherwood Anderson.
No Swank.
Philadelphia: Centaur Press, 1934.
Rare Book and Manuscript Library,
 University of Pennsylvania.

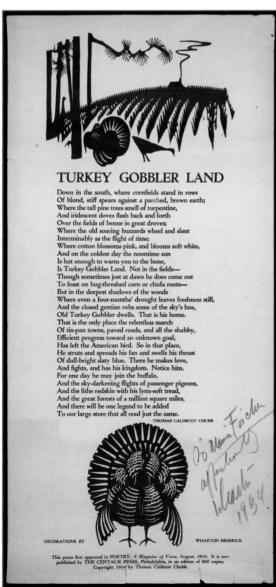

Catalog no. 72.
Harold E. Mason.
Autograph letter to Wharton Esherick.
Philadelphia, November 10, 1934.
Wharton Esherick Museum.

This letter (above), showing the Centaur Press letterhead, concerns the *Turkey Gobbler Land* broadside (left) for which Esherick made the woodcuts.

Catalog no. 73.
Wharton Esherick.
Turkey and *Turkey Gobbler Land.*
Two wood engravings, illustrations for Thomas
 Caldecot Chubb, *Turkey Gobbler Land*
 (Philadelphia: Centaur Press, 1934).
Wharton Esherick Museum.

Song of the Broad-Axe

Esherick's work on Mary Marcy's *Rhymes of Early Jungle Folk* impressed Mason, who asked him to illustrate Walt Whitman's poem, *Song of the Broad-Axe,* as the first publication of the Centaur Press. Esherick, long a fan of Whitman's poetry, liked the idea: the themes of *Broad-Axe,* which include a celebration of the individual and of physical labor, spoke to Esherick's world-view and the path in life that he had chosen.

Esherick's twelve woodcuts for the poem display not only his stylistic range but also his sympathetic emotional resonance with Whitman's poem. In *The Liquor Bar,* a demoralized desolation recalls an Edward Hopper painting, while *The Hell of War* uses a classical motif to show the chaos and destruction of war. Lighting effects reminiscent of the Baroque style are employed in *The Forger at his Forge,* who is illuminated by the glow of his forge. The dust jacket illustration, *Welcome Are All Earth's Lands,* borrows techniques commonly associated with Art Nouveau or Jungendstil. The technical skills are varied and formidable; each illustration, however, feels perfectly appropriate to Whitman's work.

Catalog no. 74.
Walt Whitman.
Song of the Broad-Axe.
Philadelphia: Centaur Press, 1924.
Rare Book and Manuscript Library,
 University of Pennsylvania.

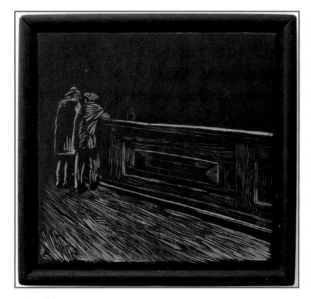

Catalog no. 75.
Wharton Esherick.
The Liquor Bar.
Woodblock, illustration from
 Song of the Broad-Axe, 1924.
Wharton Esherick Museum.

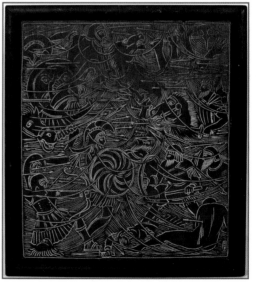

Catalog no. 76.
Wharton Esherick.
The Hell of War.
Woodblock, illustration from
 Song of the Broad-Axe, 1924.
Wharton Esherick Museum.

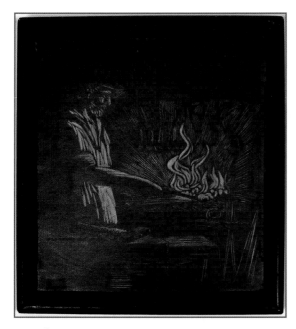

Catalog no. 77.
Wharton Esherick.
The Forger at His Forge — Furnace.
Woodblock, illustration from *Song of the Broad-Axe*, 1924.
Wharton Esherick Museum.

Catalog no. 78.
Wharton Esherick.
Welcome Are All Earth's Lands.
Woodcut, illustration for dust jacket of *Song of the Broad-Axe*, 1924.
Rare Book and Manuscript Library, University of Pennsylvania.

Esherick's woodcuts of trees were scattered throughout Wharton's prototype of *Broad-Axe*, but Centaur's designer put them together for the cover illustration.

Catalog nos. 79-82.
Wharton Esherick.
Wind in the Willows, Tree With Birds, Gnarled Tree, and *Title Medallion* .
Four woodblocks, cover illustrations from *Song of the Broad-Axe*, 1924.
Wharton Esherick Museum.

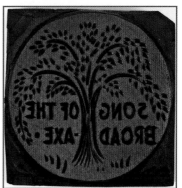

Centaur Sketches

Esherick explored many different styles and ideas as he worked to create a centaur logo for the Centaur Press, as can be seen in the sketches in this drawer. Clearly intrigued with the concept's possibilities, he later produced a number of sculptures of centaurs.

Catalog no. 83.
Centaur Press Logo.
Woodcut, illustration for prospectus for *Song of the Broad-Axe*, 1924.
Wharton Esherick Museum.

Catalog no. 84.
Wharton Esherick.
Sketches of Thirteen Centaurs.
Pencil on paper, ca. 1923.
Wharton Esherick Museum.

Catalog no. 85.
Wharton Esherick.
*Sketches of Four
 Centaurs.*
Ink on paper, ca. 1923.
Wharton Esherick
 Museum.

Catalog no. 86.
Wharton Esherick.
*Sketches of Four
 Centaurs.*
Pencil and ink on
 paper, ca. 1923.
Wharton Esherick
 Museum.

Catalog no. 87.
Wharton Esherick.
Sketches of Three Centaurs.
Pencil on paper, ca. 1923.
Wharton Esherick Museum.

Catalog no. 88.
Wharton Esherick.
Sketches of Six Centaurs.
Pencil on paper, ca. 1923.
Wharton Esherick Museum.

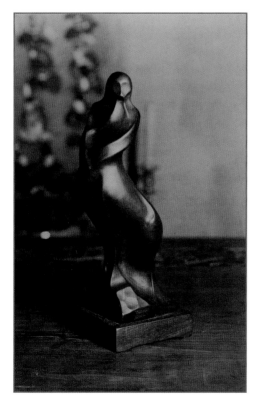

This photograph was taken by Esherick's friend from his days at Victor Talking Machine Company.

Catalog no. 89.
Harry Attmore, photographer.
"Wharton Esherick's *Centaur.*"
Photograph, 1925.
Esherick Family Collection

The Song of Solomon

The Song of Solomon is Esherick's largest project for the Centaur Press. Thirty-one blocks emphasizing the erotic content of the Biblical verses illustrate the *Song*. Esherick originally made three hand-bound copies of the book in 1924. When Elmer Adler printed Centaur's edition of this work, he imitated Esherick's exemplars as faithfully as possible. *On My Bed* shows the evolution of one of Esherick's designs for *The Song of Solomon* from sketch to block to Esherick's 1924 version of the book. For unknown reasons, a more erotic block, *By Night Upon My Bed*, was substituted for use in the printed edition.

Catalog no. 90.
Wharton Esherick.
On My Bed.
Pencil on paper, from sketchbook for *The Song of Solomon*, ca. 1924.
Wharton Esherick Museum.

Catalog no. 91.
Wharton Esherick.
On My Bed.
Woodblock, ca. 1924.
Wharton Esherick Museum.

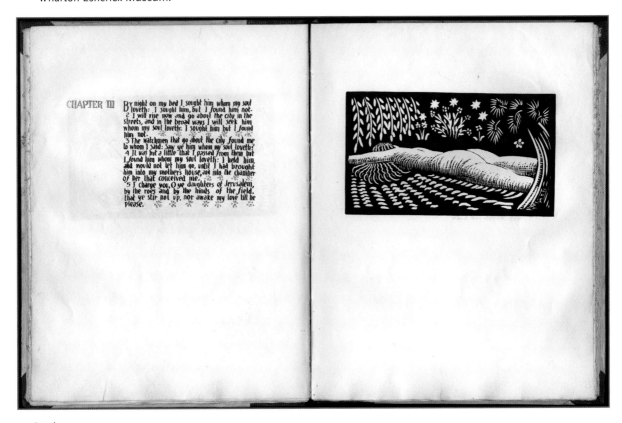

Catalog no. 92.
Wharton Esherick.
On My Bed.
Wood engraving, from original version of *The Song of Solomon*, 1924.
Wharton Esherick Museum.

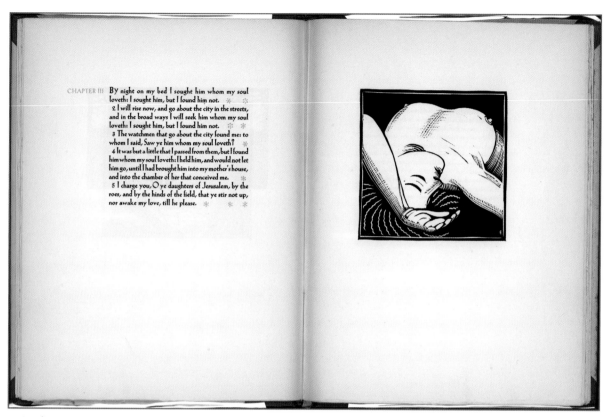

CHAPTER III: By night on my bed I sought him whom my soul
loveth: I sought him, but I found him not. ✳ ✳
2 I will rise now, and go about the city in the streets,
and in the broad ways I will seek him whom my soul
loveth: I sought him, but I found him not. ✳ ✳ ✳
3 The watchmen that go about the city found me: to
whom I said, Saw ye him whom my soul loveth?
4 It was but a little that I passed from them, but I found
him whom my soul loveth: I held him, and would not let
him go, until I had brought him into my mother's house,
and into the chamber of her that conceived me. ✳
5 I charge you, O ye daughters of Jerusalem, by the
roes, and by the hinds of the field, that ye stir not up,
nor awake my love, till he please. ✳ ✳ ✳

Catalog no. 93.
Wharton Esherick.
By Night On My Bed.
Woodcut, from *The Song of Solomon*, 1927.
Wharton Esherick Museum.

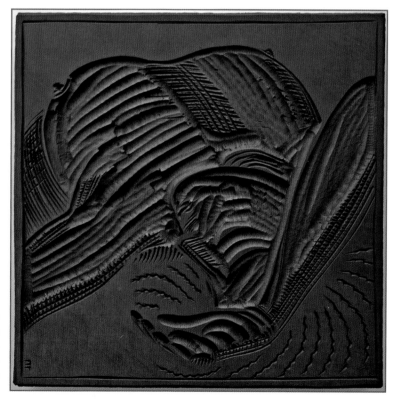

Catalog no. 94.
Wharton Esherick.
By Night On My Bed.
Woodblock, ca. 1924.
Wharton Esherick Museum.

Rhythm & Dance

The Eshericks were introduced to Adirondacks dance camps by Anderson and his second wife, Tennessee, who had been married at a camp on Lake Chateaugay in New York State in 1916. Beginning in 1920 and continuing for many years, the Esherick family spent summers in the Adirondacks at dance camps founded by Gail Gardner, an American contralto, and Ruth Doing, an Irish dancer. Gardner and Doing taught rhythmic dance, a style loosely derived from the system of eurhythmics developed by the French-Swiss musician and educator Emile Jaques-Dalcroze (1865-1950). Louise Bybee, a pianist, also worked at the camp. She was an Anthroposophist, that is, a follower of the Austro-Hungarian philosopher Rudolf Steiner (1861-1925). Steiner's eurythmy, or "visible speech and music," conceptually different from Dalcroze's eurhythmics, fit well with Gardner and Doing's broader interest in Modern dance. Bybee presented readings of Steiner's printed lectures at the camp and probably introduced eurythmy there as well.

Gardner and Doing, who opened their first camp in 1916 on Lake Chateaugay, moved to nearby St. Regis Lake in 1925. Both camps allowed students to create dances based on subjects they were studying, as well as to write their own music, weave, dye batik fabrics, and construct their own costumes and sets. The camps also strongly emphasized exercise, healthy living, and vegetarian diets.

Esherick sketched and painted the Adirondacks landscape, the camp activities, and—most importantly—the dancers. His Adirondacks sketchbooks are full of quick figure drawings that capture the energy, gesture, and diaphanous drapery worn by some of the dancers. Here Esherick began to experiment with various projects in wood. In 1923 he designed a large oak trestle table and embellished its top with relief carvings based on small abstract designs that he and a number of students created while listening to and responding to music. In later years he designed other trestle tables and created sculpture at the camp. Ideas related to dance and music continued to appear in Esherick's work throughout his career.

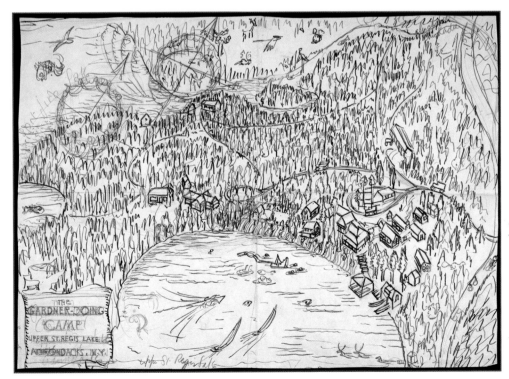

Catalog no. 95.
Wharton Esherick.
The Gardner Doing Camp, Upper St. Regis Lake, Adirondacks, N.Y.
Pencil and ink on paper, ca. 1929.
Wharton Esherick Museum.

Catalog no. 97.
"Olga Mendoza, Ruth Doing, and Gail
 Gardner at the dance camp."
Photograph in Esherick Family albums,
 1920s or 1930s.
Esherick Family Collection.

Catalog no. 96.
"Ruth Doing Camp."
Photograph in Esherick Family albums,
 1920s or 1930s.
Esherick Family Collection.

Esherick carved *Dance Finale* in 1933 from two pine logs at the Gardner-Doing Dance Camp on Lake St. Regis.

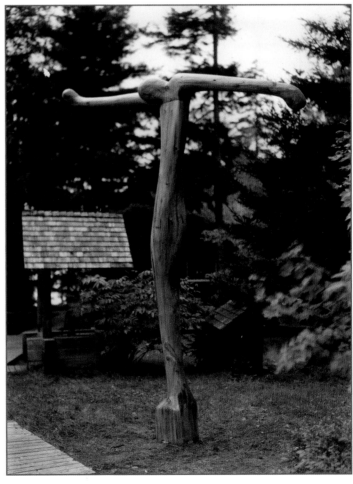

Catalog no. 98.
"*Dance Finale*."
Photograph, ca. 1933.
Esherick Family Collection.

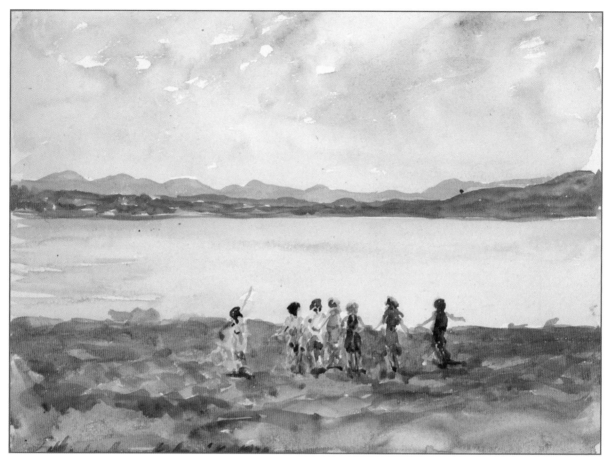

Catalog no. 99.
Wharton Esherick.
Dancers by the Lake.
Watercolor, early 1920s.
Esherick Family Collection.

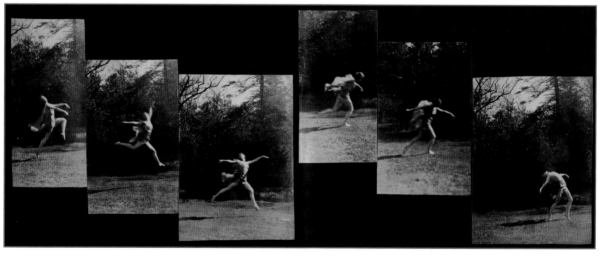

Catalog no. 100.
"Dancers."
Six photographs, opening in one of the Esherick
 Family albums, early 1920s.
Esherick Family Collection.

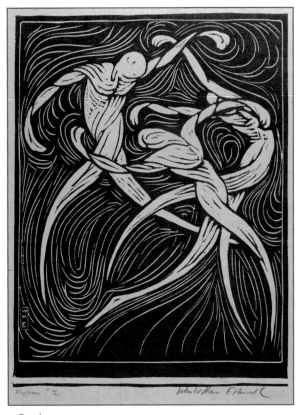

Catalog no. 101.
Wharton Esherick.
Rhythms—Opening.
Woodcut, ca. 1922.
Wharton Esherick Museum.

Catalog no. 102.
Wharton Esherick
Rhythms.
Woodcut, 1922.
Wharton Esherick Museum.

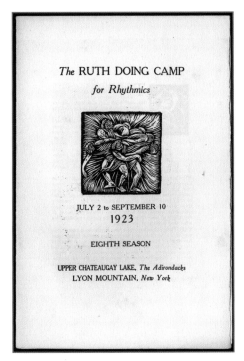

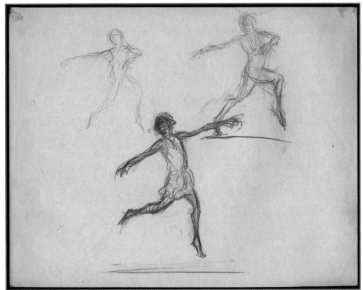

Catalog no. 103.
Wharton Esherick.
Rhythms—Opening.
Woodcut, cover illustration for *The Ruth Doing Camp for Rhythmics, July 2 - September 10, 1923, Eighth Season.*
Wharton Esherick Museum.

Catalog no. 104.
Wharton Esherick.
Sketches of Three Dancers.
Pencil on paper, ca. 1929.
Wharton Esherick Museum.

Camp Life

In addition to dance, the Adirondacks dance camps encouraged adults and children to engage in a range of other activities, including singing, crafts, art, boating, canoeing, and berrying parties, all thought to contribute to a well-rounded life.

This photograph, taken in June 1917, shows Sherwood Anderson, Waldo Frank—like Anderson, a writer and member of the Alfred Stieglitz circle—and two women campers at Camp Owlyout.

Catalog no. 105.
Sue de Lorenzi, photographer.
"Sherwood Anderson (far right) and Waldo Frank at Chateaugay Lake, with two unidentified women."
Photograph, 1917.
Sherwood Anderson Archive Collection, Smyth-Bland Regional Library, Marion, Viriginia.

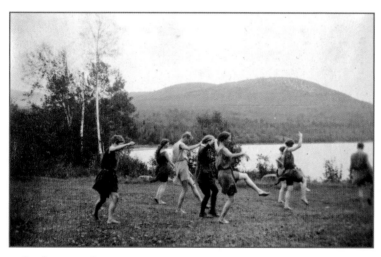

Catalog no. 106.
"Wharton Esherick and women dancing."
Photograph in Esherick Family albums, ca. 1920.
Esherick Family Collection.

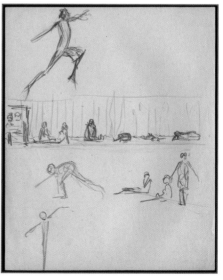

Catalog no. 107.
Wharton Esherick.
Sketch of Dancers.
Pencil on paper, 1920s or 1930s.
Wharton Esherick Museum.

In this two-page letter, Esherick writes Dreiser about Letty—in a sanitarium at this time recovering from encephalitis—as well as about having brought their children Ruth and Peter up to Ruth Doing's camp for the summer. He also mentions his plans to return to the camp with their daughter Mary in August, since Gail Gardner and Ruth Doing would like him to make something for them—"It may get me started on another trestle."

Catalog no. 108.
Wharton Esherick.
Autograph letter to Theodore Dreiser.
Paoli, Pennsylvania, July 17, 1929.
Theodore Dreiser Papers, Rare Book and Manuscript
 Library, University of Pennsylvania.

This sketch shows children eating at what was probably an Esherick table.

Catalog no. 109.
Wharton Esherick.
Dance Camp.
Crayon on paper, 1929.
Wharton Esherick Museum.

Dance Finale

Esherick carved *Dance Finale* at the Gardner-Doing camp in 1933. Thirteen feet tall, its arms spanned more than ten feet across. Originally titled *St. Se*, it was carved after Esherick had seen a dance performance of *St. Sebastian*, a piece which ended with the lead female dancer, as the martyred saint, in this pose. He renamed the piece *Dance Finale* after bringing it back to his studio in Paoli. Away from the camp, people kept mistaking it for a crucifix. The female figure with extended arms clearly appealed to Esherick, who sketched dozens of variations on this pose, and painted it as well. One of these, converted into a metal printing block, was used in a brochure advertising the camp.

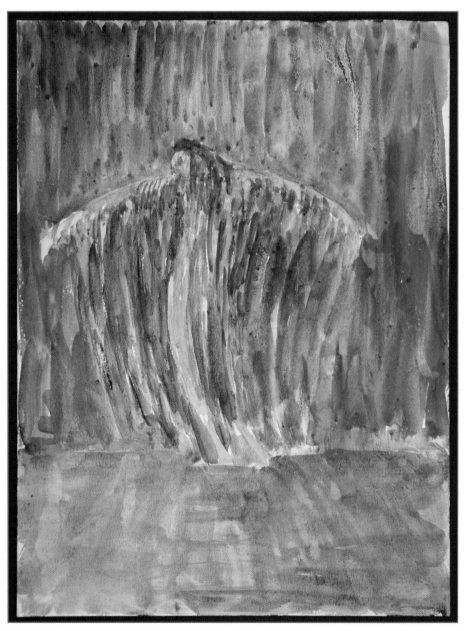

Catalog no. 110.
Wharton Esherick.
Painting of Dancer.
Watercolor, early 1920s.
Esherick Family Collection

Catalog no. 111.
Wharton Esherick.
Dance Finale.
Pencil on paper, ca. 1933
Wharton Esherick Museum.

Catalog no. 112.
Wharton Esherick.
Dance Finale.
Pencil on paper, ca. 1933.
Wharton Esherick Museum.

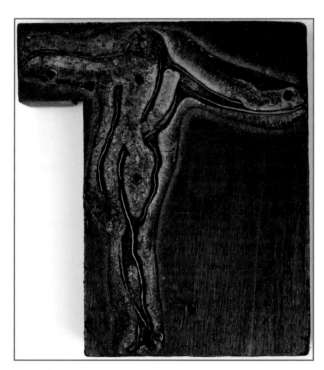

Catalog no. 113.
Wharton Esherick.
Dance Finale.
Metal printing block, early 1930s.
Wharton Esherick Museum.

An Absorbing Art Project Initiated at the Studio

Catalog no. 114.
"Wharton Esherick working on *Dance Finale*."
Photograph, in *The Gardner-Doing Camp for
 Children and Adults. Nineteenth Season*, 1935.
Wharton Esherick Museum.

Dance Sketches

The dance camp was heaven for a young artist, providing lots of models in motion. Esherick was constantly drawing, and his drawings, primarily quick abstract sketches, are attempts to capture the essence of movement in as few lines as possible. Occasionally he would fill out and develop a pose. Gail Gardner and Ruth Doing liked Esherick's work. For them, the abstract nature of his images matched the free-flowing gestures of their dances, and they often used his drawings and woodcuts to illustrate their camp brochures.

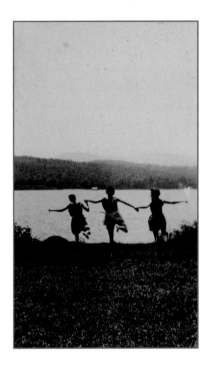
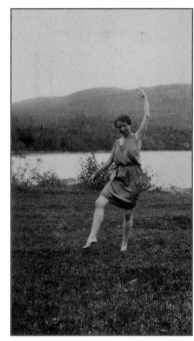

Catalog nos. 115 and 116.
"Women dancing."
Two photographs in Esherick Family
 albums, early 1920s.
Esherick Family Collection.

Notes on drawings such as this one are Esherick's comments to Gardner and Doing about the choice of illustrations for their brochures.

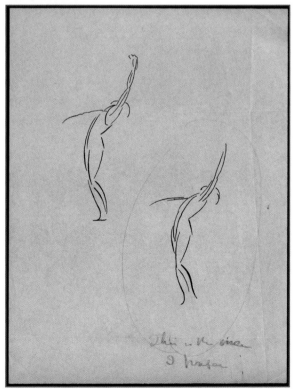

Catalog no. 117.
Wharton Esherick.
Sketches of Two Dancers.
Ink on paper, 1920s or 1930s.
Wharton Esherick Museum.

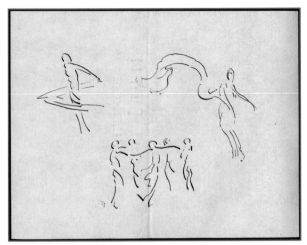

Catalog no. 118.
Wharton Esherick.
Sketches of Dancers.
Ink on paper, 1920s or 1930s.
Wharton Esherick Museum.

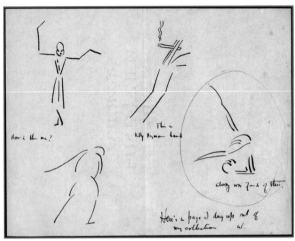

Catalog no. 119.
Wharton Esherick.
*Sketches of Three Dancers and Hand with
 Cigarette.*
Ink on paper, 1920s or 1930s.
Wharton Esherick Museum.

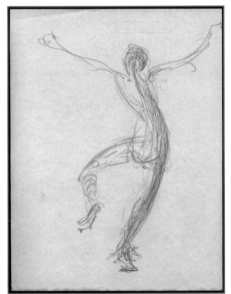

Catalog no. 120.
Wharton Esherick.
Sketch of Dancer.
Pencil on paper, 1920s or 1930s.
Wharton Esherick Museum.

Catalog nos. 121 and 122.
Wharton Esherick.
Dance illustrations for dance
 camp brochures.
Two metal printing blocks,
 1920s or 1930s.
Wharton Esherick Museum.

"Of a Great City"

Well before becoming friends with Theodore Dreiser, whom he met in 1924 and regularly visited when in New York City, Esherick recognized the importance of the New York art world. Not only did it accept and promote his work but his many friends and contacts there also enabled him to visit and keep abreast of current trends in that rapidly changing world. In 1913 he saw the "International Exhibition of Modern Art" at the 69th Infantry Regiment Armory, the landmark "Armory Show." One of Esherick's early venues for his prints was the Weyhe Book Store and Gallery, founded in 1919 and managed until 1940 by Carl Zigrosser, whose wife, Kinglet, Esherick and Letty had met in Fairhope. Esherick also exhibited his work at the American Designers' Gallery, founded in 1928 by Henry Varnum Poor, Ruth Reeves, and other artists who were blurring the boundary between art and craft, and at the Whitney Museum of American Art, where he exhibited at the First and Second Whitney Biennials.

One of Esherick's early important commissions was for the New York photographer Marjorie Content (1895-1984), whom he met in the late 1920s through Poor. Content was the friend of a number of other prominent photographers and artists, including Consuelo (Connie) Kanaga (1894-1978), Georgia O'Keeffe (1887-1986), and Alfred Stieglitz (1864-1946), who owned the influential "291" Gallery. Content had been the bookkeeper for The Sunwise Turn Bookshop, a New York bookstore staffed entirely by women. This venue had given her contacts with many major writers of the day, including Sherwood Anderson. In the spring of 1932, after moving into a brownstone at 39 West 10th Street in New York City, she ordered her first pieces of furniture from Esherick.

Less well known, but also an important influence on Esherick's artistic development, was the Threefold Commonwealth Group. Founded in New York City in November 1923 by a small group of Anthroposophists, including the pianist Louise Bybee, the Threefold Commonwealth Group hosted an exhibition of Wharton's block prints, together with a few of his watercolors and oil paintings in December 1923. Fritz Westhoff (1902-1980), a young South American-German engineer and artist who had joined the Threefold Commonwealth Group, began to make Anthroposophical furniture and interiors based on the forces of nature, the gradual metamorphosis of living organisms, and human needs (a style also described as "organic" or "spiritual" functionalism). Whether or not Westhoff and Esherick actually met is unclear. But Esherick certainly drew inspiration from Westhoff's unusual designs, which he saw at the Group's vegetarian restaurant and residential apartments.

Esherick displayed this piece at the Whitney Museum of American Art and the American Designer's Gallery before giving it to Dreiser in 1929.

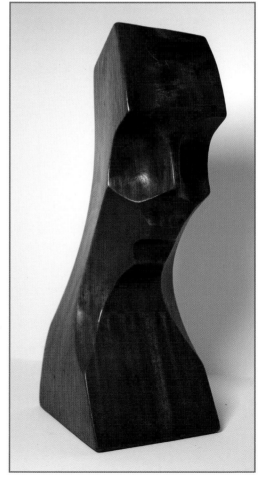

Catalog no. 124.
Wharton Esherick.
Head of Dreiser.
Mahogany, 1927.
Theodore Dreiser Papers, Rare Book and Manuscript
Library, University of Pennsylvania.

Esherick and Theodore Dreiser met in 1924, a year after Dreiser's *The Color of a Great City* (prose sketches of New York City) was published. One year later *An American Tragedy* appeared. The windfall from this best seller allowed Dreiser to move to the Rodin Studios at 200 West 57th Street, a luxurious Manhattan apartment building known for its double-height studios. Esherick made his remarkable print *Of a Great City* for Dreiser in 1928. The original drawing that served as the basis for the print was representational. In the woodblock it became a multi-perspectival view bringing the hustle and bustle of Seventh Avenue into the picture.

Catalog no. 125.
Wharton Esherick.
Dreiser's Studio.
Pencil on paper, ca. 1928.
Wharton Esherick Museum.

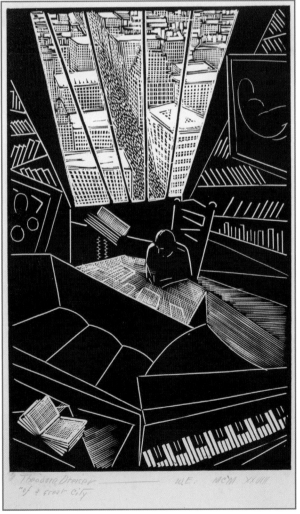

Catalog no. 126.
Wharton Esherick.
Of a Great City.
Wood engraving, 1928.
Theodore Dreiser Papers, Rare Book
and Manuscript Library, University
of Pennsylvania.

This brochure announces an April 1927 exhibition of twenty sculptures by Wharton Esherick at Weyhe Book Store and Gallery. Esherick met Henry Varnum Poor at Weyhe. On the announcement's front cover is Esherick's woodcut of Poor's tilework for the Gallery façade, on the back cover Esherick's humorous woodcut, *Chessmen at Play*.

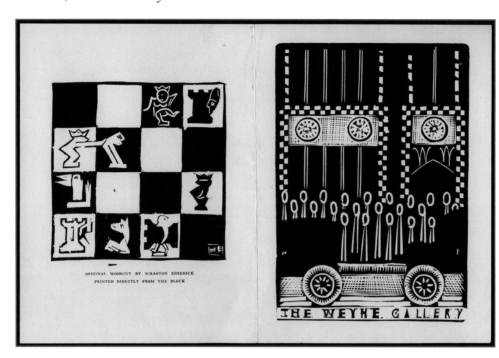

Catalog no. 127.
Chessmen at Play and *The Weyhe Gallery*.
Woodcut and wood engraving, illustrations for *Sculpture of Wharton Esherick*, April 11ᵗʰ to 30ᵗʰ, The Weyhe Gallery, 794 Lexington Avenue, New York, 1927.
Wharton Esherick Museum.

Esherick's good friend Henry Varnum Poor was a director of the American Designer's Gallery at 145 West 57ᵗʰ Street, located near Dreiser's apartment, the Threefold Restaurant, and Ruth Doing's Studio. During the gallery's short life, Esherick exhibited prints, furniture, and sculpture, including the portrait *Head of Dreiser*. Poor, known for his ceramics, is featured in this article in *Creative Art*, edited by Rockwell Kent.

Catalog no. 128.
Douglas Haskell. "The American Designers," in *Creative Art: A Magazine of Fine & Applied Art*, 3:6 (December 1928). Mark Sfirri Collection.

By 1929 the Threefold Commonwealth Group had reopened their popular vegetarian restaurant at 318 West 56th Street, its third venue. The basement of the building housed the Threefold Workshop where Fritz Westhoff designed furniture for the restaurant and for the residential apartments managed by the Group. Faceted edges, triangular forms, organic asymmetry, and tactile handles and pulls designed to accommodate the grasp of a human hand, were all features of his work.

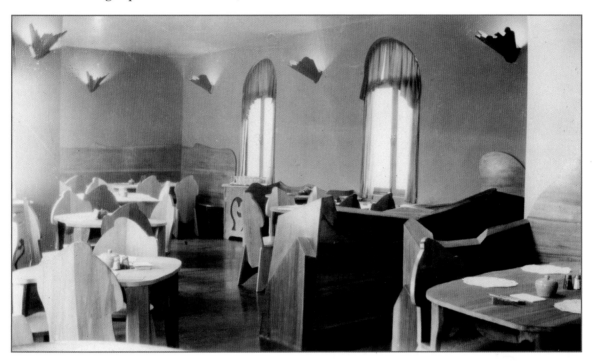

Catalog no. 129.
"Interior of Threefold Vegetarian Restaurant."
Photograph, ca. 1930.
Threefold Educational Center Collection.

Esherick's prints illustrate the front and back of this announcement for the seventeenth winter season of the Ruth Doing School, which migrated from the Adirondacks to New York City in the winter months. The School was located down the street from the Threefold Restaurant.

Catalog no. 130.
Wharton Esherick.
Spirit Inactive.
Woodcut, illustration for *The Ruth Doing School of Rhythmics*, 1932.
Wharton Esherick Museum.

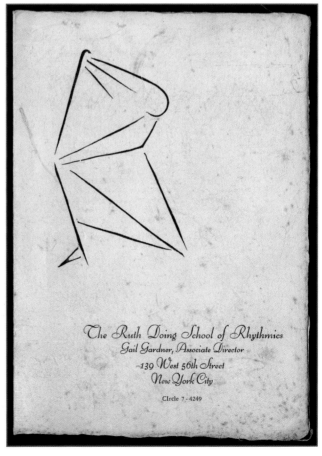

The Ruth Doing School of Rhythmics
Gail Gardner, Associate Director
139 West 56th Street
New York City

Circle 7 - 4249

In 1932, photographer Marjorie Content commissioned a number of pieces of furniture from Esherick. They came to constitute a bedroom suite that included the dressing table shown in this photograph. As Esherick called it "one of the biggest and most complete things I have done," and added, "[t]he new corner chest of drawers which also acts as a headboard to the bed I think is my best piece." Content was friends with Sherwood Anderson as well as the photographers Alfred Stieglitz and Consuela Kanaga, who would later become Esherick's client and good friend. In the letter to Dreiser, Esherick informs him that he left *Head of Dreiser* at Content's apartment and that Dreiser should pick it up from there.

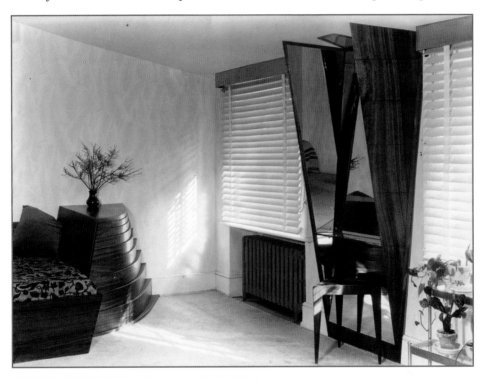

Catalog no. 131.
Marjorie Content, photographer.
"Marjorie Content's Apartment."
Photograph, ca. 1932.
Esherick Family Collection.

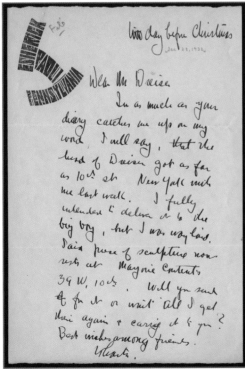

Catalog no. 132.
Wharton Esherick.
Autograph letter to Theodore Dreiser.
Paoli, Pennsylvania, December 23, [1932?].
Theodore Dreiser Papers, Rare Book and Manuscript Library, University of Pennsylvania.

Catalog no. 133.
Alfred Stieglitz.
"Sherwood Anderson."
Photograph, 1923.
W.A. Swanberg Papers, Rare Book and Manuscript Library, University of Pennsylvania.
© 2010 Georgia O'Keeffe Museum / Artists Rights Society (ARS), New York.

The Whitney Museum of American Art, then still located on 8th Street, was another place where Esherick showed his work. *Andante*, a stone sculpture carved while Esherick lived in Fairhope, was exhibited at the first Whitney Biennial. The second biennial exhibited the sculpture *Oblivion* and a pencil drawing. In this letter to Zigrosser, Esherick reports that the Whitney has bought two of his works: the sculpture *Gooslings*, of which he includes a sketch in the body of the letter, and a chess set, with box and board.

Catalog no. 134.
*First Biennial Exhibition of Contemporary
 American Sculpture, Watercolors, and Prints.*
New York: Whitney Museum of American Art,
 1934.
Wharton Esherick Museum.

Catalog no. 135.
Wharton Esherick.
Autograph letter to Carl Zigrosser.
Paoli, Pennsylvania, February 27, 1935.
Carl Zigrosser Papers, Rare Book and Manuscript
 Library, University of Pennsylvania.

Esherick sketched the English writer Ford Madox Ford (1873-1939) at a party in New York City in 1935. Esherick wrote of that meeting to Dreiser: "I enjoyed that evening didn't you? That big boy quietly placing food, forks & Dishes on the table while his pants were struggling not to fall off that belly." Ford and Janice Biala, his companion, had spent several weeks at Esherick's home in Paoli in 1934.

Catalog no. 136.
Wharton Esherick.
Ford Madox Ford 1935 N.Y.
Pencil on paper, 1935.
Wharton Esherick Museum.

Radical Crossroads

Mt. Kisco, New York

In the summer of 1927, Theodore Dreiser, having purchased thirty-five acres of land in Mount Kisco, New York, began to build a pseudo-Swedish country house of fieldstone and roughhewn planks and logs. Its windows were odd, irregular, trapezoidal shapes, and its lighting fixtures were designed by Henry Varnum Poor. The main house and guesthouse were connected by a bridge. Dreiser named the property "Iroki," said to be a Japanese word for Spirit of Color; its overall impression was highly whimsical and eccentric. It proved to be a fine retreat for Dreiser's many parties. According to Louise Campbell, Dreiser's longstanding friend and editor, Esherick designed a separate thatched-roof cabin and managed its construction while Dreiser was in Germany, and then Russia, in late 1927 and early 1928. For Dreiser's library at Iroki, Esherick designed a massive writing table out of padouk, a tropical wood, with a bold, faceted base, which he completed in 1928.

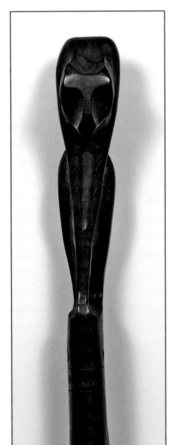

Among several pieces Esherick created for Dreiser was this attractive walking stick . A caricature of Dreiser as a cat poised with his back up, it bears Esherick's carved inscription: "To T.D. From W.E. MCMXXV."

Catalog no. 137.
Wharton Esherick.
Walking Stick for Theodore Dreiser.
Wood, 1925.
Theodore Dreiser Papers, Rare Book and Manuscript
 Library, University of Pennsylvania.

Dreiser used this table for writing. It is now part of the Theodore Dreiser Collection. Ralph Fabri, like Esherick, was involved in overseeing part of the construction of Iroki.

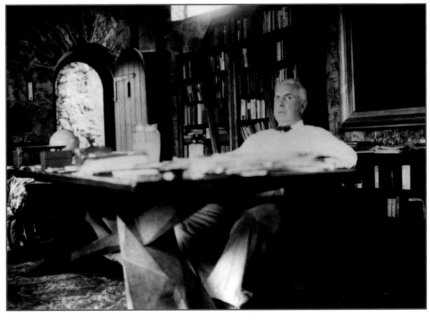

Catalog no. 138.
Ralph Fabri, photographer.
"Theodore Dreiser at Esherick
Table in Iroki Study."
Photograph, 1936.
Theodore Dreiser Papers, Rare
Book and Manuscript Library,
University of Pennsylvania.

The banter and humor characteristic of their relationship are evident in this letter from Esherick. Attempting to convince Dreiser to buy "that big table for the big room," he writes: "It belongs just there. I will sell it for $600.00, don't stop at the price as the cash is needed right here in Paoli at present." On the verso, Esherick encourages Dreiser to "plan, sell another poem, sign a few more books & pass on the orders." Although Esherick had cut the price in half, hoping to entice Dreiser to purchase the table, he was unsuccessful. Both men were feeling the effects of the Great Depression.

Catalog no. 139. Wharton Esherick. Autograph letter to Theodore Dreiser. Paoli, Pennsylvania, October 28, 1930. Theodore Dreiser Papers, Rare Book and Manuscript Library, University of Pennsylvania.

Esherick designed these gates, painting them a striking blue color, to grace the entrance to Iroki, Dreiser's country home. They are among the few elements from Dreiser's time still to survive on the property.

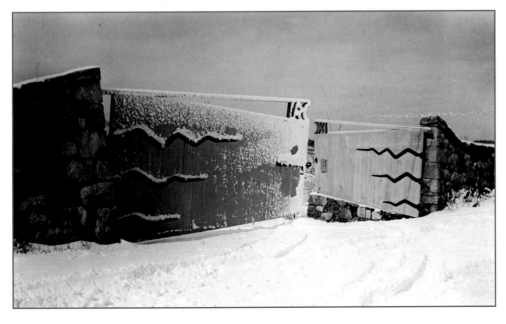

Catalog no. 140. Myrtle Patges, photographer. "Wharton sherick's Gates to Iroki, Mt. Kisco, New York." Photograph, 1930s. Theodore Dreiser Papers, Rare Book and Manuscript Library, University of Pennsylvania.

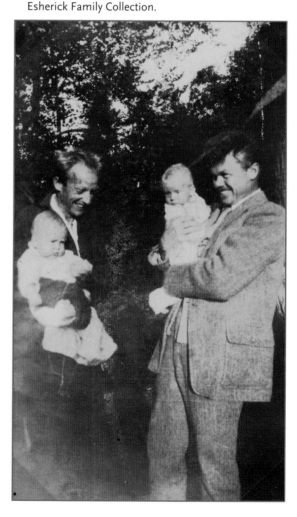

Esherick and Dreiser had an intense friendship even though Dreiser's difficult personality and his womanizing occasionally exasperated Esherick. But—as this poem shows—he still had a great affection for the man and his intellect.

Catalog no. 141.
Wharton Esherick.
"In his room I slept—."
Autograph poem, April 25, 1936.
Theodore Dreiser Papers, Rare Book and
 Manuscript Library, University of Pennsylvania.

Catalog no. 142.
"Wharton Esherick and Henry Varnum Poor with
 their sons, both named Peter."
Photograph in Esherick Family albums, ca. 1927.
Esherick Family Collection.

New City, New York

Across the Hudson from Mt. Kisco, in New City, Henry Varnum Poor built Crow House, his home and studio. Poor and Esherick had met through the American Designers' Gallery and quickly became friends. Their lives and careers presented many parallels. Both were painters who turned to craft media as ways of supporting themselves; both built highly personal homes and studios, for themselves and others, that were recognized in architectural circles, although neither had architectural training; both opposed excessive self-promotion, and so, while each was highly influential in his respective field, neither achieved wide name recognition among the public. Their friendship contained an amicable competitiveness. As they strove to outdo each other, each pushed the other to create better work. Esherick is thought to have been inspired to build his studio after Poor built his; the same seems true of the spiral stair in his studio.

Noted for his paintings on ceramic, Poor used that technique to make plates of the entire Esherick family. Plates of Mary, Ruth, Wharton, and of the entire family currently hang in the dining room at Esherick's studio.

Catalog no. 143.
Henry Varnum Poor.
Mary Esherick Plate.
Ceramic, ca. 1926.
Wharton Esherick Museum.

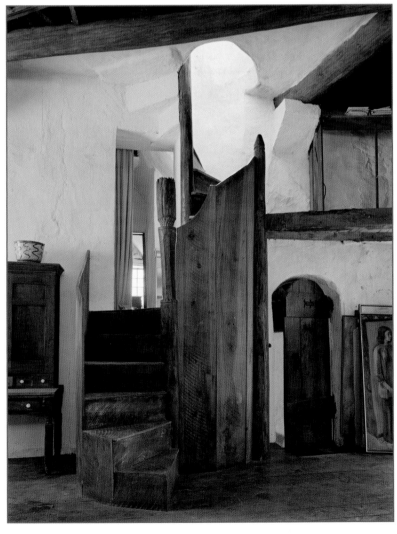

Catalog no. 144.
Elizabeth Felicella, photographer.
"Henry Varnum Poor's Crow House
 Staircase."
Photograph, 2008.
Photography funded by the Center for
 Craft, Creativity and Design.
Courtesy of Caroline M. Hannah.

Croton-on-Hudson, New York

The Eshericks came to Croton-on-Hudson for the Hessian Hills School, a progressive school started by Margaret Hatfield and Elizabeth Moos, a close friend of Carl and Kinglet Zigrosser. Moos ran her own summer camp in the Adirondacks and shared some students with Ruth Doing and Gail Gardner. The school opened in 1925 with five students, including Mary Esherick, who boarded there. Esherick paid Mary's tuition by making chairs for the school. Over the next few years this modest venture in progressive education grew, and in 1928 the school moved to an old farmhouse in Hessian Hills. That year Letty and the children moved from Paoli to the newly situated school, where Letty served as a housemother. Unfortunately, she contracted a severe case of encephalitis that winter which left her physically weakened and compromised. The next winter the family went south to Fairhope instead of returning to Hessian Hills. After Mary returned to the school in the fall of 1930, Esherick once again made chairs for it.

Hessian Hills School was one of the Associated Experimental Schools. This brochure suggests its educational philosophy on the front cover, while elaborating in its text on how that philosophy was implemented. The School hoped to provide children with an environment offering "opportunities to develop and express their own meanings and relationships" and in which "creative work in music, dancing, drama, painting, literature, and sculpture" were "an integral part of the school day."

The
Associated Experimental Schools

The Associated Experimental Schools are coeducational, non-profit-making, without race discrimination.

We are experimental in the sense that we believe experimentation to be an essential tool for learning.

We seek to establish a cooperative rather than a competitive atmosphere for work. We use no marks, rewards, nor honors.

We evaluate children's progress by comparison with their own past performance.

We gauge our educational success by the richness of the children's experiences, not merely by the amount of factual information acquired.

CITY AND COUNTRY SCHOOL	165 West 12th Street, New York City
HESSIAN HILLS SCHOOL	Croton-on-Hudson, New York
LITTLE RED SCHOOL HOUSE	196 Bleecker Street, New York City
MANUMIT SCHOOL	Pawling, Dutchess County, New York
COOPERATIVE SCHOOL FOR STUDENT TEACHERS	69 Bank Street, New York City
HARRIET JOHNSON NURSERY SCHOOL	69 Bank Street, New York City
WALDEN SCHOOL	1 West 88th Street, New York City

Catalog no. 145.
The Associated Experimental Schools.
New York: The Association, ca. 1934-1937.
Carl Zigrosser Papers, Rare Book and Manuscript
 Library, University of Pennsylvania.

This is the 1924 prototype for the chairs Esherick made in 1925 for the Hessian Hills School.

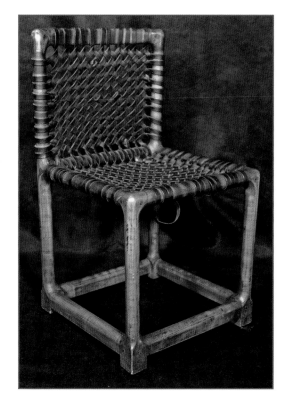

Catalog no. 146.
"Wharton Esherick's 1924 prototype for *Hessian Hills Chair*."
Photograph, 2010.
Rare Book and Manuscript Library,
University of Pennsylvania.

Writing to Dreiser, Esherick mentions that Letty, Ruth, and Peter have left for Fairhope for the winter, giving Letty a chance to recuperate from encephalitis, while "Mary is back at the Croton school."

Catalog no. 147.
Wharton Esherick.
Autograph letter to Theodore Dreiser.
Paoli, Pennsylvania, October 11, 1930.
Theodore Dreiser Papers, Rare Book and Manuscript Library, University of Pennsylvania.

Spring Valley, New York

In 1926, Esherick's friends in the Threefold Commonwealth Group bought what became the Threefold Farm in the southern part of Spring Valley, now known as Chestnut Ridge. There, some thirty miles northwest of New York City, they grew fruits and vegetables for their New York City vegetarian restaurant. Their name came from *The Threefold Commonwealth* (1922), the title of the authorized English translation of Rudolf Steiner's *Kernpunkte der Sozialen Frage*. In that book, Steiner expanded on the importance of individual spiritual expression, political rights, and economic interdependence as foundations for a healthy community. The farm eventually developed into the Threefold Educational Foundation and School. Letty lived there with Louise Bybee, a pianist at the Gardner-Doing camp, for a short time, and Esherick visited her while she was there.

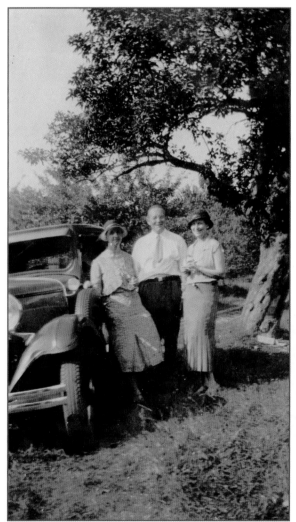

Charlotte Parker, Ralph Courtney, and Louise Bybee were among the founding members of the Threefold Commonwealth Group.

Catalog no. 148.
"Charlotte Parker, Ralph Courtney, and Louise Bybee."
Photograph, ca. 1930.
Threefold Educational Center Collection.

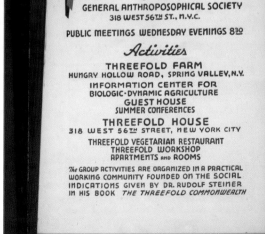

Catalog no. 149.
Threefold Commonwealth Group announcement in wooden frame.
ca. 1930.
Threefold Educational Center Collection.

Ways to a New Style in Architecture was one of several of Steiner's books in Esherick's library. The volume consists of five lectures Steiner delivered in 1914 during the building of his first Goetheanum in Dornach, Switzerland, a project intended to embody his call for a new style of architecture that was both organic and functional. Both copies of the two early translations of *Kernpunkte der Sozialen Frage*—*The Triorganic Social Organism* and *The Threefold Commonwealth*—as well as a handful of other books by Steiner, were also in Dreiser's library. The number of Steiner's works in both of their libraries indicates a serious interest in Steiner's philosophy among them and those in their circle.

Catalog no. 150.
Rudolf Steiner.
Ways to a New Style in Architecture.
London: Anthroposophical Publishing Company, and New York: Anthroposophic Press, 1927.
Wharton Esherick Museum

Catalog no. 151.
Rudolf Steiner.
The Triorganic Social Organism. Trans. by O. Henry Frederick.
Detroit, Michigan: Goetheanum Press of America, 1920.
Library of Theodore Dreiser, Rare Book and Manuscript Library, University of Pennsylvania.

Catalog no. 152.
Rudolf Steiner.
The Threefold Commonwealth. Trans. by E. Bowen-Wedgewood.
New York: Macmillan Company, 1922.
Library of Theodore Dreiser, University of Pennsylvania Libraries.

Revolutionizing Theater

Many local artistic, craft, communitarian, and utopian colonies once surrounded Philadelphia, of which New Hope now remains one of the few still active (and actively remembered). Another was Rose Valley, Pennsylvania, where, early in the twentieth century, architect William Lightfoot Price attempted to create an Arts and Crafts community, based on the ideas of William Morris. The craft industries failed, but not before successfully attracting an interesting group of artisans and intellectuals to the region, one of whom established Hedgerow Theatre.

Jasper Deeter (1893-1972), Hedgerow's innovative and inspiring founder and director, came to Rose Valley from the Provincetown Players in New York City. The Provincetown Players, founded by a group of writers and actors who intended to push the boundaries of American theater, launched the careers of Eugene O'Neill and Susan Glaspell, among others. Success led to rifts within the group and disagreements arose about its politics and mission. In 1922, after Deeter saw his sister Ruth perform in a production of *The Mikado* in Rose Valley, he decided that it would be the perfect locale for a true repertory theater whose resident cast would be primarily concerned with art, not commerce, and where plays by the avant-garde of the theater world—Shaw, Ibsen, Chekov, Pirandello, and, of course, O'Neill (as well as Shakespeare)—would be performed. The following year, 1923, he opened Hedgerow Theatre in an old gristmill that had previously served as the community hall.

Dr. Ruth Deeter, an osteopath and Letty Esherick's friend, introduced Esherick to Deeter; the two became fast friends. The Eshericks both worked at Hedgerow, doing whatever needed to be done. Working on stage sets provided Esherick with an opportunity to expand his ideas of artistic environments that he had begun to develop at Sunekrest. Esherick also created woodblock print posters for Hedgerow productions along with prints to illustrate its programs.

While Esherick was moving into the medium of sculpture, Hedgerow provided him with opportunities to experiment with design as well as a gallery in which to show his work. He made thousands of sketches of actors; these served as inspiration for his sculptures. He designed and built several tables, two sets of stairs, and thirty-six *Hammer-Handle* chairs for Hedgerow, the latter in exchange for acting school tuition for his daughter Ruth. Helene Fischer, one of Wharton's most important early patrons, first saw his sculpture *Finale* at Hedgerow. That first purchase would lead to many later commissions.

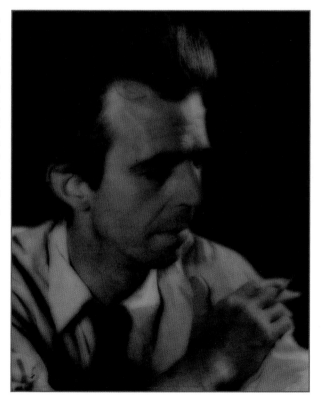

Catalog no. 153
"Jasper Deeter."
Photograph, late 1920s or early 1930s.
Hedgerow Theatre.

Catalog no. 155.
Wharton Esherick.
Hedgerow Theatre Entrance.
Pencil on paper, ca. 1929.
Wharton Esherick Museum.

Catalog no. 156.
Wharton Esherick.
Hedgerow Theatre Entrance.
Ink on paper, ca. 1929.
Wharton Esherick Museum.

Catalog no. 157.
Wharton Esherick.
Hedgerow Theatre Entrance.
Wood engraving, ca. 1929.
Wharton Esherick Museum.

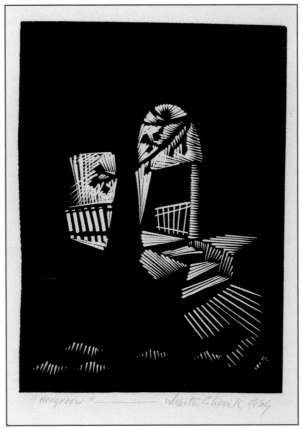

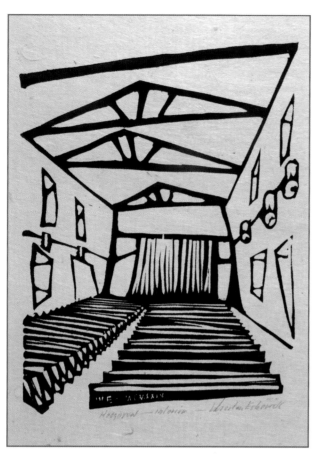

Catalog no. 154.
Wharton Esherick.
Hedgerow Theatre Interior.
Woodcut, ca. 1929.
Wharton Esherick Museum.

Catalog nos. 158 and 159.
Wharton Esherick.
Hedgerow Theatre Bookplates.
Two wood engravings, 1924.
Wharton Esherick Museum.

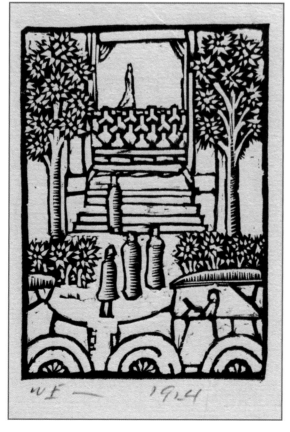

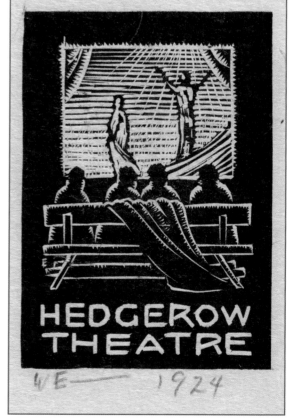

This photograph shows the two large painted oak horse sculptures, *Jeeter* and *Cheeter*, that Esherick made for Hedgerow.

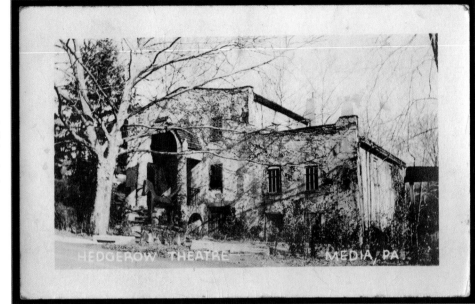

Catalog no. 160.
"Entrance to Hedgerow Theatre."
Photograph, ca. 1935.
Hedgerow Theatre.

Eugene O'Neill's *The Emperor Jones* was Hedgerow's most popular play, performed over 300 times between 1923 and 1947. Deeter played Smithers, the colonialist, a role he had originated with the Provincetown Players; several different African-American actors played Jones over the years. Deeter is credited with insisting on a black actor instead of a white actor in blackface, the tradition at the time. Hedgerow always cast black actors except when touring in the south.

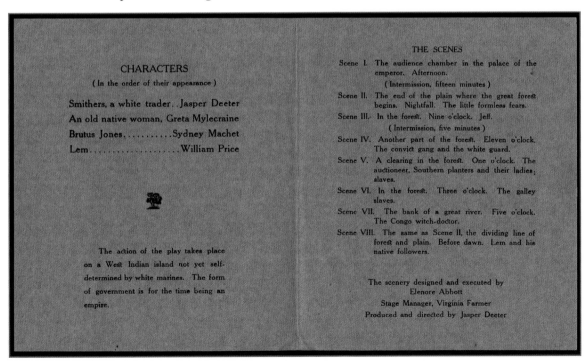

Catalog no. 161.
Program for Hedgerow Theatre's production of *The Emperor Jones*.
1926.
Hedgerow Theatre Collection, Howard Gotlieb Archival Research Center, Boston University.

Catalog no. 162.
Wharton Esherick.
*The Emperor Jones,
 Hedgerow Theatre.*
Woodcut poster,
 1930.
Courtesy of the
 Moderne Gallery.

Esherick designed the expressionistic stage sets for Hedgerow's production of Ibsen's *When We Dead Awake*, based on the affair between the French sculptors Camille Claudel and August Rodin. This experience helped spark Esherick's interest in furniture and interiors.

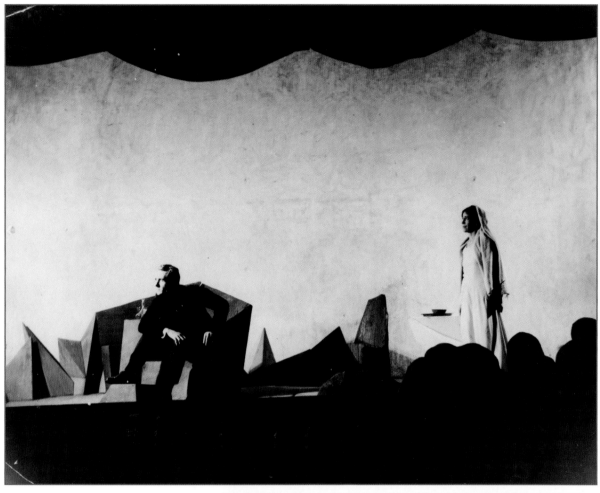

Catalog no. 163.
"Alfred Rowe and Gretchen Anton
 Smith in Hedgerow Theatre's
 production of *When We Dead
 Awake*."
Photograph, 1930.
Hedgerow Theatre.

Catalog no. 164.
"Harry Bellaver and Miriam Phillips in
Hedgerow Theatre's production of
When We Dead Awake."
Photograph, 1930.
Hedgerow Theatre.

Esherick displayed sculpture at Hedgerow in hope that his work would find buyers among the theater's audiences. *Essie*, Esherick's wood sculpture of his daughter Mary as she appears in the Hedgerow Theatre production of Shaw's *The Devil's Disciple*, was displayed at Hedgerow during the play's run. *Finale*, Esherick's sculpture in walnut of a reclining dancer, was purchased by Helene Fischer after she saw it at the theatre. She then commissioned Esherick to design and build a Victrola cabinet (made from padouk, a tropical wood) to serve as a pedestal for *Finale*.

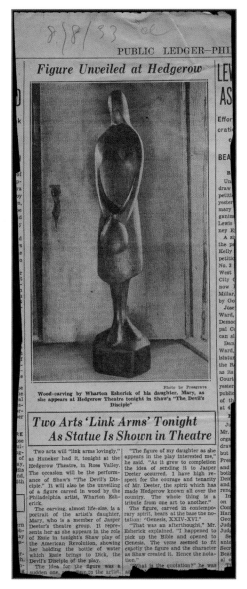

Catalog no. 165.
"Figure Unveiled at Hedgerow: Two Arts 'Link Arms' Tonight As Statue Is Shown in Theatre." [fragment]
Philadephia Public Ledger (August 8, 1933).
Theodore Dreiser Papers, Rare Book and Manuscript Library, University of Pennsylvania.

Catalog no. 166.
"Wharton Esherick's *Finale* and *Victrola Cabinet* in Helene Fischer's home."
Photograph, ca. 1937.
Barbara Fischer Eldred Collection.

Catalog no. 167.
"Helene Fischer reclining on couch in her home."
Photograph, 1930s.
Barbara Fischer Eldred Collection.

Esherick made three chess sets in this design. One was purchased by the actress Anne Harding, one by another buyer, and this one Esherick gave to Deeter. He carved "Cherokee" on the box because Lynn Riggs's *Cherokee Night* was then the newest play in Hedgerow's repertoire.

Catalog no. 168.
Wharton Esherick.
Chess set and box.
Wood, 1932.
Inscribed "Hedgerow Theatre Cherokee."
Wharton Esherick Museum.

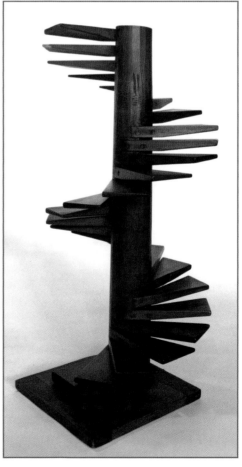

These stairs, expanding on ideas embodied in the Esherick studio's *Spiral Stair*, were built backstage at Hedgerow. They went from the basement to the stage level and continued up to a catwalk above the stage. A major fire at Hedgerow in 1985 destroyed these stairs, although another set made by Esherick, which goes to the balcony, is still in use in Hedgerow's lobby.

Catalog no. 169.
Wharton Esherick.
Hedgerow Stairs.
Wood model, 1936.
Wharton Esherick Museum.

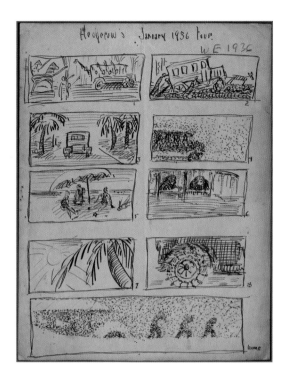

Catalog no. 170.
Wharton Esherick.
Hedgerow's January 1936 Tour.
Ink on paper, 1936.
Wharton Esherick Museum.

Hickory Dickory

Hickory Dickory: A Modern Comedy In Three Acts, by Dorothy Nichols, was the only play in which Esherick is known to have performed; he played the role of the milkman. His woodcut poster for *Hickory Dickory* shows the milkman holding a bucket of milk. He carved *The Sacristy* to commemorate a performance of *Hickory Dickory* in a church in Reading, Pennsylvania. Esherick, the figure wearing a cap in the foreground, ogles the nude actress. The other man is Ferd Nofer, Letty's brother. Miriam Phillips, who would later become Esherick's companion, applies her make-up at the dressing table.

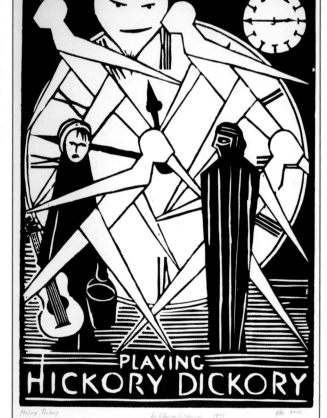

Catalog no. 171.
Wharton Esherick.
Hedgerow Moylan, Rose Valley, Playing Hickory Dickory.
Woodcut poster, 1933; restrike, 2010.
Rare Book and Manuscript Library,
University of Pennsylvania.

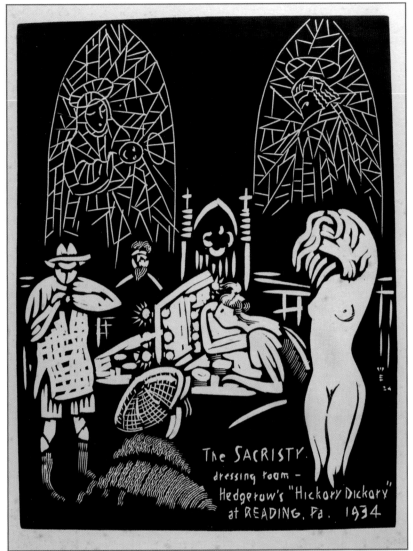

This copy of the program has the actors' names, which include Deeter, Esherick, and his daughter Mary, written in pencil. Esherick goes by the pseudonym "John Thornton," a slang term for penis.

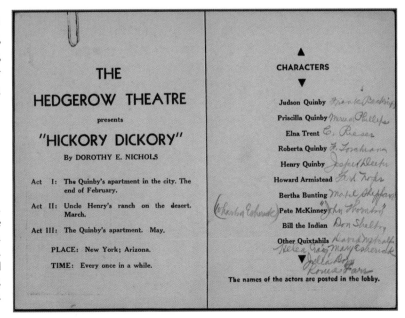

An American Tragedy
and
Winesburg, Ohio

Hedgerow Theatre was a social world as well as an artistic one. Esherick and Dreiser first met at a performance of Virginia Farmer's play *The Artist*, which featured Dreiser's former lover Kyra (or Kirah) Markham, pseudonym of Elaine Hyman. Kyra had arranged for Dreiser to stay overnight at Sunekrest. Years later Esherick acted as an intermediary in arranging for Hedgerow to perform *An American Tragedy* in an English translation of the German adaptation for the stage made by the German theater director Erwin Piscator. An exponent of epic theater, Piscator focused on the sociopolitical elements of Dreiser's novel in his adaptation.

When Anderson spoke to Esherick about adapting *Winesburg, Ohio* for the stage, Esherick suggested Jasper Deeter as "the man to do it." Anderson actually adapted his own work, with help from Deeter and Esherick. During this process, Anderson fell in love with the Hedgerow community, finding many excuses to come to Rose Valley. The Hedgrovians responded by naming one of their resident dogs—a lovable and affectionate German shepherd—"Sherwood."

Esherick most likely made these humorous sketches of Dreiser getting ready for bed and Anderson in the bathroom at times when both men stayed at Esherick's house after a production at Hedgerow. Dreiser, notoriously unselfconscious about his body, went outdoors naked and in full view of the rest of the company one morning when he couldn't find an empty bathroom to shower in. He asked Esherick's son Peter to wash him with water from an outdoor hose.

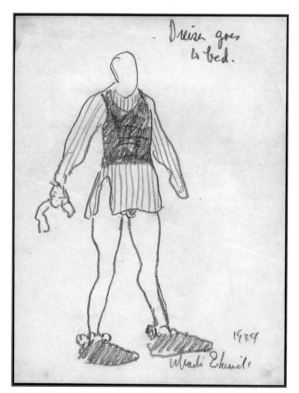

Catalog no. 174.
Wharton Esherick.
Dreiser Goes to Bed.
Pencil on paper, 1934.
Wharton Esherick Museum.

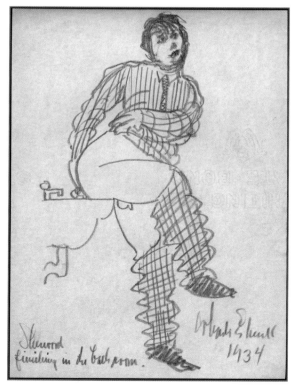

Catalog no. 175.
Wharton Esherick.
Sherwood Finishing in the Bathroom.
Pencil on paper, 1934.
Wharton Esherick Museum.

An American Tragedy

Erwin Piscator (1893-1966) asked Dreiser's permission to create a German adaptation of *An American Tragedy*. Dreiser agreed, on condition that Piscator provide him with an English translation—but Piscator never got around to doing the translation. Dreiser eventually asked Louise Campbell, one of his long-time editors and a good friend of both himself and Esherick, to do it for him. Hedgerow used her translation in its production of *An American Tragedy*.

Catalog no. 176.
Theodore Dreiser.
An American Tragedy.
Dramatization by Erwin
Piscator, translation by
Louise Campbell.
Typescript, 1930.
Theodore Dreiser Papers, Rare
Book and Manuscript Library,
University of Pennsylvania.

PROLOGUE

The SPEAKER stands downstairs in Parquet, at right, before the footlights and during his talk walks slowly left toward Loge, taking his place quickly in the Loge the moment the curtain rises.

Speaker

Attention, attention, ladies and gentlemen! You will see this evening a play that has originated from a novel, which its author, Theodore Dreiser, calls an American Tragedy. But we are concerned not so much with the naked reiteration of the novel or the simple dramatization of its incidents. This tragedy that you will see this evening is as international as the problem of Class-Contrast, Class-Distinction from which the story arises. We are here to solve a mathematical problem that shows that the fate of man to-day is as inexorable and absolute as was his fate in the old Greek tragedies. We might term it: the Law of Labor, or better yet, of Capital.

(The curtain rises, to soft music.)

Two classes have sprung from Capital. You can see that the stage is accordingly divided. On the right, the land of Poverty; on the left, the Land of Riches. And in the middle, yes, in the middle lies No Man's Land, in which both sides work out their destinies.

(The head of Clyde appears.)

Here you see Clyde Griffiths, the son of a poor, itinerant preacher, who wanders the streets singing and praying to bring salvation to a sinful world. They never have any money; they live on the pennies of pious people and the sale of tracts. They scorn anything else. They live in a mysterious dream world that contrasts so strongly with reality that even this boy of twelve years feels it. He feels, even though sorry, a contemptuous shame for his parents, their humble origin, their pious ideas, their shabby clothes, and his own lack of culture and impotence.

Catalog no. 177.
"Louise Campbell."
Photograph, ca. 1929.
W.A. Swanberg Papers, Rare Book and
 Manuscript Library, University of Pennsylvania.

Piscator's adaptation of *An American Tragedy* emphasized the class conflicts inherent in Dreiser's work, in part through its staging. In Hedgerow's production, two levels, with connecting staircases, separated the playing areas. Characters representing the upper classes, dressed in tuxedos, played their roles on top. Working class characters, dressed in t-shirts and pants, played their parts on the lower level. At times they literally supported the upper classes, as this photograph illustrates.

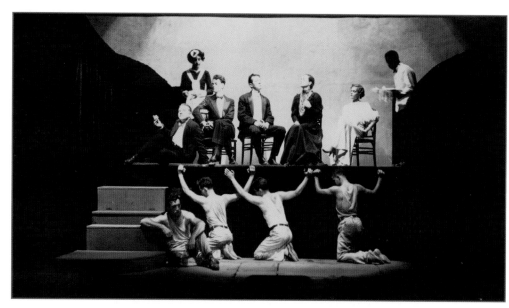

Catalog no. 178. "Scene from original Hedgerow Theatre production of *An American Tragedy*." Photograph, 1935. Hedgerow Theatre Photograph Collection, Rare Book and Manuscript Library, University of Pennsylvania.

One of the unique features of Hedgerow's production of *An American Tragedy* was the Speaker, who moved about and provided commentary while located not on the stage but in the audience.

Catalog no. 179. "Scene from original Hedgerow Theatre production of *An American Tragedy*." Photograph, 1935. Hedgerow Theatre Collection, Howard Gotlieb Archival Research Center, Boston University.

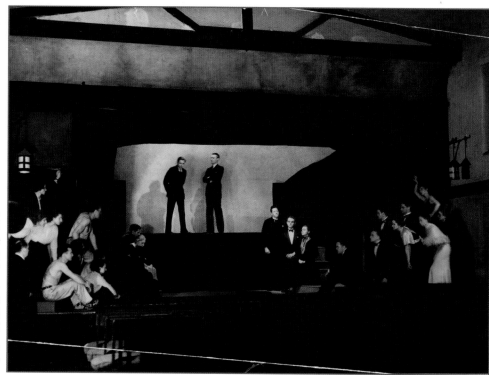

This is Dreiser's own copy of the program.

Catalog no. 180.
Program for original Hedgerow Theatre production of *An American Tragedy*.
1935.
Theodore Dreiser Papers, Rare Book and Manuscript Library, University of Pennsylvania.

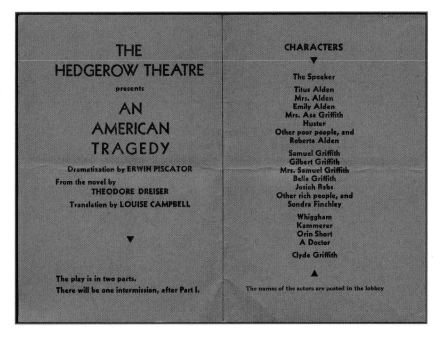

The last paragraph of the first page of this letter reports that "Sherwood [Anderson] is with them [Hedgerow] doing a new play. Dreiser's *Tragedy* went over good & this summer looks Hopeful. Thank God one of the arts marches on."

Catalog no. 181.
Wharton Esherick.
Autograph letter to Carl Zigrosser.
Paoli, Pennsylvania, May 29th, [1935].
Carl Zigrosser Papers, Rare Book and Manuscript Library, University of Pennsylvania.

Winesburg, Ohio

Anderson adapted his novel for dramatic presentation at Hedgerow. This copy contains Carl Zigrosser's bookplate (designed by Rockwell Kent).

Catalog no. 182.
Sherwood Anderson.
Winesburg, Ohio.
New York: B. W. Huebsch, 1919.
Rare Book and Manuscript Library,
 University of Pennsylvania.

Winesburg, Ohio proved less successful a theatrical production than *An American Tragedy*, although both Esherick and Anderson were quite pleased with the play.

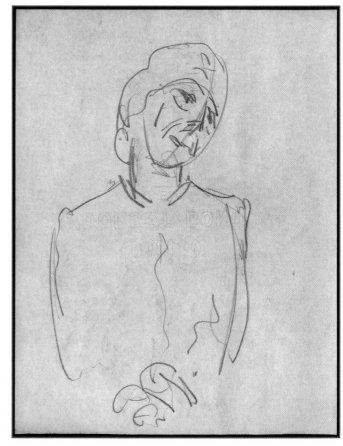

Catalog no. 183.
Wharton Esherick.
Sketch of Hedgerow production of Winesburg, Ohio.
Pencil on paper, 1934.
Wharton Esherick Museum.

Anderson and Esherick jointly invited Dreiser to come see the production of *Winesburg* at Hedgerow.

Catalog no. 184.
Sherwood Anderson and Wharton Esherick.
Autograph letter to Theodore Dreiser.
Paoli, Pennsylvania, [June 22, 1934].
Theodore Dreiser Papers, Rare Book and Manuscript Library, University of Pennsylvania.

Catalog no. 185.
"Sherwood Anderson and Jasper Deeter on set of *Winesburg Ohio*."
Photograph, 1934.
Hedgerow Theatre Collection, Howard Gotlieb Archival Research Center, Boston University.

"Freedom"

For Esherick, the sea represented freedom. As a child it was the freedom of a careless summer. As an adult, it was escape. Esherick's family vacationed at the Jersey Shore when he was young. He learned to sail on Barnegat Bay in a boat that he and his brothers rigged up with a sail. The design of sailboat interiors, with their curving forms and obsessive use of every bit of free space for storage, had a clear impact on Esherick's sense of design. After high school, he and a friend booked passage on a cattle boat to Europe. The Eshericks' honeymoon was a cruise from New Jersey to West Point on a borrowed sailboat. When the family went to Fairhope, they traveled by boat rather than by train. Esherick took friends for vacation trips to the shore where, often using borrowed boats, they would play, swim, crab, and get sunburned. This sense of freedom is reflected in his prints of sailing and the shore.

Esherick inscribed this print, one of an edition of fifty-nine, "[t]o Theodore Dreiser, Sail on good man with my best wishes. Affectionately Wharton."

Catalog no. 186.
Wharton Esherick.
The Lee Rail.
Woodcut, 1925.
Theodore Dreiser Papers, Rare Book
 and Manuscript Library, University of
 Pennsylvania.

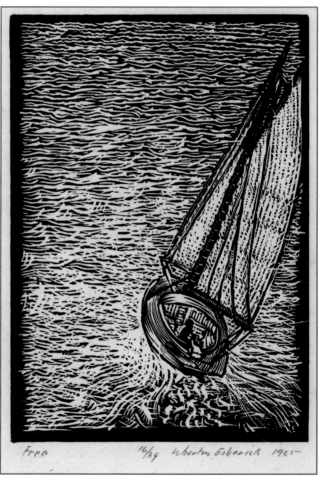

Catalog no. 187.
Wharton Esherick.
Free.
Wood engraving, 1925.
Theodore Dreiser Papers, Rare Book and Manuscript
 Library, University of Pennsylvania.

Esherick here invites Dreiser to spend a week at the shore with Henry Varnum Poor and himself. His sketch of *Henry Crabbing* depicts Poor just as he is falling overboard.

Henry Crabbing

Catalog no. 188.
Wharton Esherick.
Henry Crabbing.
Pencil and crayon on paper,
 ca. 1920.
Wharton Esherick Museum.

Catalog no. 189.
Wharton Esherick.
Autograph letter to Theodore
 Dreiser.
Paoli, Pennsylvania, [1927].
Theodore Dreiser Papers,
 Rare Book and Manuscript
 Library, University of
 Pennsylvania.

Catalog nos. 190 and 191.
"Wharton Esherick, Henry Varnum
 Poor, and Bessie Breuer (Poor's wife)
 on a sailboat."
"Henry Varnum Poor, Bessie Breuer
 (Poor's wife), and Letty Esherick with
 the day's catch."
Two photographs in Esherick Family
 albums, 1927.
Esherick Family Collection.

When Esherick took his friends to the shore, he would annotate copies of this printed map with notes and drawings describing their adventures. The June 1925 trip described here involved Theodore and Helen Dreiser, Esherick, Letty, and their daughter Mary, Mary Peck, and Skipper Dilley. Dreiser, badly sunburned on this trip, required medical care for more than a week, which delayed publication of *An American Tragedy*.

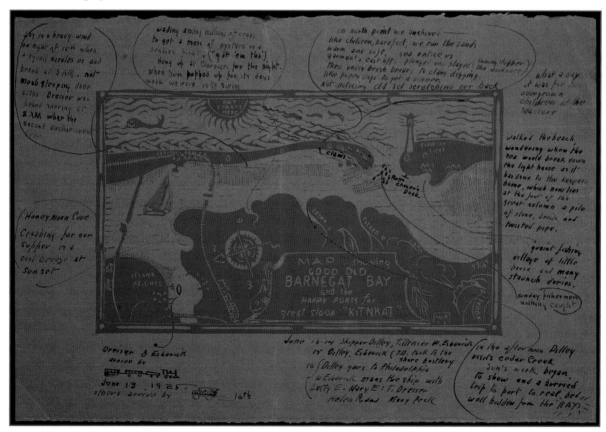

Catalog no. 192.
Wharton Esherick.
Map showing Good Old Barnegat Bay and the Happy Ports for great sloop "Kitnkat."
Woodcut, 1925.
Theodore Dreiser Papers, Rare Book and Manuscript Library, University of Pennsylvania.

Esherick often used a pencil the way other people use a camera, that is, to capture a day's events. Rather than taking snapshots, he would draw what was happening around him. His sketches function not only as souvenirs of that day's adventures but also as seeds for future work.

Catalog no. 193.
Wharton Esherick.
Lighthouse at Barnegat.
Pencil on paper, 1920s or 1930s.
Wharton Esherick Museum.

Catalog no. 194.
Wharton Esherick.
Boat.
Ink on paper, 1920s or 1930s.
Wharton Esherick Museum.

Catalog no. 195.
Wharton Esherick.
Cedar Creek L.S.S. Barnegat.
Pencil on paper, 1927.
Wharton Esherick Museum.

Katherine Garrison Chapman commissioned *Bright Mariner* as a memorial to her son, who loved to sail but had died young. She wrote the poem and Esherick provided three woodblock prints to accompany it.

Catalog nos. 196 and 197.
Katherine Garrison Chapin.
Bright Mariner. Woodcuts by Wharton Esherick.
New York: Duffield and Green, 1933.
Two copies.
Wharton Esherick Museum.
Mark Sfirri Collection.

"Buck Fever"

Our young Buck Fever, we have taken in here to work with us, is real. He is imagined. He exists. He does not exist. He is a tall young mountain man. He is the fragment of a dream. But who is not that? Who is not the fragment of a dream?
—Sherwood Anderson, *Hello Towns!*

Esherick originally met Sherwood Anderson in Fairhope, Alabama, in 1920, and a lasting friendship developed between the two men. In 1926 Anderson—after visiting Marion, Virginia, the previous year and falling in love with the region—moved to Troutdale, some twenty miles from Marion, with his third wife, Elizabeth, having earned enough money from writings and a lecture tour to buy land and build a large stone house he called "Ripshin." Esherick visited Anderson at Ripshin on numerous occasions, recording these visits in drawings, letters, and sculpture.

In the fall of 1927, Anderson acquired the two local weekly newspapers, the *Marion Democrat* and the *Smyth County News* (the Republican paper), published on Tuesdays and Thursdays, respectively. His first issue was published on November 1, 1927, and shortly thereafter he created the fictional character of Buck Fever, from Coon Hollow, based in part on two locals, Charles H. Funk, one of Anderson's oldest friends in Marion, and Anderson's neighbor Felix Sullivan. Buck was depicted as a reporter for the papers who regularly commented on the town (and newspaper) life in a humorous (Funk) and folksy (Sullivan) manner.

Before long, Anderson tired of the demands of small-town newspaper life. In late 1928, he brought his son Robert "Bob" Lane Anderson to Marion to assist him (Bob had been working at the *Philadelphia Bulletin*). He gave Bob more and more responsibility for the paper, eventually ceding ownership to him in 1932. Elizabeth, meanwhile, missed the cosmopolitan life that Anderson seemed happy to have escaped and did not take to Ripshin. In 1928 she and Anderson divorced. He later married Eleanor Copenhaver, the daughter of one of the prominent families in Marion.

During the summer of 1934, Esherick spent an extended period at Ripshin, helping Anderson edit *No Swank*, a collection of essays for Centaur Press. He also carved *Buck*, his caricature of Anderson, and the *Spiral Pole*, a response to Brancusi's *Endless Columns*, out of Virginia white pine. The following year he wrote to Dreiser: "Anderson has left for Virginia, god how I wish I was with him there, a quiet simple sensuous country, away from people, people." All of Anderson's friends visited Ripshin, including members of Hedgerow Theatre when they were on their southern tours. Anderson kept photos of all his friends in a room he called his Rogues Gallery. His untimely death in 1941 shocked and saddened his friends, who paid tribute to him in various ways.

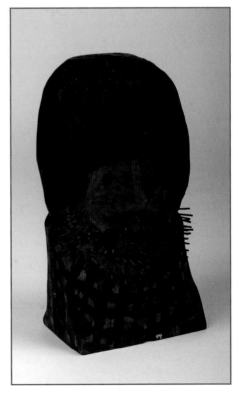

Esherick created this folk art sculpture of Anderson with a beard—a beard Anderson had sported at an earlier period in his life.

Catalog no. 198.
Wharton Esherick.
Head of Anderson.
Pine, black paint, and finish nails, 1934.
Sherwood Anderson Collection, Ripshin Farm.

Esherick had fun with his caricatures of Buck. This sculpture, entitled *Buck,* portrays Anderson, the man who brought Buck Fever to life in the pages of his newspapers. Esherick's two line drawings of Buck ran in the newspapers over Buck's by-line. The first showed him sprawled in an easy chair, a pose Esherick used in one of his drawings of Curtis Bok, a major client and good friend. It originally appeared in the *Democrat* and subsequently in the *News.* The second drawing, seen here, shows Buck standing. It first appeared in issues of the newspapers printed in late January 1929.

Catalog no. 199.
Wharton Esherick.
Buck.
Virginia white pine, 1934.
Wharton Esherick Museum.

Catalog no. 200.
Wharton Esherick.
Gathering News.
Pencil on paper, ca. 1929.
Wharton Esherick Museum.

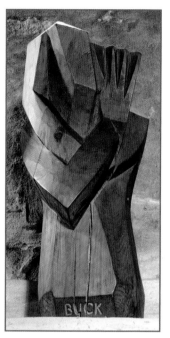

Anderson published Esherick's woodcuts in his newspapers. The issues shown here contain *Evening on Laurel Creek.* The *Marion Democrat* also contains *The Croquet Game,* a humorous print of Anderson's family and friends playing croquet, a favorite pastime at Ripshin.

Catalog no. 201.
Marion Democrat (Marion, Virginia).
August 7, 1934.
Wharton Esherick Museum.

Catalog no. 202.
Smyth County News (Marion, Virginia).
August 9, 1934.
Wharton Esherick Museum.

Below the newspaper reproduction of the croquet game print is the following caption, with the real names of the players provided in brackets:

Wharton Esherick, the American wood cutter, has been spending some time, walking about some of our Southwestern Virginia towns and watching some of our croquet players. From left to right—top row. The lawyer at play [Andy Funk]—he has a well developed push shot. The debutante [Mazie]—modern. The cool one [Elizabeth]. The ex-golfer [Bob Anderson]. He thinks he's putting. Left to right—bottom row. Out to win [Aunt Mary]. The real winner [Wharton Esherick]. The hesitant one [Eleanor]. The old champ [Sherwood Anderson]—the old champ is really the champion alibier.

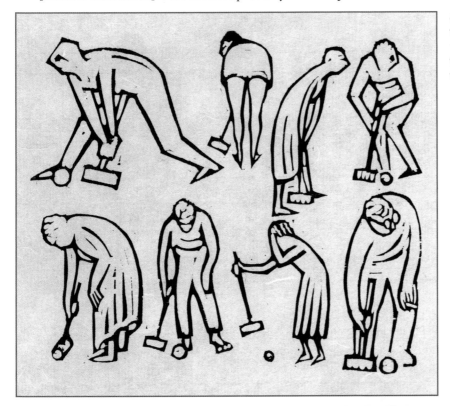

Catalog no. 203.
Wharton Esherick.
The Croquet Game.
Woodcut, 1934; restrike, 2010.
Wharton Esherick Museum.

Anderson's home, Ripshin, was designed by the architect James Spratling. This photograph shows the croquet court in the foreground.

Catalog no. 204.
"Exterior view of Ripshin."
Photograph, ca. 1930s.
Sherwood Anderson Collection, Ripshin Farm.

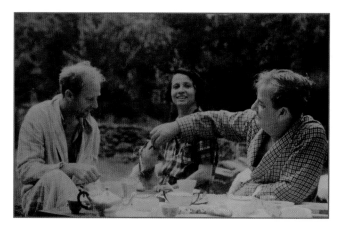

This photograph, taken by Marjorie Content and framed by Esherick, hung in Anderson's Rogues Gallery at Ripshin.

Catalog no. 206.
Marjorie Content, photographer.
"Wharton Esherick."
Photograph, early 1930s.
Sherwood Anderson Collection, Ripshin Farm.

This photograph, taken at Ripshin, clearly shows the deep affection Anderson, his fourth wife Eleanor, and Esherick all had for one another.

Catalog no. 205.
"Wharton Esherick, Eleanor Anderson, and
 Sherwood Anderson eating breakfast."
Photograph, ca. 1934.
Sherwood Anderson Archive Collection, Smyth-
 Bland Regional Library, Marion, Virginia.

Writing to Dreiser, Esherick laments the death of Ford Madox Ford, "so difficult to live with," and recounts his recent visit with Anderson in Virginia, who "lives like a country gentleman, works alone in his cabin in the woods in the morning; wanders over the hills in the afternoon, talking crops or cattle with his man."

Catalog no. 209.
Wharton Esherick.
Autograph letter to Theodore Dreiser.
Paoli, Pennsylvania, August 21, 1939.
Theodore Dreiser Papers, Rare Book and
 Manuscript Library, University of Pennsylvania.

In March 1929, Anderson's son Bob reported a local story about legal proceedings arising from the pasturing of steers on another farmer's property. Sherwood Anderson published the story separately as a pamphlet, *Thwarted Ambitions*, with his own forward—"The Small Town Paper"—and Esherick's humorous woodcut illustrations. The pamphlet went through two editions, the second distributed by the Centaur Book Shop. In an article for the *Saturday Review of Literature*, the author and critic Christopher Morley assumed that Sherwood Anderson, not his son, had written the piece. Writing as "Buck Fever," Sherwood Anderson responded with irritation: "[n]ot only does he [Sherwood Anderson] get away with paying a swell reporter like me but seven dollars and no cents a week but he gets all the credit for what Bob does."

Catalog no. 207.
Wharton Esherick.
Bull Rear View and *Bull Grazing*.
Two woodcuts, illustrations for prospectus
 for Robert Lane Anderson, *Thwarted
 Ambitions*, ca. 1935.
Wharton Esherick Museum.

Catalog no. 208.
Robert Lane Anderson.
*Thwarted Ambitions. With a Foreword by
Sherwood Anderson and Woodcuts by
Wharton Esherick.*
Marion, Virginia: Marion Publishing
Company, 1935.
Rare Book and Manuscript Library,
University of Pennsylvania.

Anderson had asked Esherick to design a grave marker for him before his death. This grave marker, carved in black granite by Victor Riu, was one of the designs Esherick completed after Eleanor rejected his original design, the sculpture *Reverence*. Carved in the black granite is the phrase "Life, not death, is the great adventure." This photograph by Consuela Kanaga was probably taken at the carver's studio in Coopersburg, Pennsylvania.

Reverence

Esherick's sorrow at the death of his friend Sherwood Anderson is evident in *Reverence*, carved as a marker for Anderson's grave and inspired by the sight of Anderson's neighbor, Felix Sullivan, leaning against his staff at Anderson's graveside. Anderson's widow, Eleanor, rejected it, feeling that wood sculptures do not last outdoors and also worrying that such a tall narrow piece would be susceptible to vandalism.

Catalog no. 210.
Consuelo Kanaga, photographer.
"Sherwood Anderson's grave."
Photograph, ca. 1945.
Esherick Family Collection.

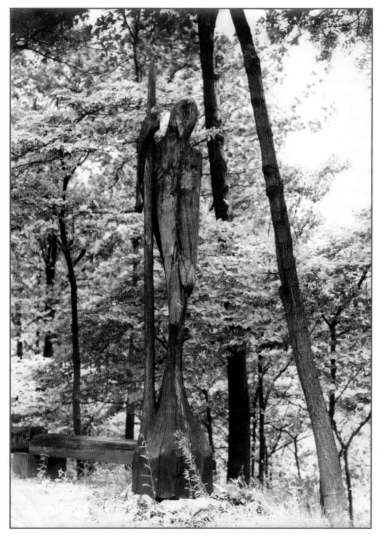

Catalog no. 211.
Consuelo Kanaga, photographer.
"Wharton Esherick's *Reverence*, 1942."
Photograph, ca. 1942.
Esherick Family Collection.

KROIZ GALLERY

Radical Vernacular

Wharton Esherick began to work in wood in the 1920s. He started by carving designs on frames for his paintings as well as on antique furniture he had purchased. As he became increasingly interested in making his own furniture, he drew upon the traditions around him, those of the Pennsylvania farmhouse and particularly of the Arts and Crafts movement as expressed in the Rose Valley community near Moylan, Pennsylvania. An oak high chair made for his son Peter melds the simplified form of Arts and Crafts furniture with a carved surface that resembles the texture of hand-hammered copper. Likewise, his first tables are trestle tables, with straightforward variations or with Arts and Crafts-style carvings.

Esherick's design ideas quickly evolved. He experimented with prismatic forms borrowed from German Expressionism, Cubism, and designs derived from Rudolf Steiner's Anthroposophical architecture. Steiner had championed a design based on the forces of nature, the gradual metamorphosis of living organisms, and human needs (a style also described as "organic" or "spiritual" functionalism). For Steiner, such design would influence thought, feeling, and connection to others: drawn from essential organic forms, proper design would promote harmony.

Esherick incorporated many of these ideas in his 1926 studio (now the Wharton Esherick Museum) while also paying homage to the stone bank barns that dot Chester County. Esherick's radical breakthrough came in 1928 with his *Farmhouse Dining Set*, comprised of a five-sided, asymmetrical table, four chairs, and a bench. Unlike traditional farmhouse tables, which had spaces between the boards of the tabletop, he placed ebony strips between the walnut boards. He also played with Euclidean geometry, using different triangular forms to make his chairs, following the ideas of Anthroposophy. The legs of the table and chairs are irregularly angled, further emphasizing the multi-perspectival nature of their design, which look as if they had emerged from one of Picasso's cubist paintings.

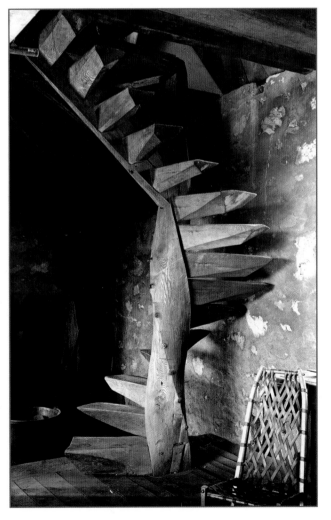

Catalog no. 212.
Consuelo Kanaga, photographer.
"Wharton Esherick's *Spiral Stair*."
Photograph, ca. 1940.
Esherick Family Collection.

Esherick carved and gilded this wood frame with pine needles to complement his painting of Alabama pine trees by moonlight.

Catalog no. 213.
Wharton Esherick.
Moonlight.
Oil on canvas, carved and gilded wood frame, 1919-1920.
Mansfield and Ruth Bascom.

Trestle Table for Ruth Doing

Esherick designed this oak table, but did not build it. This piece has inscribed circles and lozenges along the perimeter of the top. Esherick designed and carved three of the four corners, shown here, along with Louise Bybee's carving. Ruth Doing's students and others made designs for the remaining spaces on the table while they listened and responded to music as part of their dance camp experience in the Adirondacks. However, not all of the designs were ultimately carved in the table.

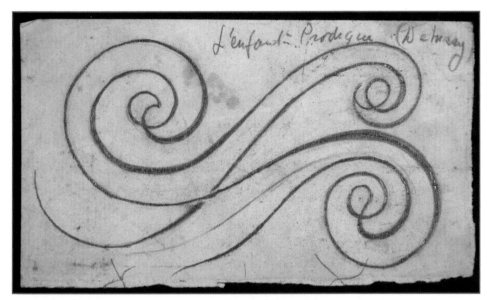

Catalog no. 214.
Wharton Esherick and Others.
Fourteen Sketches of Musical Designs for Trestle Table for Ruth Doing [Louise Bybee's sketch shown here].
Pencil on paper, 1923.
Wharton Esherick Museum.

Catalog nos. 215-218.
Wharton Esherick.
"*Carved Details on Trestle Table for Ruth Doing, 1923.*"
Four photographs, 2009.
Threefold Educational Center Collection.
Photographs by Mark Sfirri.

Moving into Furniture

One of the first pieces made by Esherick in what came to be his signature style, curvilinear free forms that sought to capture the essence of his subject, is this sculpture of race horses. It is based on a racing game the Esherick family played on board ship during their first trip to Fairhope, Alabama. Esherick felt the horses in the game appeared asleep in their stalls, so he thought he would try to carve horses that conveyed a sense of speed. His success in doing so led him into further efforts at sculpture.

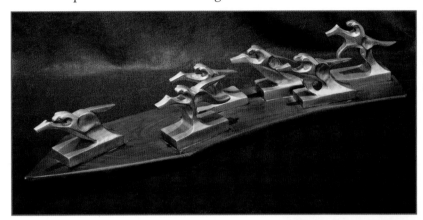

Catalog no. 219.
Wharton Esherick.
The Race.
Brass casting of painted wood
 original, 1925.
Wharton Esherick Museum.

Esherick carved this antique chest with an art nouveau depiction of Sunekrest, his farmhouse and studio on Diamond Rock Hill.

Catalog no. 220.
Wharton Esherick.
Carved Chest.
Wood, ca. 1925.
Wharton Esherick Museum.

Historic photograph by
Mansfield Bascom, 1977.

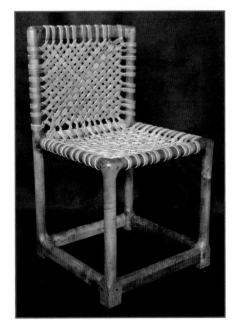

Esherick made the *Hessian Hills Chairs* in exchange for his daughter Mary's tuition at the Hessian Hills School in Croton-on-Hudson, New York. Although the leather makes the chair looks rustic, the form is modern. Its continuous legs and stretchers form a cube, reminiscent of Marcel Breuer's 1925 *Wassily Chair*. The original chairs were lost in a fire in January 1931, so Esherick made a new set of chairs to replace them.

Catalog no. 221.
Wharton Esherick.
Hessian Hills Chair (original 1925 design).
Wood and leather, 1931.
Wharton Esherick Museum.

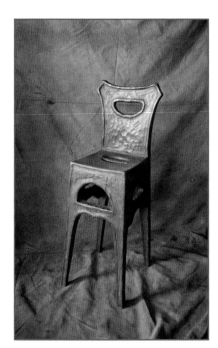

Its carved, hammered-looking surface and use of oak both show the Arts and Crafts influence on Esherick's high chair.

Catalog no. 222.
Wharton Esherick.
High Chair.
Oak, 1926.
David Esherick Collection.

Historic photograph by Emil Luks, 1926.
Esherick Family Collection.

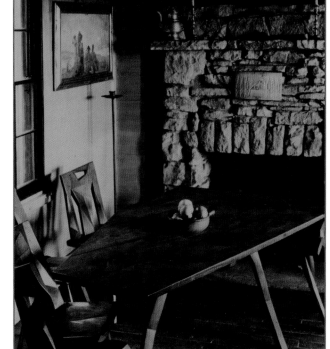

This photograph was taken in Esherick's farmhouse on Diamond Rock Hill.

Catalog no. 223.
Wharton Esherick.
Farmhouse Dining Set (table, four chairs, and bench).
Walnut and ebony wood, 1928.
Peter Esherick Collection.

Historic photograph by Emil Luks, ca. 1928.
Esherick Family Collection.

These chairs by Fritz Westhoff, based on Steiner's Antroposophical ideas, clearly influenced Esherick.

Catalog nos. 224 and 225.
"Threefold Apartment (left) and Restaurant (right) Chairs, ca. 1927-1930."
Two photographs, 2009.
Threefold Educational Center Collection.
Photographs by Mark Sfirri.

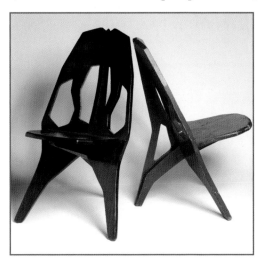

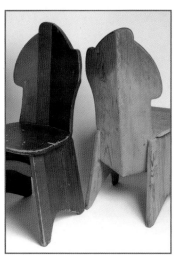

This desk was exhibited at the American Designers' Gallery at West 57th Street in New York City. The inspiration for this piece was a pair of inverted sawhorses used by Henry Varnum Poor to make a table to display his ceramics at the Gallery in 1928. Esherick's interpretation of this form shows the slanted asymmetry found in some of Westhoff's Anthroposophical cabinets. At the same time, the use of aluminum was a mark of high-style modern design.

Catalog no. 226. "Wharton Esherick's *Desk with Aluminum Top,* 1929." Photograph, ca. 1929. Esherick Family Collection.

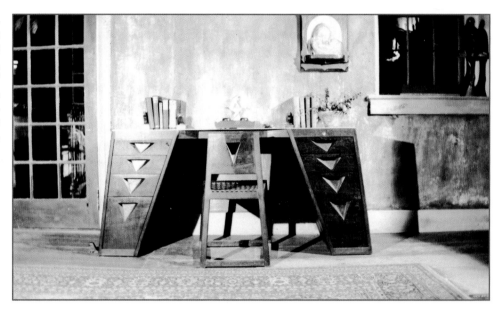

Inside Esherick's studio one sees the 1930 *Spiral Stair,* truly a work of rustic cubism, with its asymmetrical trapezoidal steps cantilevered into the spiraling red oak truck.

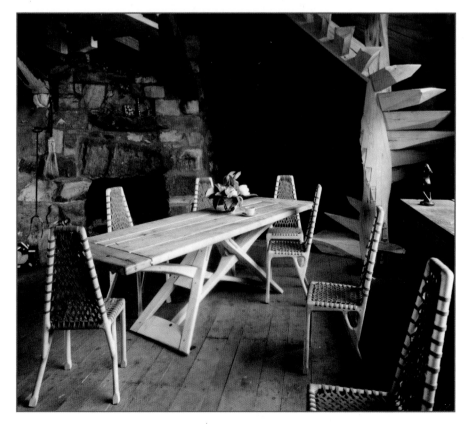

Catalog no. 227. Emil C. Luks, photographer. "Wharton Esherick's *Trestle Table* and *Spiral Stair,* ca. 1931." Photograph, ca. 1931. Esherick Family Collection.

The 1928 log garage adjacent to the studio, with its skewed and curving surfaces—a playful exploration of concave and convex—is reminiscent of German Expressionism.

Catalog no. 228.
Wharton Esherick
Esherick's Studio Garage.
Pencil on paper, 1930-31.
Mark Sfirri Collection.

Catalog no. 229.
Wharton Esherick
Esherick's Studio Garage.
Pencil on paper, 1930-31.
Mark Sfirri Collection.

Esherick used wagon wheels and cart traces—wood pieces used to attach the axle or shafts of the cart to the collar, yoke, or harness of the animal pulling it—purchased from a defunct wheelwright shop to make this chair for a harness room in Mt. Kisco, New York.

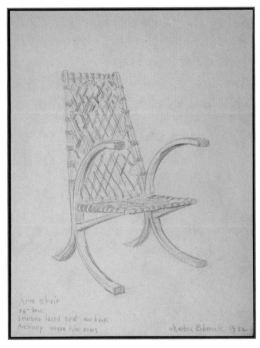

Catalog no. 230.
Wharton Esherick.
Armchair [Wagon Wheel].
Pencil on paper, 1932.
Signed "Wharton Esherick 1932."
Wharton Esherick Museum.

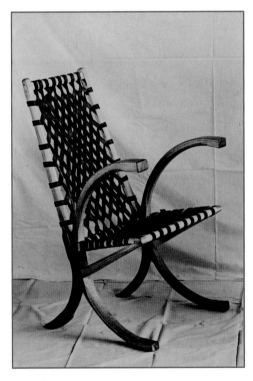

Catalog no. 231.
Wharton Esherick.
Wagon Wheel Chair.
Hickory and laced leather, 1931.
Mansfield and Ruth Bascom.

Historic photograph by Emil Luks, ca. 1931.
Esherick Family Collection.

Great Patrons

When he first started to make furniture, Esherick was frustrated by his "need" to do so when his "desire" was to make sculpture. Fortunately, commissions in the 1930s from three significant patrons provided him not only with money and encouragement but also, and more importantly, with freedom to experiment, grow, and ultimately eliminate the distinction between furniture and sculpture.

Relationships between Esherick and his patrons were far more than simply contractual. Throughout his life, Esherick had a knack for turning clients and patrons into friends who ate and drank together, sharing thoughts and opinions. His patrons gave Esherick access to people and ideas that would further his career. Equally noticeable, Esherick's friends often became his clients. Neighbors and friends—like Theodore Dreiser, for whom he made a large table out of padouk, a tropical wood—appreciated his skills just as did those who reached his studio from afar.

Helene Fischer

Helene Koerting Fischer (1879-1970) was the proprietor of the Schutte and Koerting Company (designers and manufacturers of valves, condensers, thermocompressors, and other parts) in Philadelphia and a resident of the Chestnut Hill section of the city. She bought *Finale*, Esherick's reclining dancer sculpture, after having seen it displayed at Hedgerow Theatre, where Esherick often displayed his work in the 1920s and 1930s. She then commissioned a pedestal for the sculpture, which evolved into a Victrola (a phonograph with an internal horn or speaker) cabinet, along with a bench with record storage under the seat. The padouk cabinet that Esherick made for her is reunited with *Finale* for this exhibition. He produced a group of prismatic pieces for her, beginning with the 1931 *Corner Desk*, which remains one of his most highly regarded works. When he completed the desk, he wrote to Dreiser, "Wish you could have seen the desk finished.

People like ants swarmed the studio, spilled the butter, but really I think, were thrilled, if not pleased." He also designed and built a sewing cabinet and a bedside table, both in walnut. The Fischer commissions represent some of Esherick's most imaginative expressionist pieces.

Finale shows a reclining dancer at rest after a performance.

Catalog no. 232.
Wharton Esherick.
Finale.
Black walnut, 1929.
Peter Fischer Cooke Collection.
and
Victrola Cabinet.
Padouk, 1930.
Kaitsen Woo Collection.

Historic photograph by Emil Luks, ca. 1930.
Esherick Family Collection.

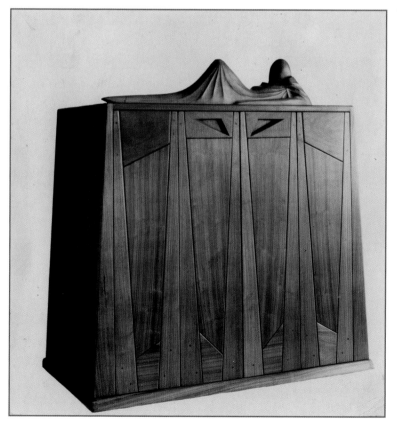

This remarkable desk was roughly contemporary with the cubist designs of John Storrs, one of the few American artists to create and exhibit cubist and nonobjective sculpture in the 1920s and 1930s.

Esherick sent out invitations to friends to come and see the *Corner Desk* that he had made for Helene Fischer.

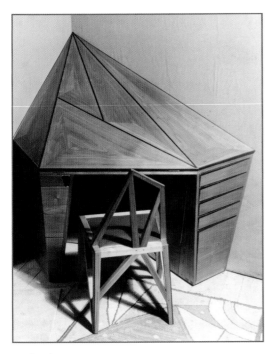

Catalog no. 233.
"Wharton Esherick's *Corner Desk with Original Chair*, 1931."
Photograph, ca. 1931.
Esherick Family Collection.

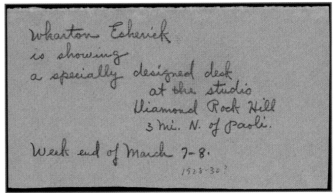

Catalog no. 234.
Wharton Esherick.
"Wharton Esherick is showing a specially designed desk at the studio, Diamond Rock Hill, 3 mi. N. of Paoli. Week end of March 7-8."
Handwritten invitation, 1931.
Theodore Dreiser Papers, Rare Book and Manuscript Library, University of Pennsylvania.

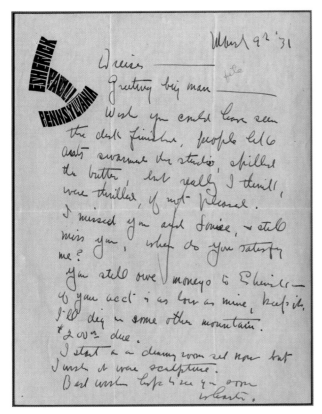

In this letter, Esherick not only speaks about showing Helene Fischer's desk and how well it was received, but also reminds Dreiser that he still owes him $200.

Catalog no. 235.
Wharton Esherick.
Autograph letter to Theodore Dreiser.
Paoli, Pennsylvania, March 9, 1931.
Theodore Dreiser Papers,
 Rare Book and Manuscript Library,
 University of Pennsylvania.

Louise Campbell, one of Dreiser's editors, wrote this evocative piece—one of two slightly different versions of the text—in response to seeing Esherick's *Corner Desk*. It mentions by name Gertrude Stein, James Joyce, e.e. cummings, Igor Stravinsky, Mary Wigman (a proponent of modern dance), D. H. Lawrence (for whose *Reflections* Esherick had made his porcupine), and Henry Ford—a list of names that also functions as a brief index of the variety of cultural and social forces a sensitive observer could locate in Esherick's artistic production. Sherwood Anderson had met both Stein and Joyce and stayed friends with Stein until his death.

Catalog no. 236.
Louise Campbell.
"Portrait of a Desk."
Manuscript, ca. 1931.
Barbara Fischer Eldred Collection.

PORTRAIT OF A DESK

Rhythmic planes triangularly merged into a fascinating pattern of intricate simplicity.

Modern. Sophisticated. Exciting. Unexpected differences in proportion of the various sections. The element of surprise.

Sculpture with a purpose. A piece of sculpture that evolved itself into a desk, or rather, a desk that evolved itself into a sculptural creation. But utilitarian purpose by no means sacrificed to artistic expression. As a desk, it does not fail in its function. There is everything that a good desk ought to have. Drawers - even a secret drawer, (for even a modern has secrets) - that slide with mechanistic precision; adequate writing space, lock, light, etc.. And all a part of the sculptural design.

Certainly not an accidental ode to modernity. Too much restraint for that. Restraint that curbs execution at the proper point, and the economy of expression that marks genuine artistry.

A woman's desk. Her evening gowns are by Patou; sports clothes by Chanel; pajamas by Nowinsky; luggage by Vuitton; her perfume and lipstick as modern as her desk.

Words by Gertrude Stein, E.E.Cummings and James Joyce; to music by Stravinsky, and rhythmics by Mary Wigman; with explanatory notes by D. H. Lawrence, assisted by Henry Ford. Merged into sculptural expression by Wharton Esherick.

- Louise Campbell

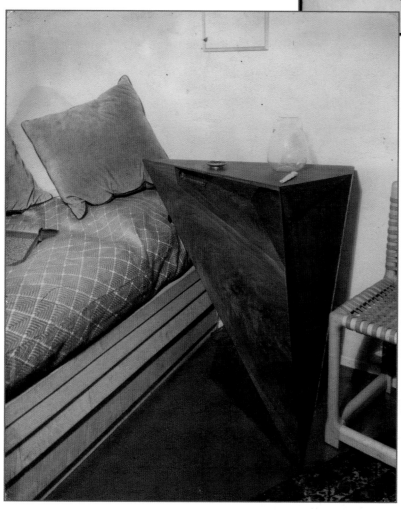

Catalog no. 237.
Wharton Esherick.
Bedside Table.
Walnut and cherry, 1933.
Peter Fischer Cooke Collection.

Historic photograph, 1933.
Esherick Family Collection.

Marjorie Content

The photographer Marjorie Content (1895-1984) was closely connected with some of the most creative writers and artists working in New York City in the 1920s and 1930s. Her first husband was Harold A. Loeb, a descendant of the Guggenheim family and later Ernest Hemingway's inspiration for the character Robert Cohn in *The Sun Also Rises* (1926). In 1921, Loeb founded and edited *Broom*, a journal of new writing and art. Her second husband, the British painter and theatrical designer Michael Carr, died in 1927. Her third husband was the poet Leon Fleischman, whom she married in 1929 and had left by 1931.

In 1932 Content commissioned a bedroom suite from Esherick for her New York City apartment. He continued his prismatic experiments with the vanity: two floor-to-ceiling inverted pyramids with mirrors on the interior faces and pull-out drawers on the outer faces. The pyramids are joined together by a trapezoidal mirror; a triangular stool completes the piece. For the bed and chest of drawers he moved in a new direction. The thick walnut slabs of the bed base slope outward as they rise from the floor. The slope of the head mates with the back of the chest of drawers. Instead of a straight or rectangular form, the chest is a quarter of an irregular circle that narrows as it rises. The drawers pivot from the far corner. The pattern is repeated in the telephone table that mates with the foot of the bed. Esherick wrote of the suite: "It is one of the biggest & most complete things I have done. The new corner chest of drawers which also acts as a headboard to the bed I think is my best piece." The tapering angle of the chest did not please Content as a headboard and so she commissioned another headboard from Esherick.

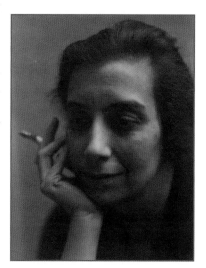

Content continued to commission work from Esherick after her marriage to the Harlem Renaissance poet and novelist Jean Toomer in 1934. Some of these commissions were for Mill House, a farm on the outskirts of Doylestown, Pennsylvania, which became the Toomers' permanent residence in 1936.

Marjorie Content began taking photographs around 1922. She was mentored by photographer Consuelo Kanaga and produced an impressive body of work, including photographs of Esherick and his art. In 1933, Content was hired by the Bureau of Indian Affairs in New Mexico to photograph Native Americans in the Southwest.

Catalog no. 238.
Marjorie Content, photographer.
"Self-portrait."
Photograph, ca. 1928.
Courtesy Jill Quasha, New York.

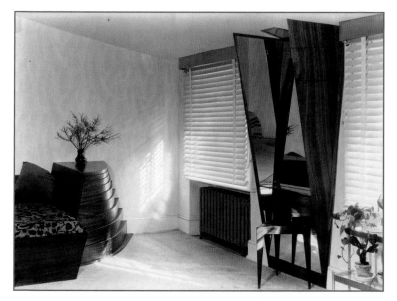

Catalog no. 239.
Marjorie Content, photographer.
"Wharton Esherick's *Content Bedroom Suite
in New York City Apartment*."
Photograph, ca. 1933.
Esherick Family Collection.

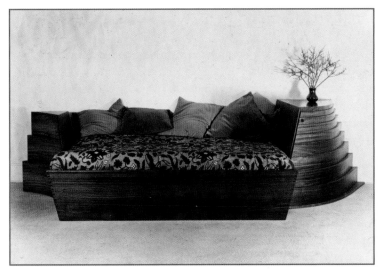

Catalog no. 240.
Phinney, photographer.
"Wharton Esherick's *Content Bed with Pivot Drawers*."
Photograph, ca. 1932.
Esherick Family Collection.

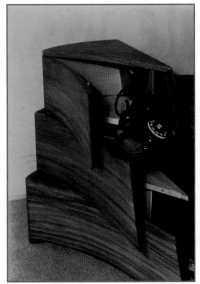
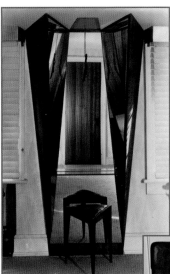

Catalog no. 241.
Wharton Esherick.
Three Curved Drawer Cabinet at Foot of Commissioned Bed.
Padouk, 1932.
Sandberg Family Collection.

Historic photograph by Marjorie Content, ca. 1932.
Esherick Family Collection.

Catalog no. 242.
Marjorie Content, photographer.
"Wharton Esheick's *Content Vanity Table and Stool*."
Photograph, ca. 1933.
Esherick Family Collection.

Esherick made this headboard for Content after she complained that the chest of drawers was not a good angle and size for a headboard.

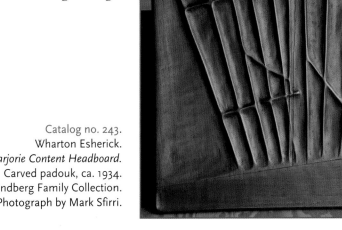

Catalog no. 243.
Wharton Esherick.
Marjorie Content Headboard.
Carved padouk, ca. 1934.
Sandberg Family Collection.
Photograph by Mark Sfirri.

Curtis Bok

William Curtis Bok (1897-1962), who went by his middle name, was a respected Philadelphia lawyer, judge, and president of the Philadelphia Orchestra's board of directors. Some facets of his personality seemed to fit well with Esherick's interests. Like Esherick, he gardened and loved to sail. He also played the piano, wrote novels, and, in 1932, went to Russia to work as a machine laborer in a factory and to learn more about the Bolshevik Revolution.

In 1935, Esherick's good friend Alexander Hilsberg, the concertmaster of the Philadelphia Orchestra, introduced him to Bok. Bok had mentioned to Hilsberg that he needed bookshelves for his new house. Hilsberg told him, "I know a man who has what you need and needs what you have." This introduction began what would become the largest of Esherick's commissions. Working on the Bok House in Gulph Mills, Pennsylvania, a suburb of Philadelphia, for three years, he built not only the book shelves but also an entrance foyer, a spiral stair, a home office designed specifically for doing legal research, several fireplaces and fireplace surrounds, and a music room. At the project's peak, Esherick employed eleven workers, including his nephew Joseph Esherick, then completing his architectural degree at the University of Pennsylvania. Joseph would later become a renowned architect in California.

For the Bok House, Esherick expanded upon ideas first explored in his Fischer and Content commissions. Elements became more architectural in detail and expression and reflected Esherick's increasing interest in integrated interior spaces furnished appropriately. The doorway to the music room and the adjacent fireplace are prismatic in form, while the spiral stair in the foyer is a graceful curving form that changes from a circle at the bottom to a triangle at the top. The music room plays with converging and diverging facets, most clearly seen in the chimney but also apparent in the room's oak paneling and the massive oak sills of the four-foot by sixteen-foot picture window. One wall contained shelving for records and sheet music. The phonograph, on wheels, could be tucked into an alcove on the shelf unit when not in use. Speakers were mounted behind a carved wood grill over the fireplace. Bok did not care for the grill and wanted a painting hung over it. Esherick did not like the painting, so he mounted it so it could be raised to show the grill. You always knew who had been in the room last by the position of the painting.

Although the Bok House was torn down in 1986, all of Esherick's work was carefully removed. The fireplace and entry to the music room are on display in the American wing of the Philadelphia Museum of Art. The spiral stair is at the Wolfsonian Museum in Miami, Florida.

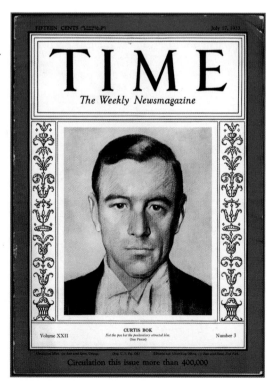

Catalog no. 244.
"Curtis Bok."
Time, 22:3 (July 17, 1933).
Magazine cover.
Mark Sfirri Collection.

Catalog no. 245.
Wharton Esherick.
Curtis Bok Tells Us in His Easy Way.
Pencil on paper, 1930s.
Wharton Esherick Museum.

In this one-page letter, Esherick talks about "rushing thru some work for Bok," complaining, "Artist? Shit I'm a contractor."

Catalog no. 246.
Wharton Esherick.
Autograph letter to Theodore Dreiser.
[1935-6]
Theodore Dreiser Papers, Rare Book and Manuscript
Library, University of Pennsylvania.

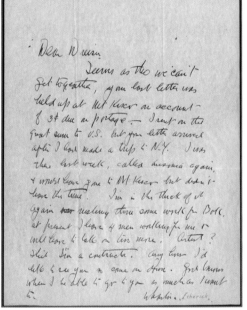

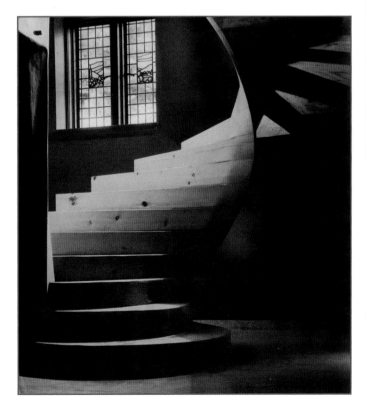

Catalog no. 247.
Marjorie Content, photographer.
"Bok House—Spiral Stair."
Photograph, 1935.
Esherick Family Collection.

Catalog no. 249.
Consuelo Kanaga, photographer.
"*Bok House Desk—Open.*"
Photograph, ca. 1937.
Esherick Family Collection.

Catalog no. 248.
Wharton Esherick.
Office Doorway.
Pencil on paper, ca. 1936.
Wharton Esherick Museum.

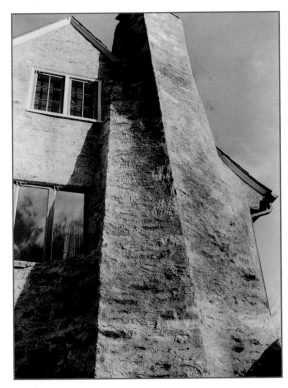

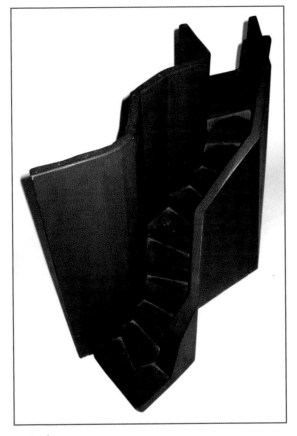

Catalog no. 250.
Consuelo Kanaga, photographer.
"*Bok House—Exterior of Chimney.*"
Photograph, ca. 1937.
Esherick Family Collection.

Catalog no. 251.
Wharton Esherick.
Bok House Outside Staircase.
Wood model, 1938.
Wharton Esherick Museum.
Photograph by Paul Eisenhauer.

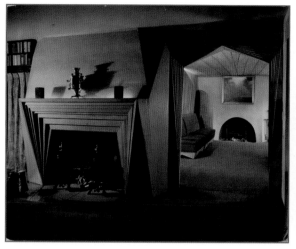

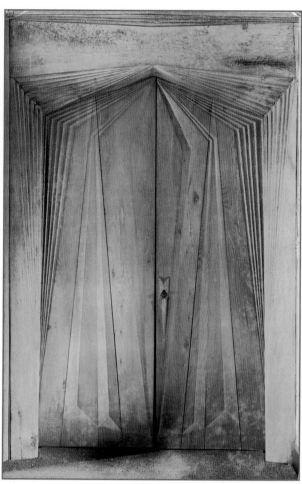

Catalog no. 252.
Edward Quigley, photographer.
"*Bok House—View Looking from Library through
 Carved Oak Doorway into Music Room.*"
Photograph, 1938.
Esherick Family Collection.

Catalog no. 253.
Emil C. Luks, photographer.
Bok House—Doorway to Music Room."
Photograph, ca. 1935.
Esherick Family Collection.

Catalog no. 254.
Edward Quigley, photographer.
"*Bok House—Music Room.*"
Photograph, 1938.
Esherick Family Collection.

Catalog no. 255.
Consuelo Kanaga, photographer.
"*Bok House—Corner of Music Room
 Showing Stone Fireplace.*"
Photograph, ca. 1937.
Esherick Family Collection.

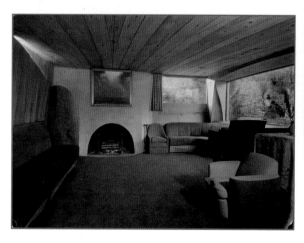

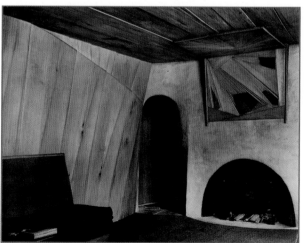

Catalog no. 256.
Consuelo Kanaga, photographer.
*"Bok House—View from Study to Music Room
 Cabinet."*
Photograph, ca. 1937.
Esherick Family Collection.

Catalog no. 257.
Edward Quigley, photographer.
"Bok House—Radio and Phonograph Cabinet."
Photograph, 1938.
Esherick Family Collection.

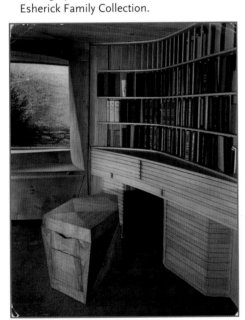

Catalog no. 258.
Wharton Esherick.
*Turntable Cabinet from Bok House Music
 Room.*
Oak, 1937.
Philadelphia Museum of Art: Partial and
 promised gift of Enid Curis Bok Okun,
 daughter of Curtis and Nellie Lee Bok, 2001.

Historic photograph by Edward Quigley, 1938.
Esherick Family Collection.

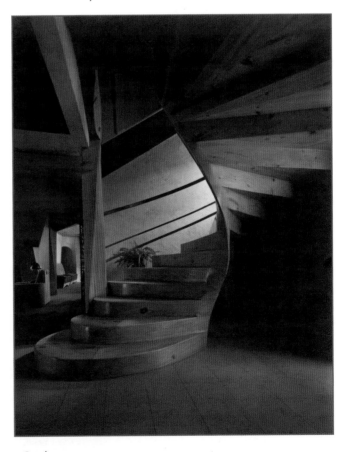

Catalog no. 259.
Reuben Goldberg, photographer.
"Bok House—Spiral Stair with View to Music Room."
Photograph, late 1930s.
Esherick Family Collection.

In this one-page letter, Esherick mentions that he is "finishing some work at Bok House & ... doing some sculpture. I'm doing a piece now I call *The Actress.*"

Catalog no. 260.
Wharton Esherick.
Autograph letter to Helen Dreiser.
February 6, 1939.
Theodore Dreiser Papers, Rare Book and
Manuscript Library, University of Pennsylvania.

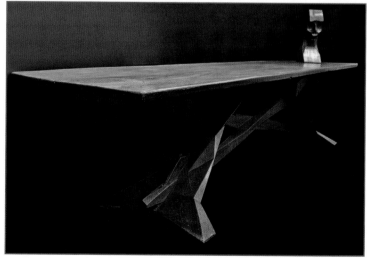

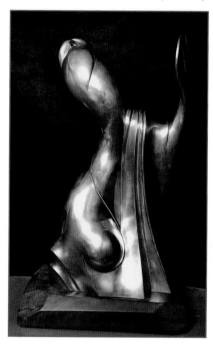

Catalog no. 261.
Wharton Esherick.
The Actress.
Bronze casting of cherry original, 1939.
Esherick Family Collection.

Theodore Dreiser

Theodore Dreiser was introduced to Esherick in 1924, the beginning of a long and sometimes difficult friendship. In the mid- to late 1920s, Esherick made a number of different pieces for Dreiser, including a walking stick (1925), a sculpture of Dreiser's head (1927), a large table out of padouk with a faceted base (1928), and a remarkable print of Dreiser in his New York City apartment (1928). He also designed a separate thatched-roof cabin and an ethereal blue entrance gate with large hinges that resembled bolts of lightning for Dreiser's country house, "Iroki," in Mount Kisco, New York, and managed its construction in late 1927 and early 1928 while Dreiser was away.

Catalog no. 262.
Wharton Esherick.
Theodore Dreiser's Padouk Table.
Padouk, 1928.
Theodore Dreiser Papers, Rare Book and
Manuscript Library,
University of Pennsylvania.

A Mark of Success

By 1940, when this exhibition stops tracing Esherick's career (which continued through the 1940s, 1950s, and 1960s), his work had come to embody a clear and thorough synthesis of formal and material elements. This synthesis, the fundamental quality of his subsequent work, led to a widespread reassessment of the place of craft in America and in modern art. Previously distinct categories, only recently—in postmodern theory—accorded anything like parity, art and craft were joined by artists like Esherick in a manner now often neglected but which anticipates their modern unity. In his modernism, in other words, Esherick can be seen as a precursor of a postmodern aesthetic.

Key to Esherick's renown was his collaboration with architect George Howe (1886-1955) in the creation of the Pennsylvania Hill House for the America at Home pavilion at the 1940 World's Fair in New York City. The oak *Spiral Stair* from Esherick's studio, a curving sofa rejected by the Boks because of its deep center, an elk-hide chair like one designed for the Bok music room, and other Esherick pieces were assembled into a rustic contemporary room, its centerpiece a table with thin hickory legs supporting a five-sided black phenol top. Organic and contemporary, the room represented a new direction for Esherick and proved to be a precursor of his later work.

Esherick would continue to create new and exciting works of art for another thirty years, until his death in 1970. His work can be found in many of the country's major art museums, including Boston's Museum of Fine Arts, New York's Metropolitan Museum of Art, the Philadelphia Museum of Art, and New York's Whitney Museum of American Art, as well as countless private collections. His studio—now the Wharton Esherick Museum—is undoubtedly his greatest work of art. He worked on it throughout his life. A major retrospective of Esherick's work, held in 1958 at the Museum of Contemporary Craft (now the Museum of Arts & Design) in New York City, was followed a decade later by a smaller display in the Peale Galleries of the Pennsylvania Academy of Fine Arts. The year after his death the American Institute of Architects awarded him the national Craftsmanship Medal. Since his death, Esherick's work has been included in a number of group exhibitions celebrating American studio furniture (Renwick Gallery, 1972; Museum of Fine Arts, Boston, 2003), Philadelphia artists (Philadelphia Museum of Art, 1976), and American design (Metropolitan Museum of Art, 2001), and several solo shows have focused on his woodblock prints (Woodmere Art Museum, 1984; Pennsylvania Academy of Fine Arts, 1991).

This exhibition has looked at Esherick's origins and placed him within the contexts of the people and places that influenced him. Out of this background he emerged as an artist in wood, one whose work, forty years after his death, continues to speak to us and to invite our further engagement.

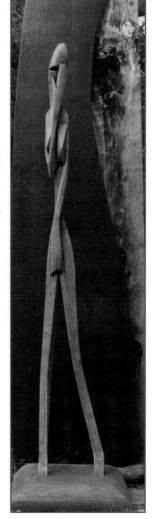

Catalog no. 267
Wharton Esherick.
Adolescence.
Birch, ca. 1941.
Mansfield and Ruth Bascom.

Historic photograph by Consuelo Kanaga, 1940s.
Esherick Family Collection.

This early example of Esherick's *Hammer Handle Chair* was given to his good friend Sherwood Anderson.

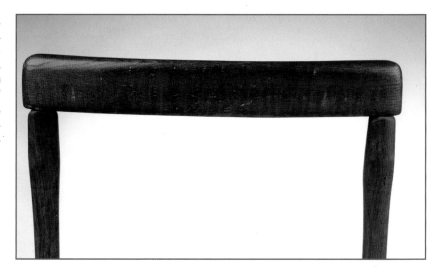

Catalog no. 263.
Wharton Esherick.
Hammer Handle Chair.
Wood and industrial belting, 1938.
Inscribed "To Ripshin from
Hedgerow and WE."
Sherwood Anderson Collection,
Ripshin Farm.
Photograph by Paul Eisenhauer.

Each *Hammer Handle Chair* was made using approximately twelve hammer handles with industrial belting for the seats. Esherick originally made them in exchange for Ruth's tuition to Hedgerow's theater program, and a number of them remain in use at Hedgerow Theatre.

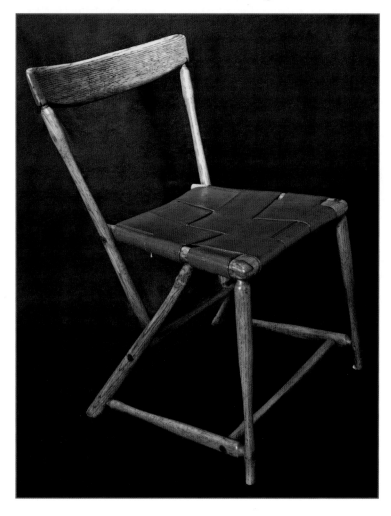

Catalog no. 264.
Wharton Esherick.
Hammer Handle Chair.
Wood and industrial belting, 1938.
Wharton Esherick Museum.

This vinyl-topped card table, similar to the phenol-topped one exhibited at the 1940 World's Fair, was made at the same time. The combination of the rustic look of the hickory, the modern plasticity of the phenol, and the organic blending of the legs and supports marked a new synthesis for Esherick, and pointed towards the direction he would take in the future.

On the right is one of Esherick's *World's Fair Chairs*, the predecessor of which was the *Hammer Handle Chair*. Esherick had hickory hammer handles—purchased in great quantity at an auction—to create chairs for Hedgerow Theatre. The length of those handles required him to rethink the form of the chair and led to a functional redesign that Esherick used in different ways for the rest of his career, including here. The *Ash Chair* is a later variant of the *Hammer Handle Chair*.

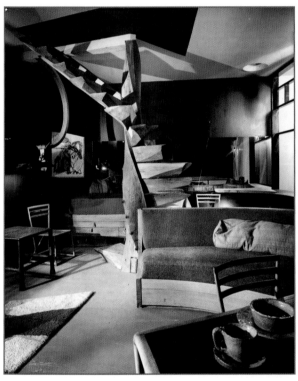

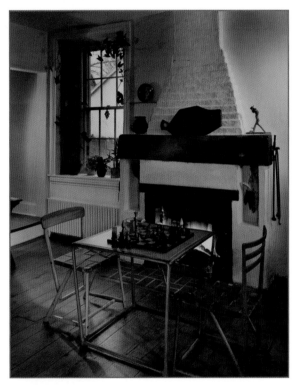

Catalog no. 265.
Richard Garrison, photographer.
"Wharton Esherick and George Howe's
 'Pennsylvania Hill House' exhibit in
 the World's Fair display, 'America at
 Home.'"
Photograph, 1940.
Esherick Family Collection.

Catalog no. 266.
Wharton Esherick.
World's Fair Style Card Table.
Hickory and vinyl, 1940.
Collection of LongHouse Reserve, East
 Hampton, New York.
and
World's Fair Chair.
Hickory and leather, 1940.
Wharton Esherick Museum.

Historic photograph of table with *Ash
 Chair* (left) and *World's Fair Chair*
 (right) by William F. Howland, 1940.
Esherick Family Collection.

Selected Bibliography

Archival Sources

Campbell, Louise. "Portrait of a Desk," [ca. 1931]. Barbara Fischer Eldred Collection.

Anderson, Sherwood, Papers. Newberry Library, Chicago, Illinois.

Centaur Book Shop and Press Archive. University of Pennsylvania Libraries.

Dreiser, Theodore, Papers. University of Pennsylvania Libraries.

Esherick, Wharton, Papers. Archives of American Art, Smithsonian Institution.

Hedgerow Theatre Photo Collection. University of Pennsylvania Libraries.

Hedgerow Theatre Collection. Howard Gottlieb Archival Research Center, Boston University.

Swanberg, W. A., Papers. University of Pennsylvania Libraries.

Zigrosser, Carl, Papers. University of Pennsylvania Libraries.

Interviews

The interviews were conducted by Mansfield Bascom, Ruth Esherick Bascom, and Miriam Phillips. They were transcribed by Sue Hinkel. Transcripts are in the archives of the Wharton Esherick Museum, Paoli, PA.

Esherick, Wharton. ca. 1968–70. Interviews by Mansfield Bascom, Ruth Bascom, and Miriam Phillips.

Mason, Harold. n.d. Interviews by Mansfield Bascom, Ruth Bascom, and Miriam Phillips.

Ray, Ed. n.d. Interview by Mansfield and Ruth Bascom.

Shearer, Mae. February 11, 2002. Interview by Mansfield Bascom.

Toomer, Marjorie Content. n.d. Interview by Mansfield and Ruth Bascom.

Published Works

"After Curtis." *Time* 22, no. 3 (July 17, 1933): 30–32.

Alyea, Paul E. and Blanche R. *Fairhope, 1894–1954: The Story of a Single Tax Colony.* University: University of Alabama Press, 1956. Reprint, New York: AMS Press, 1979.

"America at Home." *Art Digest* 14, no. 17 (June 1940): 9.

Anderson, Sherwood. *The Buck Fever Papers.* Charlottesville: University Press of Virginia, 1971.

_____. *Hello Towns!* New York: Horace Liveright, 1929.

_____. *No Swank.* Philadelphia: Centaur Press, 1934.

_____. *Sherwood Anderson's Memoirs.* New York: Harcourt, Brace, 1942.

Antliff, Allan. "Carl Zigrosser and the Modern School: Nietzsche, Art, and Anarchism." *Archives of American Art Journal* 34, no. 4 (1994): 16–23.

Bascom, Mansfield. Exhibition catalog for *Hammer Handle Chair* exhibition. Paoli, Pa.: Wharton Esherick Museum, 2006.

_____. *Wharton Esherick: The Journey of a Creative Mind.* New York: Abrams, 2010.

Benson, Gertrude. "Wharton Esherick." *Craft Horizons* (January/February 1959): 32-37.

Boswell, Peyton, Jr. *Varnum Poor.* New York: Hyperion Press; Harper & Brothers, 1941.

The Centaur Press Announcement [for *The Song of the Broad-Axe* and *Edgar Saltus: A Critical Study*]. Philadelphia: Centaur Press, 1924.

Cerf, Bennett. "Death of a Centaur." *Publishers' Weekly* 142 (Sept. 12, 1942): 931–32.

Conn, Peter J. *The American 1930s: A Literary History.* New York: Cambridge University Press, 2009.

Cooke, Edward S., Gerald W. R. Ward, and Kelly H. L'Ecuyer. *The Maker's Hand: American Studio Furniture, 1940–1990.* Boston, MA: MFA Publications, 2003.

Coppard, A. E. *Yokohama Garland and Other Poems.* Vignettes by Wharton Esherick. Philadelphia: Centaur Press, 1926.

Dreiser, Theodore. *Letters to Women.* Vol. 2, *New Letters.* Edited by Thomas P. Riggio. Urbana: University of Illinois Press, 2009.

Dudley, Jane. "The Early Life of an American Modern Dancer." *Dance Research: The Journal of the Society for Dance Research* 10, no. 1 (Spring 1992): 3–20.

Edwards, Robert and Robert Aibel. *Wharton Esherick, 1887–1970, American Woodworker.* Exhibition catalog. Philadelphia: Moderne Gallery, 1996.

Eisenhauer, Paul D. *Wharton Esherick Studio & Collection.* Atglen, PA: Schiffer Publishing, 2010.

Esherick, Wharton. *The Song of Solomon.* Illustrated by Wharton Esherick. Philadelphia: Centaur Press, 1927.

Esherick, Wharton and Robert A. Laurer. *The Furniture and Sculpture of Wharton Esherick.* Exhibition catalog. New York: Museum of Contemporary Craft, 1958.

Ford, Ford Madox. *Great Trade Route.* New York: Oxford University Press, 1937.

Friedman, Marilyn F. "Defining Modernism at the American Designers' Gallery, New York," *Studies in the Decorative Arts* 14, no. 2 (Spring-Summer 2007): 79-116.

Furst, Herbert, ed. *The Woodcut: An Annual.* London: The Fleuron Limited, 1928.

Grafly, Dorothy. "Wharton Esherick." *Magazine of Art* 43, no. 1 (January 1950): 9-11.

Halton, Eugene. *The Great Brain Suck and Other American Epiphanies.* Chicago and London: The University of Chicago Press, 2008.

Ham, Peter, Eleanore Price Mather, Judy Walton, and Patricia Ward, eds. *A History of Rose Valley.* [Rose Valley,] Delaware County, PA: Borough of Rose Valley, [1973].

Hannah, Caroline. "Crow House Rising." *American Craft* 68, no. 3 (June/July 2008): 56–63.

Hartshaw, Horace B. *A Pencil in the Hand of the Master: Recollections of Esherick.* N.p.: Seasholtz Publications, Inc., 2004, 2006.

Hinkel, Susan R. "Wharton Esherick: Dean of American Craftsmen." *American Woodworker,* no. 12 (February 1990): 36–42.

_____. "A Maverick's Mansion." *Art & Antiques* (May 1988): 76–81, 114.

Holmes, David J. "Joseph's Coat with the Canvas Seams: D. H. Lawrence and the Centaur Press." Lecture, Bryn Mawr College, Bryn Mawr, PA, April 27, 1988.

Howe, George. "New York World's Fair 1940." *Architectural Forum* 73, no. 1 (July 1940): 31–39.

Illustrated Catalogue of Lithographs, Engravings, and Etchings Published by the Weyhe Gallery, 794 Lexington Avenue, New York. New York: Weyhe Gallery, 1928.

Innes, C. D. *Erwin Piscator's Political Theatre: The Development of Modern German Drama.* London: Cambridge University Press, 1972.

Johnson, Marietta. *The Fairhope Idea in Education.* New York: Fairhope Educational Foundation, 1926.

_____. *Thirty Years with an Idea.* Published for the Organic School, Fairhope, AL, by The University of Alabama Press, 1974.

Lawrence, D. H. *Reflections on the Death of a Porcupine and Other Essays.* Philadelphia: Centaur Press, 1925.

Levins, Hoag. "The Modern Genius of Wharton Esherick." *Old House Interiors* 10, no. 4 (July 2004): 82–86.

_____. "A Thoreau in Wood: the Making of Wharton Esherick." *Modernism Magazine: 20th Century Art & Design* 1, no. 2 (Fall 1998): 22–29.

Lingeman, Richard R. *Theodore Dreiser.* 2 vols. New York: Putnam, 1986–1990.

Marcy, Mary. *Rhymes of Early Jungle Folk.* Illustrated by Wharton Esherick. Chicago: Charles H. Kerr, 1922.

Marion, John Francis. "Books and Music: A Portrait of Harold Mason." *Tempos* 4, no. 4 (February 1959): 4.

Mayer, Roberta A. and Mark Sfirri. "Early Expressions of Anthroposophical Design in America: The Influence of Rudolf Steiner and Fritz Westhoff on Wharton Esherick." *The Journal of Modern Craft* 2, no. 3 (November 2009): 299–324.

Miller, Henry. *The Air-Conditioned Nightmare.* Vol. 2, *Remember to Remember.* New York: New Directions, 1947.

Millstein, Barbara Head, and Sarah M. Lowe. *Consuelo Kanaga: An American Photographer.* Brooklyn, New York: The Brooklyn Museum in association with University of Washington Press, 1992.

Parker, Charlotte. *A Short History of the Threefold Community, 1922–1972.* Spring Valley, NY: Threefold Community, 1972.

Prints by Wharton Esherick. Exhibition catalog. Philadelphia: Woodmere Art Museum, 1984.

Quasha, Jill. *Marjorie Content: Photographs.* With essays by Ben Lifson and Richard Eldridge, and Eugenia Parry Janis. New York: W. W. Norton, 1994.

Renwick Gallery. *Woodenworks; Furniture Objects by Five Contemporary Craftsmen: George Nakashima, Sam Maloof, Wharton Esherick, Arthur Espenet Carpenter, Wendell Castle.* St. Paul: Minnesota Museum of Art, 1972.

Rideout, Walter B. *Sherwood Anderson: A Writer in America.* 2 vols. Madison: University of Wisconsin Press, 2006.

Rochberg, Gene. *Drawings by Wharton Esherick.* New York: Van Nostrand Reinhold, 1978.

Rosse, Herman. *American Designers Gallery, Inc.* New York: American Designers' Gallery, 1930.

The Ruth Doing Camp for Rhythmics, July 2 to September 10, 1923, Eighth Season [camp prospectus]. N.p., 1923.

Salaman, Malcolm C. *The New Woodcut. The Studio,* special spring number. Edited by C. Geoffrey Holme. London: The Studio; New York: Albert & Charles Boni, 1930.

Saunders, Max. *Ford Madox Ford: A Dual Life.* 2 vols. Oxford: Oxford University Press, 1996.

Sfirri, Mark. "Anatomy of a Masterpiece: The 1931 Corner Desk by Wharton Esherick." *Woodwork,* no. 112 (August 2008): 52–56.

_____. "Esherick Emerges: A Recent Auction Brings the 'Dean of American Craftsmen' Some Overdue Notice." *Woodwork,* no. 105 (June 2007): 59–65.

_____. "The Hammer-Handled Chairs: Found Object Art by Wharton Esherick." *Woodwork,* no. 110 (April 2008): 60–62.

"Six New Eastern Bookshops. IV: The Centaur Book Shop, Philadelphia." *The Publishers' Weekly* 107, no. 14 (April 4, 1925): 1246–47.

Swanberg, W. A. *Dreiser.* New York: Charles Scribner's Sons, 1965.

Townsend, Kim. *Sherwood Anderson.* Boston: Houghton Mifflin Company, 1987.

Wentz, John C. "The Hedgerow Theatre: An Historical Study." PhD diss., University of Pennsylvania, 1954.

Wharton Esherick, Master of the Woodcut: An Exhibition of Woodblock Prints from the Collection of Rose and Nathan Rubinson. Exhibition catalog. Philadelphia: School of the Pennsylvania Academy of the Fine Arts, 1991.

"Wharton Esherick: Museum is Sculptor's Masterpiece." *Fine Woodworking* 2, no. 1 (Summer 1977): 45.

Whitman, Walt. *Song of the Broad-Axe.* Illustrated by Wharton Esherick. Philadelphia: Centaur Press, 1924.

Willett, John. *The Theatre of Erwin Piscator: Half a Century of Politics in the Theatre.* London: Eyre Methuen, 1978.

Yarnall, Sophia. "Sculptured Wood Creates the Unique Interiors of the Curtis Bok House." *Country Life & The Sportsman* 74, no. 2 (June 1938): 67-74.

Internet Sources

Marietta Johnson Museum–Fairhope, AL. http://www.ariettajohnson.org/

"The Story of Schutte and Koerting Company." http://www.s-k.com/pdf/History.pdf

Wessells, Henry. "The Book Illustrations of Wharton Esherick." The Avram Davidson Website. http://www.avramdavidson.org/esherick.htm